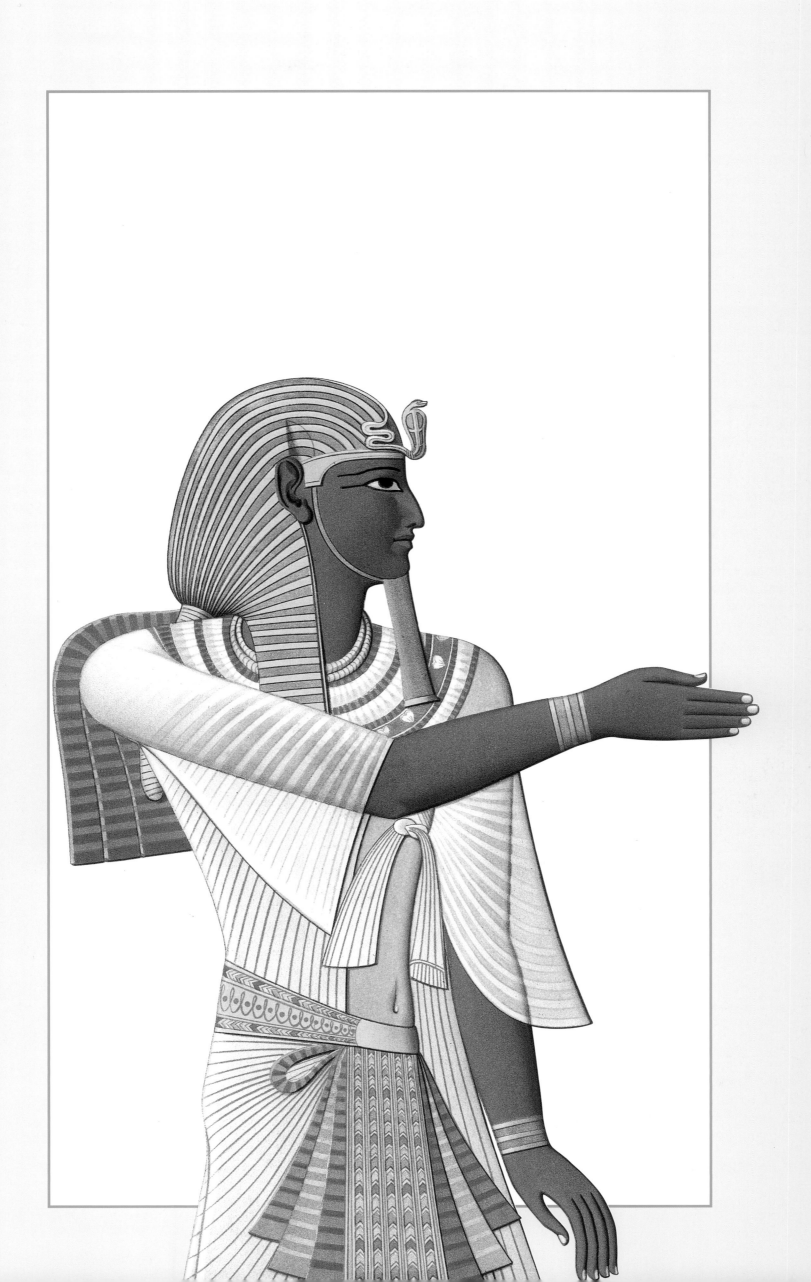

FOREWORD

The nineteenth century was a busy time in Thebes. Ancient Egyptian art and architecture were all the rage in Europe, and scores of travelers were making their way up the Nile to see firsthand what everyone agreed was one of the world's most fascinating sites. Among those visitors was a number of highly skilled artists who sought to record in sketches and watercolors the landscape of Thebes and the hundreds of beautifully decorated monuments that lay there. Sometimes their drawings were made as aides-memoire in personal journals or as contributions to scholarly surveys of Egyptian culture. Some were intended for interior designers back in Europe who catered to the Egyptomania sweeping the continent. Whatever their motivation, these adventurous and talented artists left behind brilliant records of the monuments of Thebes as they were over a century ago.

• • •

In many cases, these records are all we have. Many of the monuments they recorded have since been destroyed by erosion, water, vandalism, and theft, and the modern-day Egyptologist must rely heavily on these nineteenth-century paintings to reconstruct badly damaged tomb and temple walls. The paintings have proved essential to our knowledge of ancient Egypt. But they can be appreciated in their own right, too: they are not only accurate records, they are also works of art, elegant testimonials to their artist's keen eye and aesthetic sensibility.

• • •

No less fascinating than the images are the stories of the artists who made them. Always colorful and often downright eccentric, these dedicated men worked in arduous conditions, often threatened by violence and disease. Their lives are told in fascinating detail in this volume, and certainly justify the high regard in which they are held by modern scholars. It is no exaggeration to claim that Egyptology today would be much the poorer were it not for the works of the nineteenth-century explorers and artists described in this book. Their work is every bit as important to our field of study as that of modern epigraphers and photographers. It proudly stands as one of the pillars of our discipline.

Kent R. Weeks
Director
Theban Mapping Project

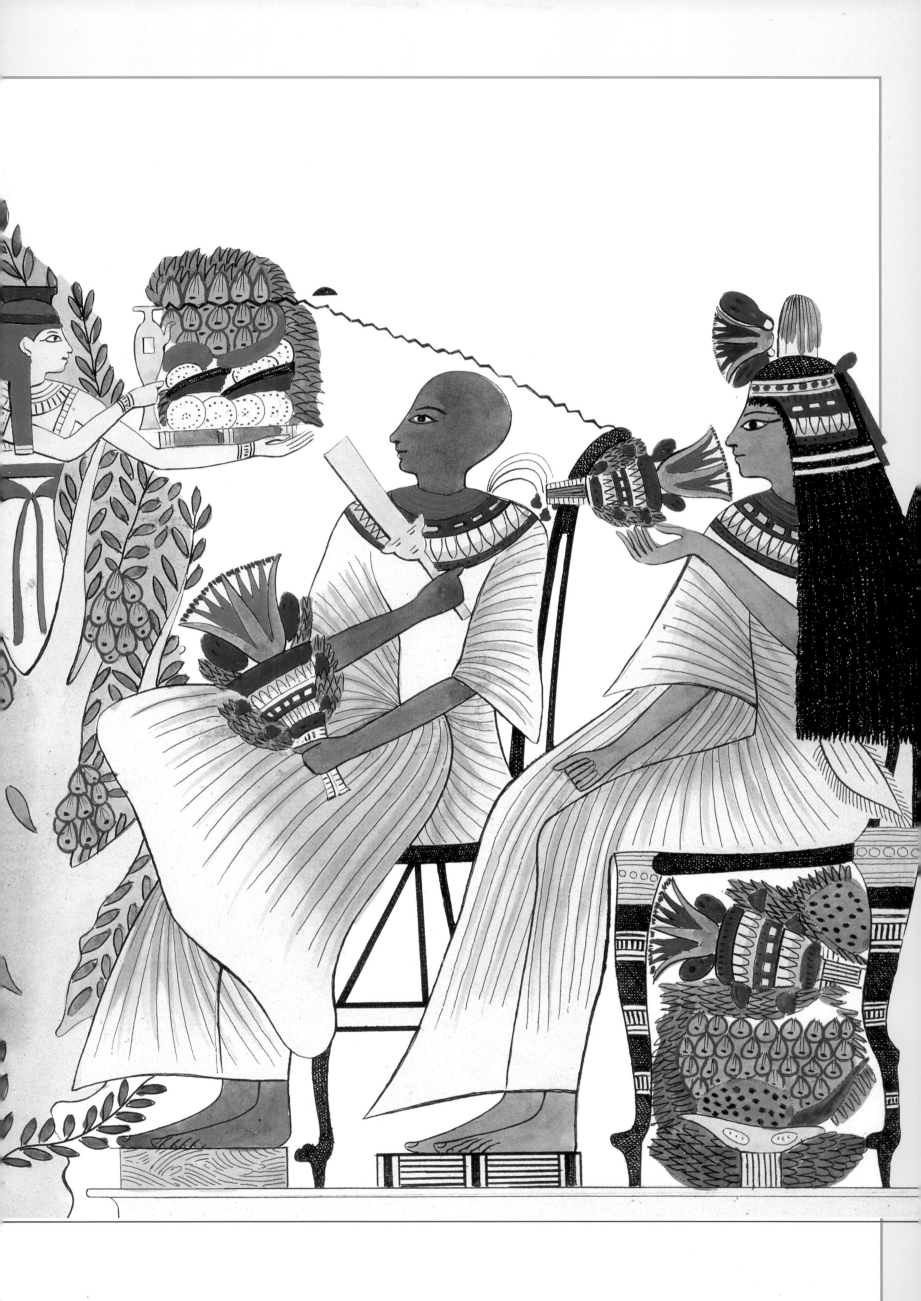

EXPLORERS and ARTISTS
in the Valley of the Kings

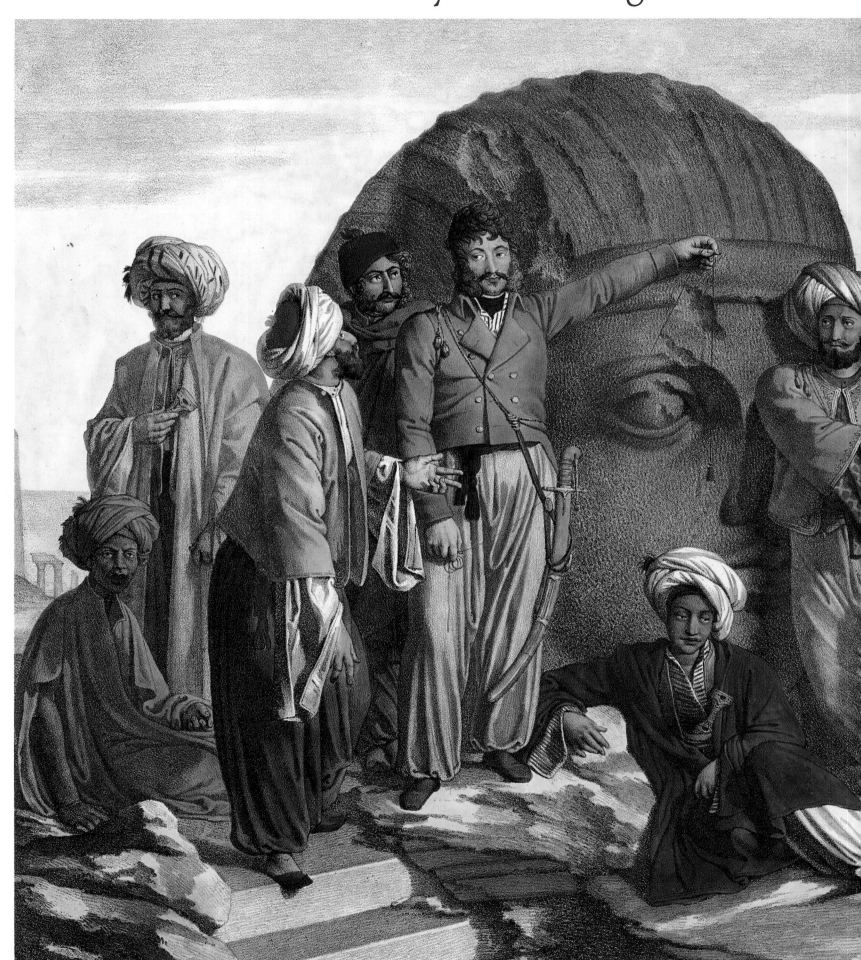

THE AMERICAN UNIVERSITY IN CAIRO PRESS

CONTENTS

TEXTS BY
Catharine H. Roehrig

GRAPHIC DESIGN BY
Patrizia Balocco Lovisetti

The publishers would like to thank:
H.E. Farouk Hosny -
The Egyptian Minister of Culture;
Gaballah Ali Gaballah - Secretary General
of the Supreme Council for Antiquities;
Nabil Osman - President of the Egyptian
Information Center;
Gamal Morsi - Director of the Cairo Press
Center;
Sabry Abd El Aziz Khater - General Director
of Antiquities of Luxor and Upper Egypt;
Mohamed A. El-Bialy - General Director
of Antiquities of Thebes-West;

The publishers would also like to
acknowledge Eni and its Egyptian
subsidiary IEOC, which have supported and
promoted the publication of this volume.

Published in Egypt in 2002 by
The American University in Cairo Press
113 Kasr el Aini Street - Cairo, Egypt

© 2001 White Star S.r.l.

This edition published by arrangement with
White Star S.r.l. - Vercelli, Italy

All rights reserved.

Dar el Kutub No. 16716/01
ISBN 977 424 705 1

Printed in Italy by Officine Grafiche De Agostini
Color separation by Fotomec, Turin

1
Émile Prisse d'Avennes published some of the most accurate
copies that were produced in the nineteenth century. This
image of Merenptah was copied from his tomb in the Valley
of the Kings (KV 8). From Émile Prisse d'Avennes's
Histoire de l'Art Egyptien.

2-3
This illustration, from Rosellini's Monumenti Civili, depicts
a man and his wife seated before a sycamore fig tree.
The "Lady of the Sycamore" offers them fruits and water.

4-5
Bernardino Drovetti served as consul-general for the French
in Egypt in the early nineteenth century. He formed
substantial collections of Egyptian art, which are now in
European museums. He is shown here at Thebes, holding
a plumb-line, in a drawing by the Comte de Forbin.
To his left stands one of his principal agents, Jean Jacques
Rifaud. From L.N.P.A. Forbin's Voyage dans le Levant.

5 top
Illustration from Rosellini's Monumenti di Culto.

INTRODUCTION

Among the earliest tourists to western Thebes were the Egyptians themselves. In the early Eighteenth Dynasty (ca. 1500-1450 B.C.), scribes visited an offering chapel that had been dedicated by the vizier Antefoker to his mother Senet. This brightly painted rock-cut chapel was already 500 years old, having been carved in the early Twelfth Dynasty, during the reign of Senwosret I (ca. 1950 B.C.). Some of the visitors just wrote their names—"the scribe Siamen came to see this tomb." Others included a funerary offering to the dead, and a few commented on the tombs beauty—"He found it like heaven in its interior," "They found it exceedingly pleasant in their hearts."

More than a thousand years later, Greek and Roman travelers left their names on the temples, tombs and statues of the western plain. To these visitors, the already ancient city on the east bank of the Nile—called *Waset* by the Egyptians—was known as the hundred-gated Thebes, a designation first recorded in Homer's Iliad. One of the most popular attractions was the Valley of the Kings where fourteen tombs contain more than 2000 Greek and Latin graffiti. By far the favorite, with nearly one thousand graffiti, was the tomb of Rameses VI (KV 9 - ca. 1140 B.C.). Located in the center of the Valley, this huge rock-cut tomb is decorated with graphic funerary texts and vignettes

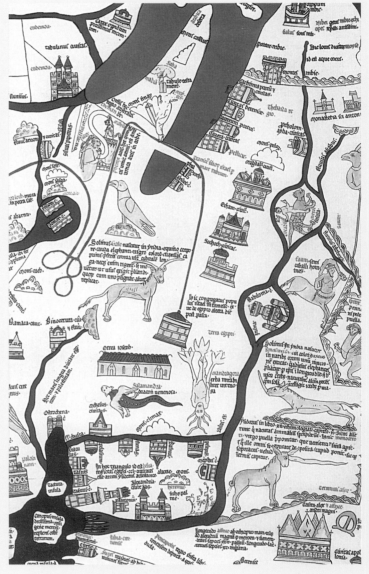

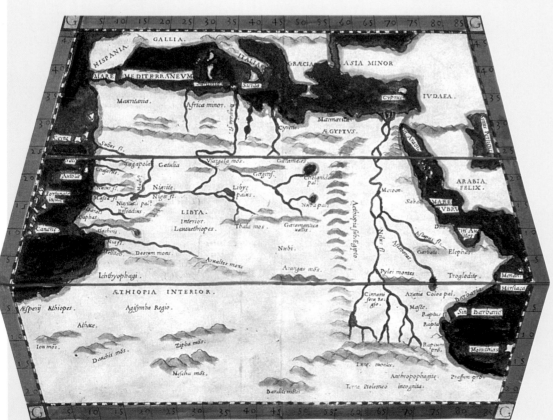

6 top

In this detail from the Mappa Mundi, drawn by Richard of Haldingham in 1290, the word "Thebaidea", a term applied to a large portion of Upper Egypt, is written in red between the Red Sea town of Berenice and the Nile, below the mountains separating Egypt from Nubia to the south.

6 bottom

This sixteenth century map, drawn by Jacopo Gastaldi, is based on one drawn by Claudius Ptolemaeus, who lived in the second century. At that time, the kingdom of Meroe, whose capital is prominently indicated along the Nile, was a powerful rival to Roman control of Egypt.

7

This detail of a map, copied in the eleventh century from one dating to the eighth century, shows how little was known of Africa, which has been reduced to Libya, Egypt, and Ethiopia. The "island of Meroe," surrounded here by the Nile and included within Egypt, is actually a huge region in southern Sudan.

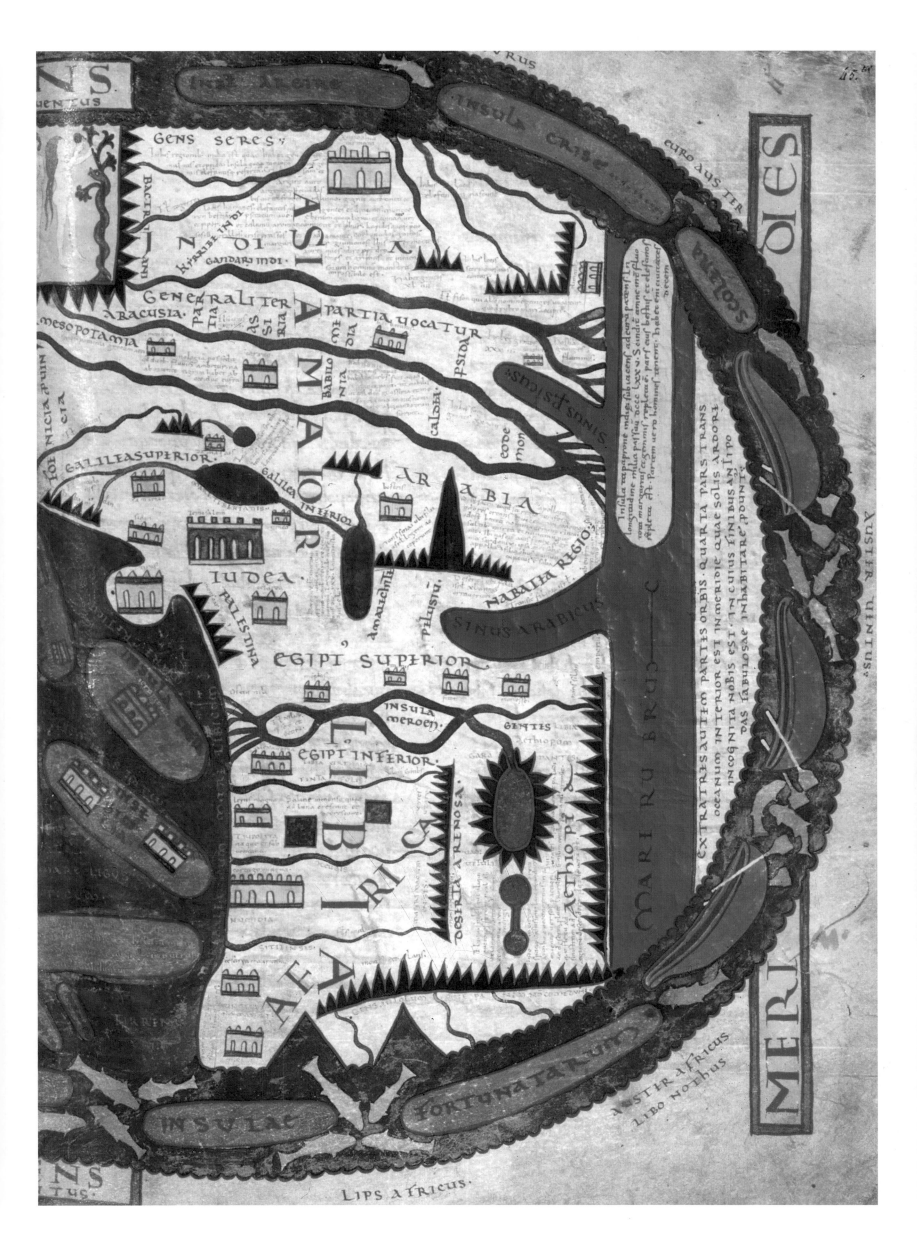

that must have seemed as strange to these early western tourists as they did to the European travelers who arrived more than a thousand years later. In Roman times, the tomb was identified as belonging to Memnon, a mythical king of Ethiopia, who had fought in the Trojan war and been killed by Achilles.

Another popular stopping place was in the flood plain where two colossal statues, measuring more than fifteen meters (fifty feet) in height, dominate the landscape.

Dozens of classical graffiti cover the base and ankles of the northern colossus, identifying it as an image of Memnon. This statue had been damaged in such a way that it emitted a strange sound at sunrise. Since Memnon was the son of Eos, goddess of the dawn, the sound was interpreted as Memnon greeting his mother. Among the visitors who waited to hear the statue speak was the emperor Hadrian (A.D. 130). In reality, these seated quartzite giants (still called the colossi of Memnon) once flanked the entrance to the mortuary temple of Amenhotep III (ca. 1375 B.C.). Amenhotep had built the largest temple in western Thebes, but the great entrance pylon was of mud-

and was one of the first European travelers to leave both drawings and descriptions of what he saw.

Perhaps the most famous of the ancient visitors to Egypt was Herodotus. In the mid-fifth century B.C., Egypt was under Persian rule, but the Greek historian seems to have traveled freely, sailing up the Nile as far as Aswan. The information he gathered from priests and his own observations filled book II of his *History*, which was a popular resource for later European travelers.

Another important Classical source was written by Diodorus Siculus, a scholar of Greek descent living in Sicily in the time of Julius Caesar. The first book of his history of the world was devoted to Egypt and includes a number of descriptions of western Thebes, many of them based on earlier literary references. For example, Diodorus paraphrases a description by Hecataeus of a monument belonging to King Ozymandias. This seems to be the mortuary temple of Ramesses II (identified as the Memnonium by early European travelers, but now called the Ramesseum) and includes the fallen colossus of the king, whose throne name, Usermaatra, is probably the source of the name Ozymandias. This statue was reported to

have a completely mythical inscription that was later reinterpreted by the British poet, Percy Shelley "My name is Ozymandias, King of Kings: Look on my works, ye Mighty, and despair!"

In regard to the Valley of the Kings, Diodorus states that: "...the priests claim to find records of forty-seven royal tombs, but they say that by the reign of Ptolemy son of Lagus only seventeen remained; and many of these were in ruins at the time of our visit..." (Book I, 46; trans. Murphy).

Not long after Diodorus, the geographer Strabo visited western Thebes: "Here are two colossal figures near one another, each consisting of a single stone. One is entire; the upper parts of the other, from the chair, are fallen down, the effect, it is said, of an earthquake. It is believed, that once a day a noise as of a slight blow issues from the part of the statue which remains in the seat and on its base. When I was at those places ... I heard a noise at the first hour (of the day), but whether proceeding from the base or from the colossus, or produced on purpose by some of those standing around the base, I cannot confidently assert." (Book XVII, Chapter I, paragraph 46; trans. Hamilton).

With the Arab conquest of Egypt, in the

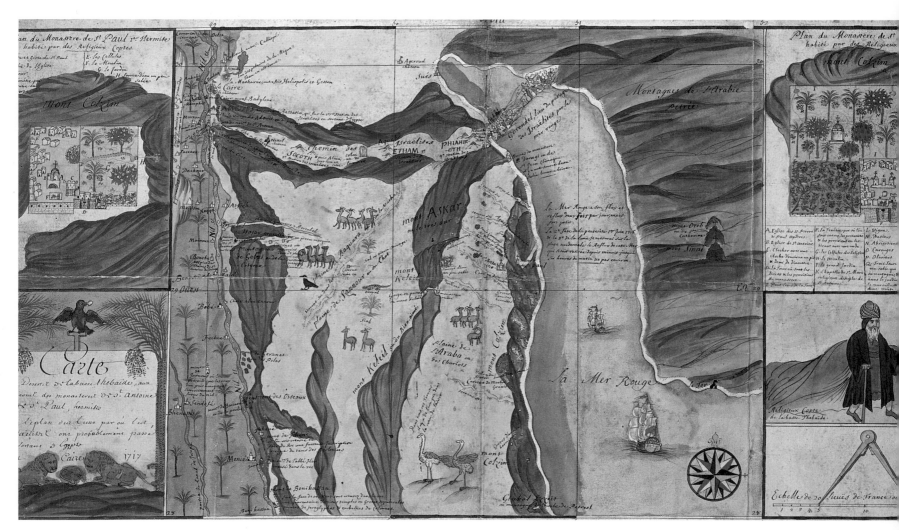

brick which eventually melted away with the encroachment of the annual Nile flood. The reliefs, statues, and columns, made of sandstone or limestone, were reused in other structures, or were left to disintegrate over thousands of years in the damp soil. But traces of the column bases and statues were still visible to Richard Pococke, a British cleric who visited Thebes in January of 1738

8

This map, by the Dutch cartographer Abraham Ortelius, first published in 1570, is far more detailed than earlier maps, and more accurate than many later ones. Thebes may be seen on the east bank just south of the large bend in the river. On the west bank, Ortelius has placed one of the principal monuments mentioned by Classical authors, the Memnonium.

9

The French Jesuit, Claude Sicard, traveled extensively in Egypt in the early eighteenth century. On his map of the country, he located dozens of ancient sites, including Thebes.

seventh century, access to ancient Thebes became restricted to Europeans, though Alexandria and Cairo were still open to traders and pilgrims to the Holy Lands. As a result, although the pyramids at Giza and other northern sites were known to Europeans even in the middle ages, little was known about Egypt or the ancient monuments south of Cairo, a fact that is evident in early maps.

Beginning in the eighteenth century, however, a few intrepid travelers ventured farther up the Nile valley. One of the first was Claude Sicard (1677-1726) who had joined the Jesuits in 1692. In 1700, he had become a missionary to Syria and in 1707, he was sent to the Jesuit mission in Cairo and remained in Egypt until his death. Fluent in Arabic, and with a thorough knowledge of the classical writers, he is credited with being the first European in modern times to recognize the contemporary town of Luxor as the site of ancient Thebes. His purpose for being in Egypt was to bring the Coptic church under the authority of Rome, but he was also asked by Philippe d'Orleans, the French Regent, to make a record of the ancient monuments. Sicard eventually drew a map of Egypt on which he located 24 temples, 50 decorated tombs, and 20 pyramids.

Less than two decades after Sicards death, Richard Pococke and Ludwig Norden, traveling separately, journeyed up the Nile and returned home to publish illustrated accounts of their travels in Egypt. More than half a century later, the first of the great scientific expeditions arrived in Egypt with Napoleons invading army. Their scholarly efforts, published as the multi-volumed *Description de l'Égypte* provided Europeans with the first comprehensive view of the monuments of Western Thebes.

While exploring the Valley of the Kings, a small group climbed to the top of the cliffs that separate this desert wadi from the western plain of the Nile valley. Perhaps the first Europeans to see this remarkable view, one of them (M. Costaz) described it thus: "It is impossible to imagine a contrast more striking than that presented by the two scenes that

we had before our eyes: on one side, solitude, aridity, desolation, and death; on the other, temples, palaces, a beautiful river, vegetation, cultivated fields, herds, people, and all the movement of living nature."

The early nineteenth century also brought individuals such as Giovanni Belzoni and Jean Jacques Rifaud, who came not as tourists or scholars, but as the agents of the European consuls to Egypt, who had become avid collectors of Egyptian antiquities. These men invariably spent time in Thebes, one of the richest archaeological sites in the world. Belzoni's description of the impression created by the monuments is eloquent: "The most sublime ideas, that can be formed from the most magnificent specimens of our present architecture, would give a very incorrect picture of these ruins: for such is the difference, not only in magnitude, but in form, proportion, and construction, that even the pencil can convey but a faint idea of the whole. It appeared to me like entering a city of giants, who, after a long conflict, were all destroyed, leaving the ruins of their various temples as the only proofs of their former existence."

By the middle of the nineteenth century, the ancient Egyptian language had been deciphered, and dozens of individual travelers, scholars,

adventurers, artists, and two more great scientific expeditions had explored and published volumes on the ruins of western Thebes. But even Richard Lepsius, leader of the Prussian expedition, was inspired to comment in a letter dated February 25, 1845: "Thebes...has been more explored than any other place by travelers and expeditions ... and we have only compared and supplied deficiencies in their labors, not done them afresh. We are also very far from imagining that we have exhausted the immense monumental riches to be found here. They who come after us with fresh information, and with the results of science further extended, will find new treasures in the same monuments, and obtain more instruction from them" (trans. Mackenzie). After a century and a half of further exploration, and discoveries, these observations remain valid today.

Between 1815 and 1819, the British antiquarian, W.J. Bankes traveled in Egypt and the Near East. During this journey, Bankes visited the temple of Philae, south of Aswan, and hired Giovanni Belzoni to transport an obelisk from there back to England. Bankes commissioned this view of the Giza pyramids and sphinx with Cairo in the distance.

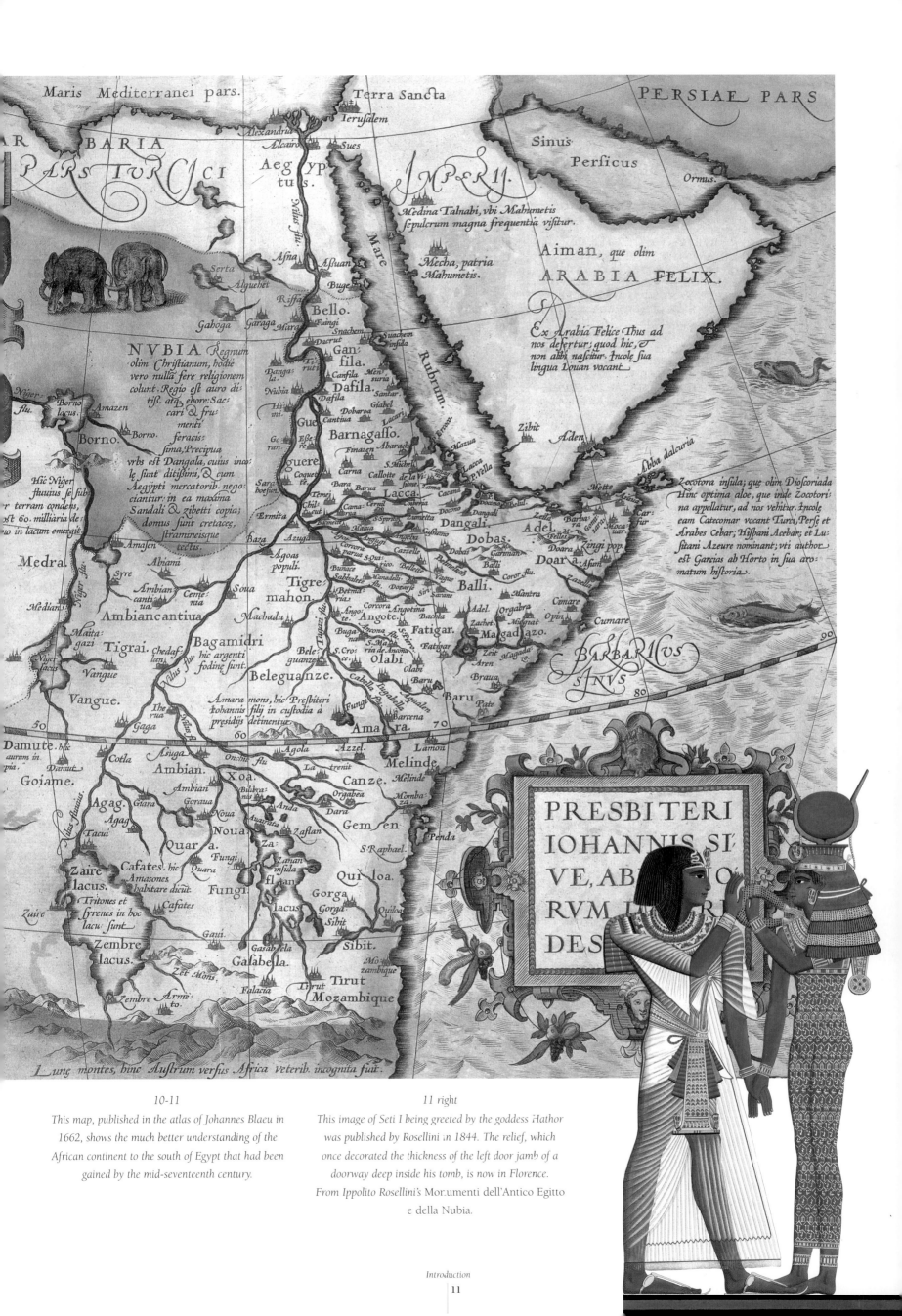

The map contains the following labels and text:

Maris Mediterranei pars.

Terra Sancta

PERSIAE PARS

AR ARIA

PARS TVRCICI

Ierusalem

Alexandria

Alcairo

Aegyp tus.

Sues

Sinus

Persicus

Ormus.

IMPERII.

Medina Talnabi, vbi Mahumetis sepulcrum magna frequentia visitur.

Asna

Assuan

Buge

Riffa

Mecha, patria Mahumetis.

Aiman, que olim

ARABIA FELIX.

Serta

Alguchet

Bello.

Fuingi

Ex Arabia Felice Thus ad nos defertur; quod hic, et non alibi nascitur. Incole sua lingua Douan vocant

Gahoga

Garaga

Mara

Snachem.

Suackem insula

NVBIA Regnum olim Christianum, hodie vero nulla fere religionem colunt. Regio est auro di-tiss. atq; ebore: Sac-cari et fru-menti feracis-sima, Precipua vrbs est Dangala, cuius inco-le sunt ditissimi, et cum Aegypti mercatorib. nego-ciantur: in ea maxima Sandali et zibetti copia; domus sunt cretacee, stramineisque tectis.

Ganfila.

Danga-la.

Nubia

Dacrut

Canfila

Men suria

Santar.

Dafila.

Dafila

Hi mi.

Giabel

Dobaroa

Cantiua

Lacari

Niger flu.

Borno lacus.

Amazen

Gue

Esse ran.

Barnagasso.

Finazen

Abarach

Go ran.

Zibit

Aden

Abba dalcuria

Zocotora insula; que olim Dioscoriada Hinc optima aloe, que inde Zocotori-na appellatur, ad nos vehitur. Incole eam Catecomar vocant Turci, Perse et Arabes Cebar; Hispani Acebar; et Lu-sitani Azeure nominant; vti author est Garcias ab Horto in sua aro-matum historia.

Borno.

Borno.

Coquet te.

Bara

Barua

Callotte de la fi-sione.

Zama

S.Michel

Mazua

Lacca

P.Vella

Hette

Carfur

Hic Niger fluuius se sub terram condens, post 60. milliaria de-nuo in lacum emergit.

Sarc boesuer

Temei

Chili sucut

Carna

Cernil

Cohena

Spurato

Cabella

Lacca

Dangali

Zelle

Barba

Gomi

zarci

Moca uar.

Medra.

Ermita

Barmeill

Malua

Angelu

Kasouro

Docona

Dangali

Adel

Fellas

Kingi pop.

Doara

Asum

Amasen

Baza

Azuga

Corcora parua

Quia

Cazzelle

Garuman

Dobas.

Medran

Abiami

Agoas populi.

Bunace

Fico

Bellette

Belinchach

Vague

Balli

Coror flu.

Doar a.

Zazella

Syre

Ambian cantiq ua.

Cemenia

Soua

Sablalete

Kanadalli Ihi.

Dozarsi

Siri Sauans

Balli.

Mantra

Ambiancantiua

Machada

Tigre mahon.

Argo te.

Corcora Angotina

Angeo

S. Ste zeo

Adel.

Zachet

Orgabra

Miggat

Opin

Cimare

Maita gazi

Tigrai.

chedaf len.

Bagamidri hic argenti fodin sunt.

Bele guanze

Buga nan

S. Ma ria de Ancona

Ancota

Fatigar.

Zeit

Magada zo.

Aren

Magadazo.

Cimare

Opin

Cumare

BARBARICVS SINVS

Vangue

Nilus flu.

Olabi

Fatigar

90

Vangue.

Ihe rua flu.

S.Cro ce.

Olabi

Cabella fugabella.

Baru

Braua

80

Gaga

Beleguanze.

Amara mons, hic Presbiteri Iohannis filij in custodia à presidijs detinentur.

Fungi

Barcena

Baru

Pate

50

60

Amara.

70

Damute. hic aurum in pia.

Cotla

Asuga

Onchia flu

Agola

Azzel

Lamon

Melinde

Goiame.

Damut

Ambian.

Xoa.

La trenit

Canze.

Melinde

Agag

Giara

Ambian

Goraua

Bilibra nas

Anda

Orgabea

Dara

Momba za.

Agag

Noua

Auarata

Zaflan

Gemsen

Tacui

Quar a.

Fungi

Za

Lanan insula fl an

S.Raphael.

Penda

Zaire lacus.

Cafates. hic Amasones habitare dicūt.

Quara

Fungi

Qui loa.

Nilus fluuius

Tritones et syrenes in hoc lacu sunt

Cafates

Gorga.

Gorga

Sibit

Quiloa

Zaire

Gaui

Zembre lacus.

Gasabela

Galabella.

Sibit.

Zet Mons

Mo zambique

Zembre

Arme to.

Falacia

Tirut

Tirut Mozambique

Lunæ montes, hinc Austrum versus Africa veterib. incognita fuit.

PRESBITERI IOHANNIS SI VE, ABY O RVM I RI DES

10-11

This map, published in the atlas of Johannes Blaeu in 1662, shows the much better understanding of the African continent to the south of Egypt that had been gained by the mid-seventeenth century.

11 right

This image of Seti I being greeted by the goddess Hathor was published by Rosellini in 1844. The relief, which once decorated the thickness of the left door jamb of a doorway deep inside his tomb, is now in Florence. From Ippolito Rosellini's Monumenti dell'Antico Egitto e della Nubia.

RICHARD POCOCKE

In 1737, the Reverend Richard Pococke
(1704-1765) embarked on a journey that took
him to archaeological sites of Egypt, western Asia,
the Aegean islands and Greece. Having studied
religion at Oxford, Pococke was familiar with the
classical authors whose descriptions of the
ancient sites he used as a guide for his own
travels. Pococke arrived in Egypt in late
September 1737. After exploring Lower Egypt, he
sailed south from Cairo in early December, finally
arriving in the Luxor area in mid-January 1738.

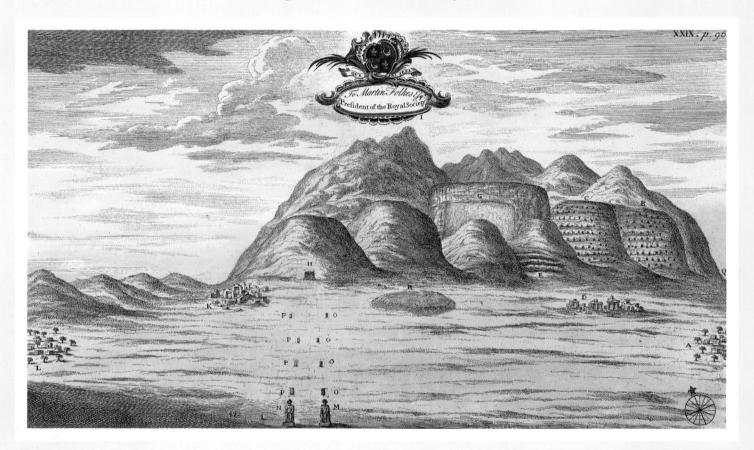

12

*Pococke's view of western Thebes, though not precise,
gives an impression of the magnificent landscape, and
generally locates the sites mentioned in his text. A,
Qurna village; B & C, tombs of New Kingdom officials;
D, the Ramesseum; I, el-Qurn—the highest point on the
west bank that also dominates the Valley of the Kings; K,
"various other temples" (perhaps around the Valley of
the Queens); L, Medinet Habu; M & N, the Colossi of
Memnon; O & P, statues and column bases from the temple
of Amenhotep III that were still visible in Pococke's day;
Q, the wadi leading to the Valley of the Kings.*

13

*Though far from being an accurate plan of the site,
Pococke's birds-eye view of the Valley of the Kings
captures the rugged topography of this royal cemetery,
dominated by the Qurn, which appears to be a
pyramidal peak from this vantage point.*

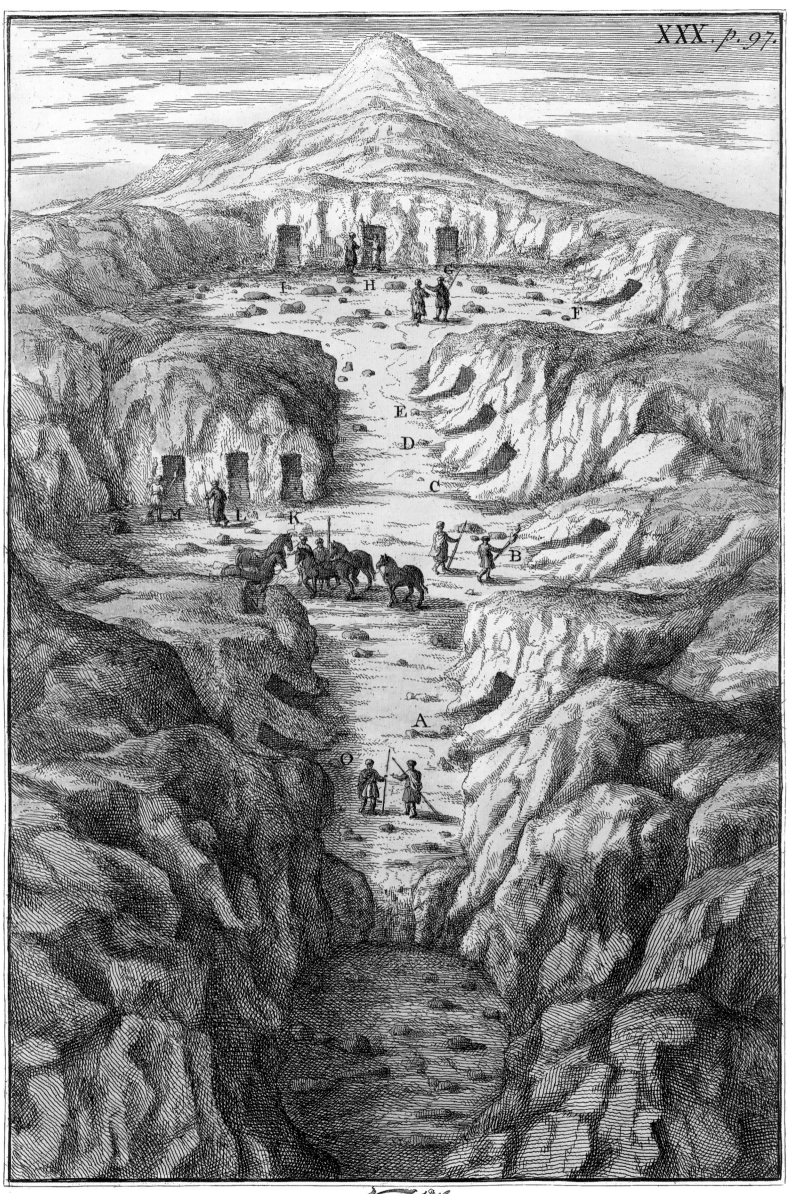

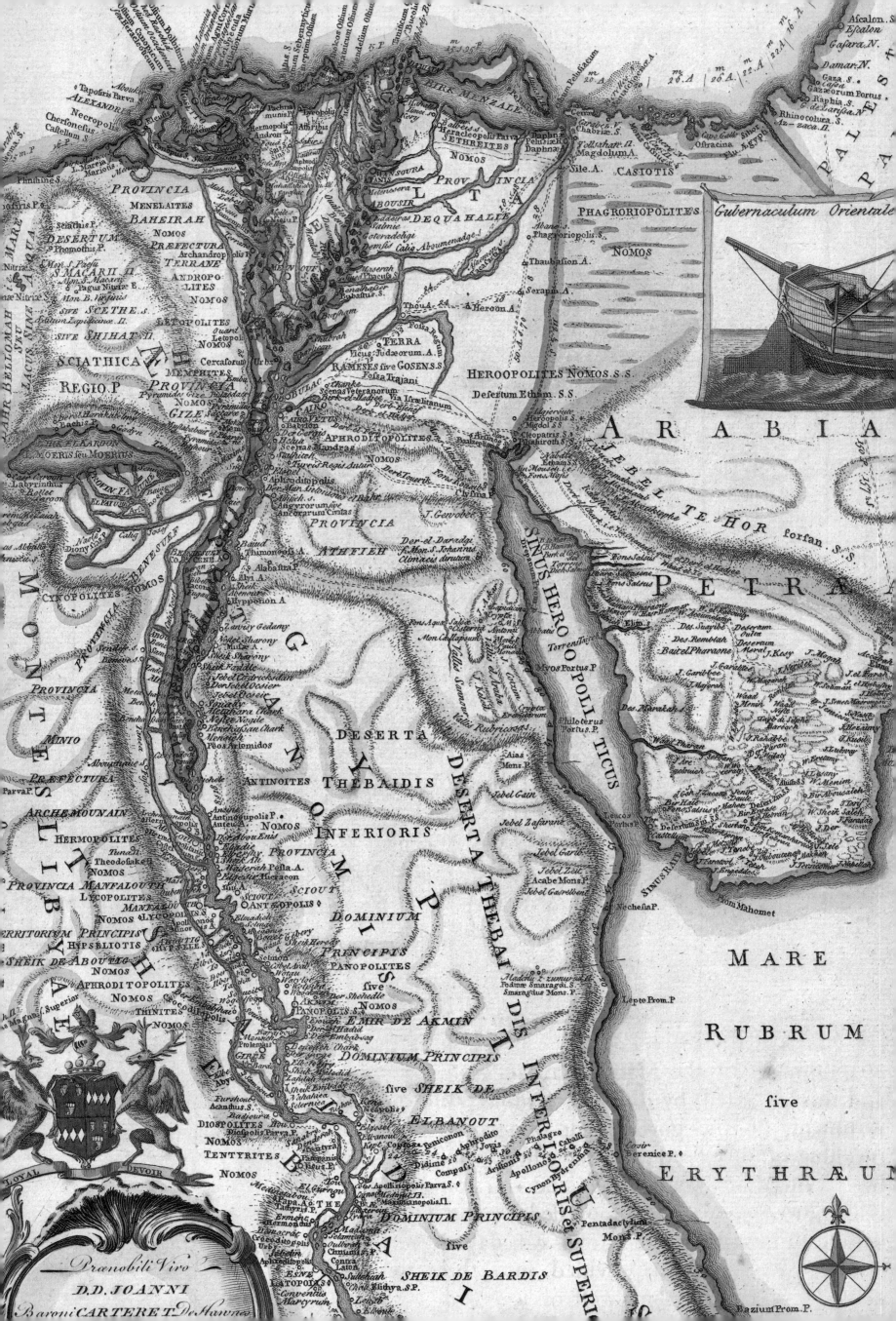

In the eighteenth century, travel in Egypt was a risky undertaking for European travelers, and before embarking on his jounrey up the Nile, Pococke had obtained letters of introduction to the local sheikhs and took along a variety of goods to present as gifts. These preparations allowed him relatively easy access to the antiquities on both banks of the river. After his arrival at Thebes, Pococke spent several days documenting the temples of Karnak. Then, on January 16th, he set out to explore western Thebes, having already sent his letter of introduction to the sheikh of Qurna, who provided him with horses for his journey to the Valley of the Kings. This was a trek of some 8 kilometers (5 miles) round-trip up the same rugged desert wadi that had seen the funerary processions of the New Kingdom pharaohs 3000 years before. In the royal cemetery, Pococke identified 18 tombs of which nine were accessible. His plans of these tombs are quite recognizable, though two were reversed in the printing process. The next day, January 17th, Pococke visited the Ramesseum and the colossi of Memnon. On his return trip from Aswan, he finally saw Medinet Habu temple, which he incorrectly identified as the Memnonium of the classical authors. Pococke's drawings and the account of his travels in Egypt appeared in 1743 as *A description of the East and some other countries*.

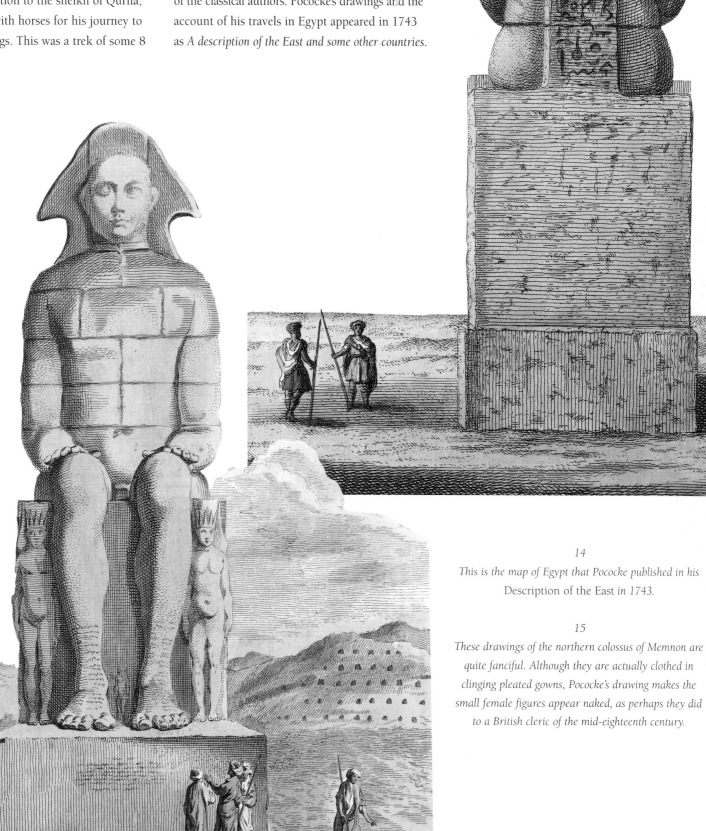

14
This is the map of Egypt that Pococke published in his Description of the East in 1743.

15
These drawings of the northern colossus of Memnon are quite fanciful. Although they are actually clothed in clinging pleated gowns, Pococke's drawing makes the small female figures appear naked, as perhaps they did to a British cleric of the mid-eighteenth century.

THE IMAGES REPRODUCED IN THIS SECTION ARE TAKEN FROM *A DESCRIPTION OF THE EAST, AND SOME OTHER COUNTRIES*, BY RICHARD POCOCKE (LONDON 1743-1745).

FREDERIK LUDWIG NORDEN

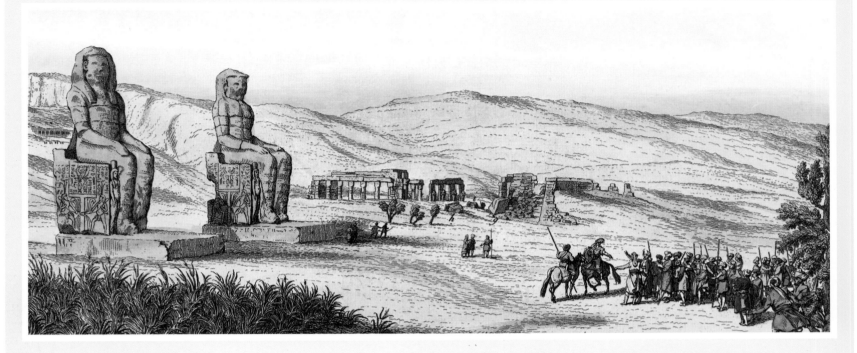

Frederik Ludvig Norden (1708-42), an officer in the Danish navy, was educated in mathematics, architecture, and draftsmanship. On the orders of his sovereign, Christian VI, he was sent to Egypt in 1737 on a mission that included documentation of the ancient monuments. Unlike Pococke, who was in Egypt at the same time, Norden ignored the customs of the country in which he was traveling. He did not provide himself with letters of introduction, nor did he carry gifts to smooth his way. Instead, as a military officer, his methods of dealing with the local population included threats and the show of arms. As a result, he met with constant resistance and was unable to visit a number of sites, including the Valley of the Kings. Norden caught his first glimpse of the ruins of ancient Thebes in the late afternoon of December 11.

Unable to persuade the captain to set him ashore on the east bank, he spent the rest of the day sketching what he could see from the boat. On the following morning, he and some companions set off to explore the west bank using as their guide two colossal statues (the colossi of Memnon) that were visible in the distance. Because of canals and other obstacles, it took them three hours to reach the statues, which Norden spent some time sketching. He then moved on to the Ramesseum, which was visible in the distance and which he identified as the palace of Memnon. Here he made a skillful drawing of the ruins, indicating several fallen statues, including a huge overturned figure that he thought, because of its immense size, must be the colossus of Memnon described by the classical authors.

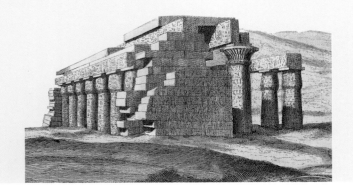

THE IMAGES REPRODUCED IN THIS SECTION ARE TAKEN FROM *VOYAGE D'EGYPTE ET DE NUBIE*, BY FREDERIK LUDWIG NORDEN (COPENHAGEN 1755).

16 top and bottom
Norden's drawing of the Ramesseum shows the two types of columns used in the clerestory construction of the hypostyle hall.

16 center
Norden's drawing of the colossi of Memnon shows the Ramesseum in the background. He mistakenly thought that the two statues represented a man and a woman. Nordens party was challenged by the local sheikh when they visited western Thebes, an event that is probably alluded to here.

17 left
The inaccuracies of the maps Norden took on his voyage up the Nile affected his understanding of Theban geography and he perpetuated the errors on his own map, placing the east bank sites from Medinet Habu to Arment opposite Karnak (Carnac). In fact, Medinet Habu is nearly opposite Luxor temple and Arment is some kilometers to the south.

17 right
Although Norden and Pococke traveled in Egypt at the same time, they first met in 1841, as fellow members of Londons Egyptian Society. Norden's Travels in Egypt and Nubia, which included his drawings and descriptions of the monuments, was published in both French and English in the 1850s, more than a decade after his death.

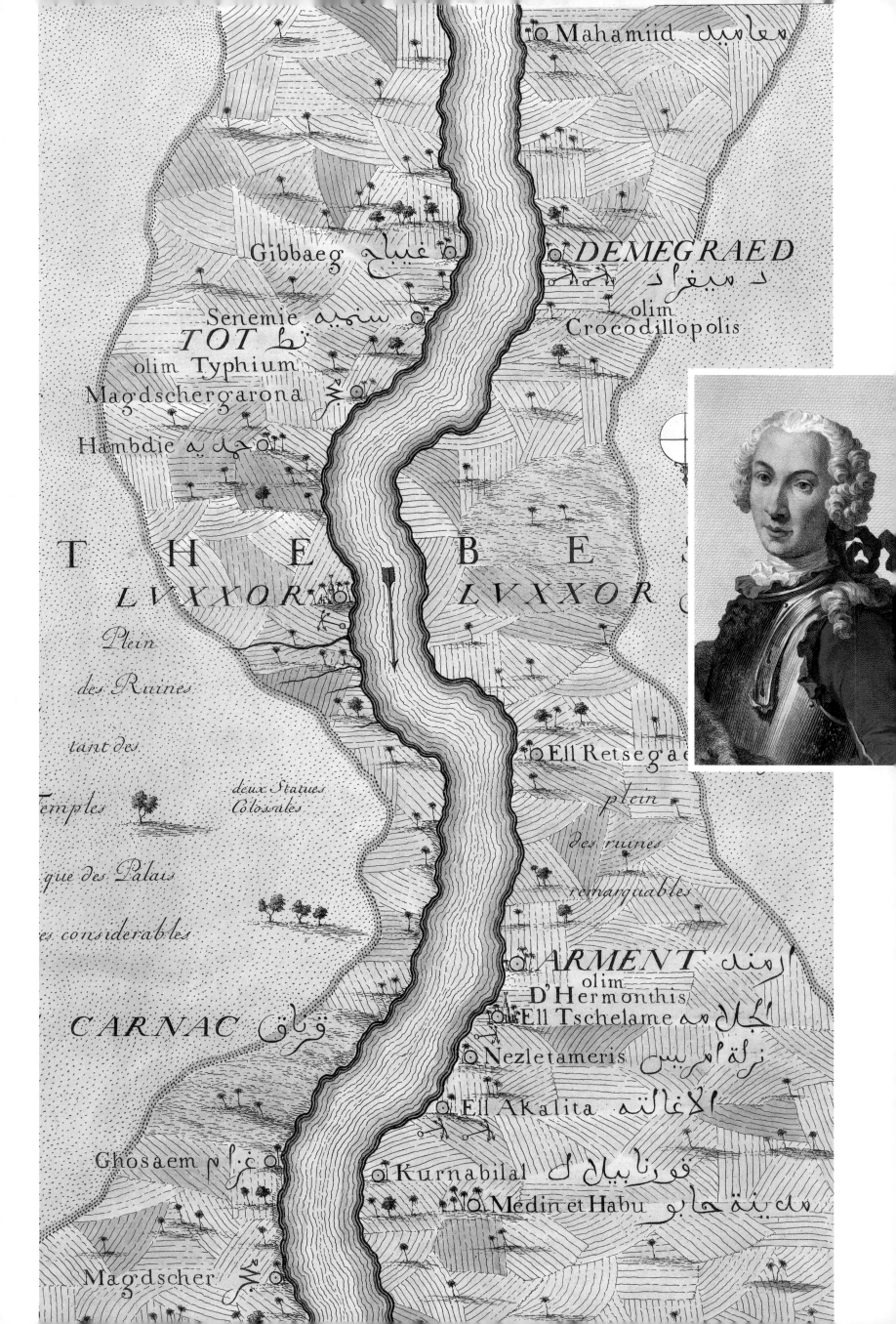

Mahamiid معامىد

Gibbaeg غباج

DEMEGRAED د ميغراد

Senemie سنمه

TOT ط

olim
Crocodillopolis

olim Typhium

Magdschergarona

Hambdie حمبده

T H E B E E

L V X X O R L V X X O R

Plein

des Ruines

tant des

Ell Retsegae

plein

Temples

deux Statues
Colossales

des ruines

que des Palais

remarquables

es considerables

ARMENT ارمند

olim
D'Hermonthis

Ell Tschelame اتجلام

CARNAC قرناق

Nezletameris نزلة امريس

Ell Akalita الاغالته

Ghosaem غوصع

Kurnabilal قورنابيلال

Medin et Habu مدىنة حابو

Magdscher

JAMES BRUCE

After serving as the British consul in Algiers from 1762-65, James Bruce (1730-94) traveled extensively in the eastern Mediterranean, reaching Egypt in July 1768. Bruce's aim was to discover the source of the Nile, but on his travels through Egypt, he stopped at Thebes and visited the royal tombs in the Valley of the Kings. Here, he became interested in the tomb of Rameses III, which he partially cleared. Bruce was particularly taken with depictions of two blind harpers which he reproduced in a pair of fanciful etchings that bear little resemblance to the originals. The illustrations were first published in 1790 in Bruce's *Travels to discover the source of the Nile in the years 1768, 1769, 1770, 1771, 1772, and 1773.* These romanticized images of ancient Egyptians struck such a chord with all who saw them that the tomb became known as "Bruce's Tomb" or the "Harpers' Tomb"—designations that were used into the twentieth century, long after the name of the royal owner, Rameses III, could be deciphered.

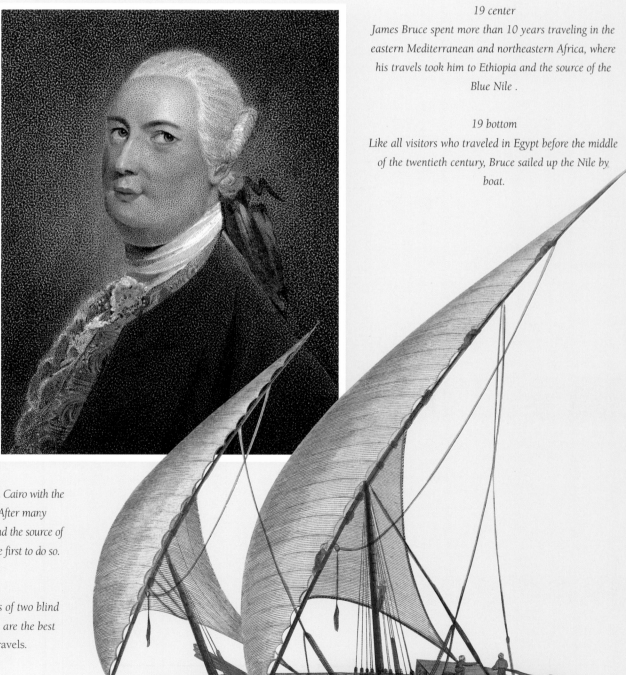

19 center
James Bruce spent more than 10 years traveling in the eastern Mediterranean and northeastern Africa, where his travels took him to Ethiopia and the source of the Blue Nile .

19 bottom
Like all visitors who traveled in Egypt before the middle of the twentieth century, Bruce sailed up the Nile by boat.

18 left
At the end of 1768, James Bruce set out from Cairo with the intent of reaching the source of the Nile. After many difficulties, he eventually reached Ethiopia and the source of the Blue Nile in 1770, though he was not the first to do so.

18 right
These etchings, loosely based on paintings of two blind harp players in the tomb of Rameses III, are the best known illustrations from Bruce's Travels.

THE IMAGES REPRODUCED IN THIS SECTION ARE TAKEN FROM *TRAVELS TO DISCOVER THE SOURCE OF THE NILE*, BY JAMES BRUCE (EDINBURGH 1790).

DOMINIQUE VIVANT DENON

Baron Dominique Vivant Denon (1747-1825) was a man of great learning and artistic talent. In spite of being a courtier and diplomat during the reigns of Louis XV and Louis XVI, he managed through his courage and personal charm to survive the French revolution. In 1897, at the age of 50, he embarked for Egypt with Napoleon's army and the *Commission des arts et des sciences*, becoming one of the 36 founding members of the *Institut d'Egypte*. At the end of August 1798, Denon accompanied General Desaix to Upper Egypt on his military campaign to defeat Murad Bey, commander of Egypt's Mameluke troops. The expedition caught its first site of the ruins of ancient Thebes on the morning of January 27, 1799. On this occasion, Denon was able to get only a glimpse of the monuments on the west bank, stopping briefly at one site, then racing on to the next as the army's progress left him behind. In his published account he writes that "at this time, I saw Thebes only at a gallop." In this fashion he visited the temple of Seti I, the Ramesseum, the colossi of Memnon, and Medinet Habu temple. Over the next six months, Denon was able to examine the monuments of Thebes several more times, making excellent plans and drawings. In early July, he finally saw the Valley of the Kings, where he entered eight tombs in a mere three hours. Like most of his visits to Thebes, this one had been too brief: "I found, as on all other occasions, that a visit to Thebes was like an attack of fever, it was a kind of crisis that left me with an impression of equal parts impatience, enthusiasm, irritation, and fatigue." Denon left Egypt with Napoleon in August 1799 and spent the next year preparing his notes and drawings for publication. Appearing in 1802, Denon's volumes remain valuable resources today.

20
At 50, Denon was among the oldest members of the Commission that accompanied Napoleon to Egypt. This sketch was made by one of his companions on the expedition, André Dutertre.

20-21
On their first visit to Thebes, Denon and General Desaix were attacked by local residents when they attempted to examine one of the Eleventh Dynasty saff tombs of western Thebes (foreground). These monuments are now almost completely obscured by the modern village of Tarif.

21 top
Denon was finally able to visit the Valley of the Kings in July 1899. Among others, he entered the tomb of Rameses IV, the entrance of which is seen here. The plans of this tomb (left) and the conjoined tombs of Ramesses III and Amenmesse (right) seem to have been copied from Pococke, whose publication also reverses these last two.

21 bottom
Denon's view of the gateway leading into the precinct of Medinet Habu temple captures the grandeur of this triumphal entrance that Rameses III patterned on a Near Eastern design. A Ptolemaic era pylon is visible at the right.

THE IMAGES REPRODUCED IN THIS SECTION ARE TAKEN FROM *VOYAGE DANS LA BASSE ET LA HAUTE EGYPTE*, BY DOMINIQUE VIVANT DENON (PARIS 1802).

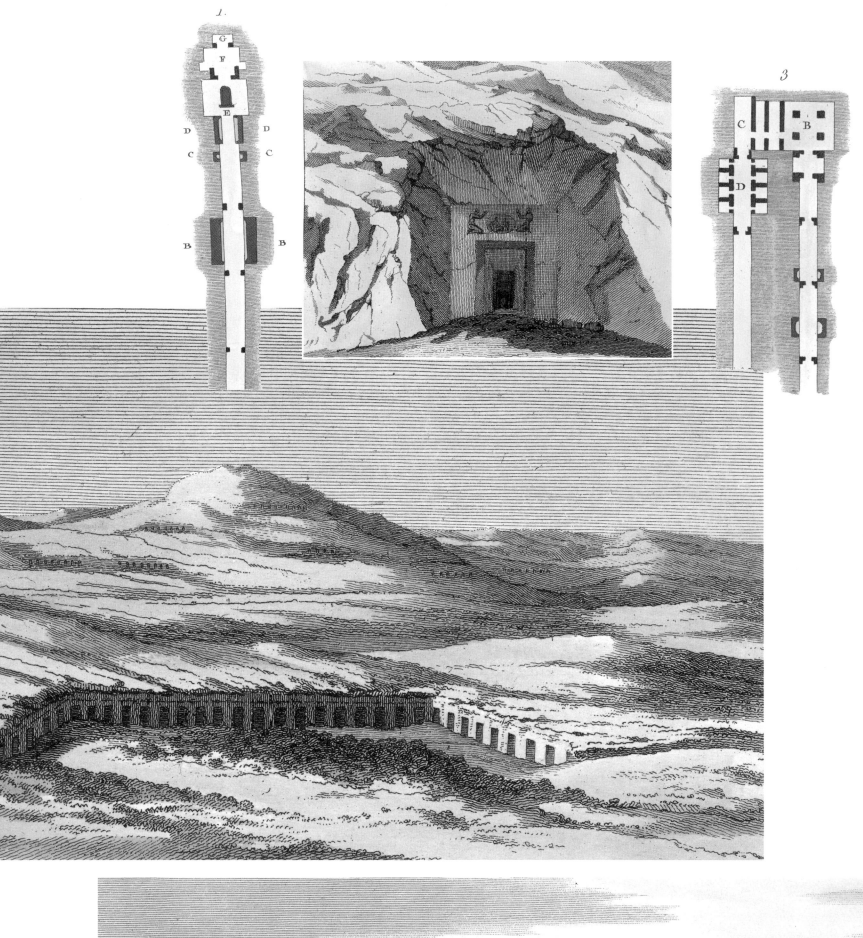

1.

3.

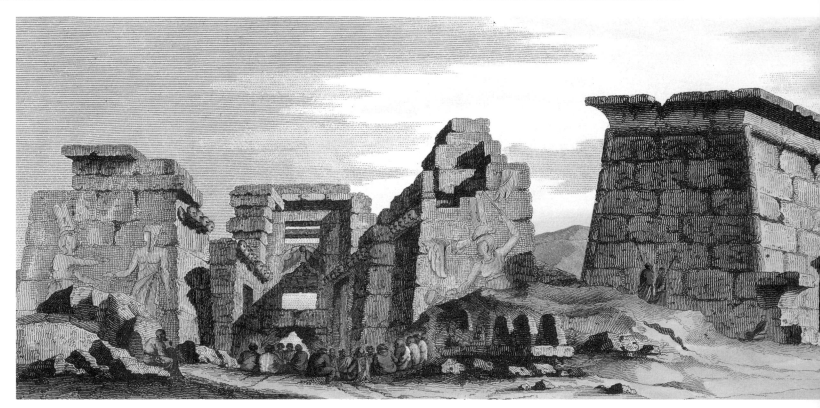

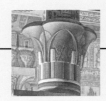

DESCRIPTION DE L'ÉGYPTE

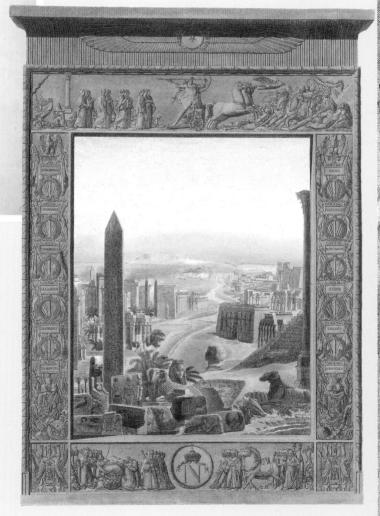

Dominique Vivant Denon was only one of 167 members of the *Commission des arts et des sciences* who arrived in Egypt with Napoleon's army in July of 1798. The Commission was made up of a diverse group of specialists including architects, archaeologists, astronomers, engineers, geologists, geographers, mathematicians, naturalists, and Orientalists as well as artists, draftsmen, and printers. The aims of these

scholars included recording monuments—both ancient and contemporary—and studying the flora, fauna and geology of Egypt. Napoleon's primary purpose was the conquest of Egypt which was of strategic importance as base for trade with the far east. Although he tried to present himself to the Egyptians as a liberator, who would free them from Mameluke domination, the clash of cultures and religions resulted in uprisings

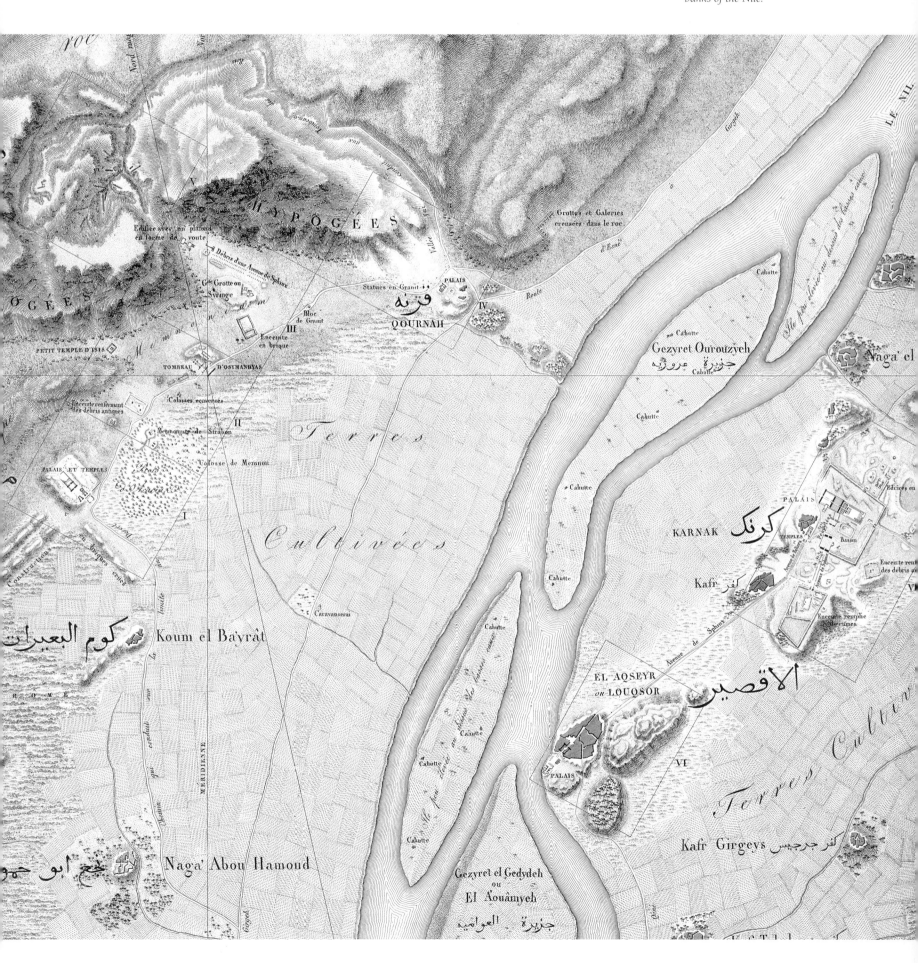

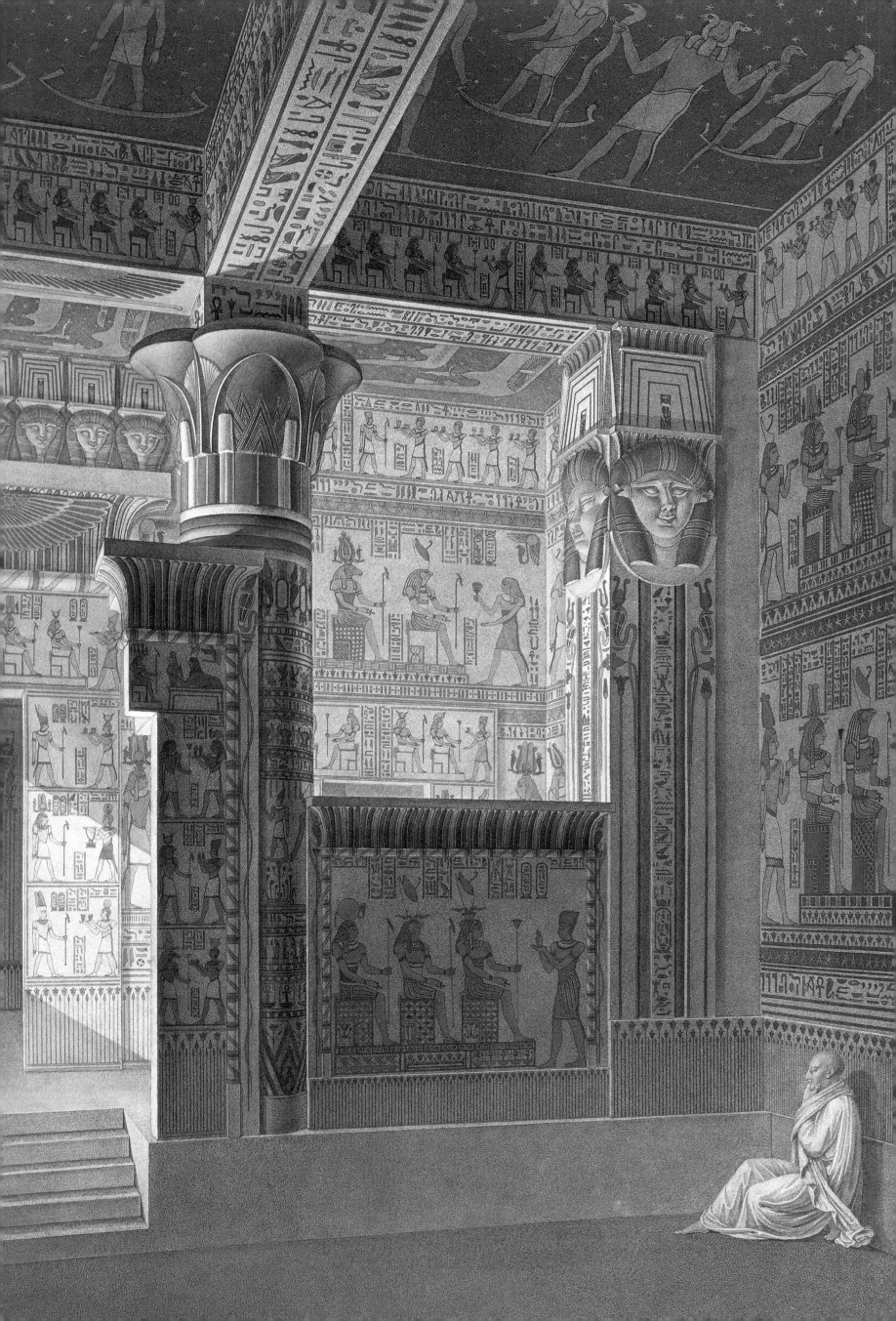

around Cairo in October, 1789. After crushing the rebellion, Napoleon showed great magnanimity which earned him a measure of respect from the population in the north of Egypt, but elsewhere, the subjugation of the population was often brutal, causing resentment and stubborn resistance. It was under these circumstances that the intellectuals of the *Commission* proceeded with their recording, often working as battles raged around them and more than thirty perished because of wounds or disease.

The massive volumes of the *Description de l'Egypte* were published over a decade, beginning in 1809. Volume II of the plates is devoted to the monuments of western Thebes. One task facing two young civil engineers, Prosper Jollois and Edouard de Villiers du Terrage, was to make an overall map of the Theban area, locating the ancient monuments on both banks of the Nile. This map, covering an area of approximately 50 square miles, is reproduced in a double plate at the beginning of Volume II. At the time of the expedition, the ancient Egyptian language was undeciphered, and the French scholars were still identifying monuments based on descriptions of the classical writers, or by using contemporary Arabic place names.

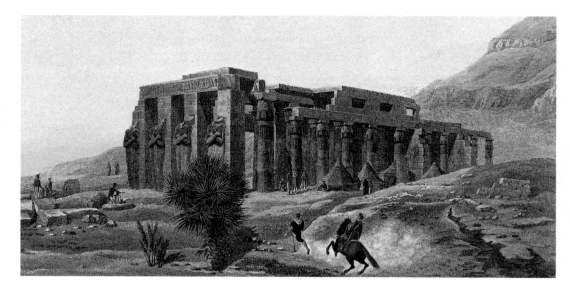

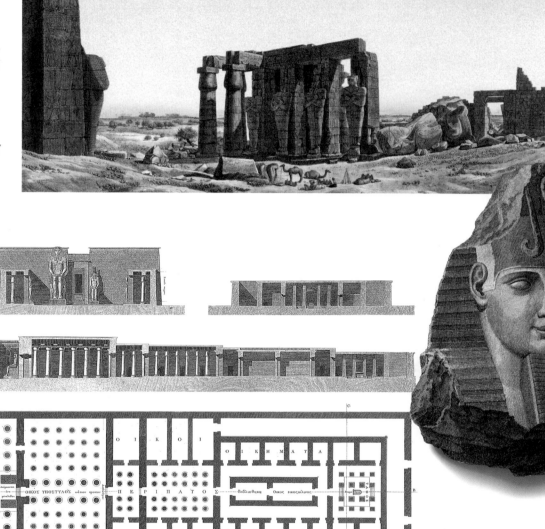

24
This interior view was intended to give an impression of the brightly painted decoration in the "temple de l'ouest," which was considered remarkable for its sculptural decoration. This small Ptolemaic temple is located near the workmen's village of Deir el-Medina, a site that was nearly invisible at the time of the Napoleonic expedition.

25 top
The tents of the French expedition are shown here at the Ramesseum, near the ruins of the hypostyle hall.

25 center
This view shows the front half of the ruins of the Ramesseum including the first pylon and the fallen colossus of Rameses II. The name Ozymandias, often used to identify this colossus, is probably a corruption of the kings throne name, User-maat-ra.

25 bottom left
Following the classical writer, Diodorus Siculus, the French thought that the Ramesseum—which is actually the mortuary temple of Rameses II—was built by Ozymandias. They drew two sets of plans and

reconstructed elevations of the temple: one based on the archaeological remains, and another more complete set (shown here) based on the description of Diodorus.

25 bottom right
This head of a red granite colossus, also recorded by earlier travelers, was lying in the second court of the Ramesseum. The French expedition would have transported it with them to Paris, but found the task impossible. The head was eventually moved by Giovanni Belzoni in 1816 and is now in the British Museum.

26-27
This view of Medinet Habu shows the entrance gate into the temple enclosure and the Ptolemaic pylon and Roman forecourt. The ruins of the Ramesseum are visible in the distance.

26 bottom, 27 top, 27 bottom
Medinet Habu was used as a building site for more than 1500 years. The earliest structure (ca. 1450 B.C.) is an Eighteenth Dynasty temple (plan 1), which was augmented in the Ptolemaic period (ca. 100 B.C.) by the addition of a Pylon, and in the Roman period (ca. A.D. 150) with a

front court or propylon. The principal structure (ca. 1175 B.C.) is the huge mortuary temple of Rameses III (plan 2, elevation 1), who also built an unusual entrance gate (called a pavillion, plan 1, elevation 2). This was based on an architectural design that he had seen on his military campaigns into western Asia.

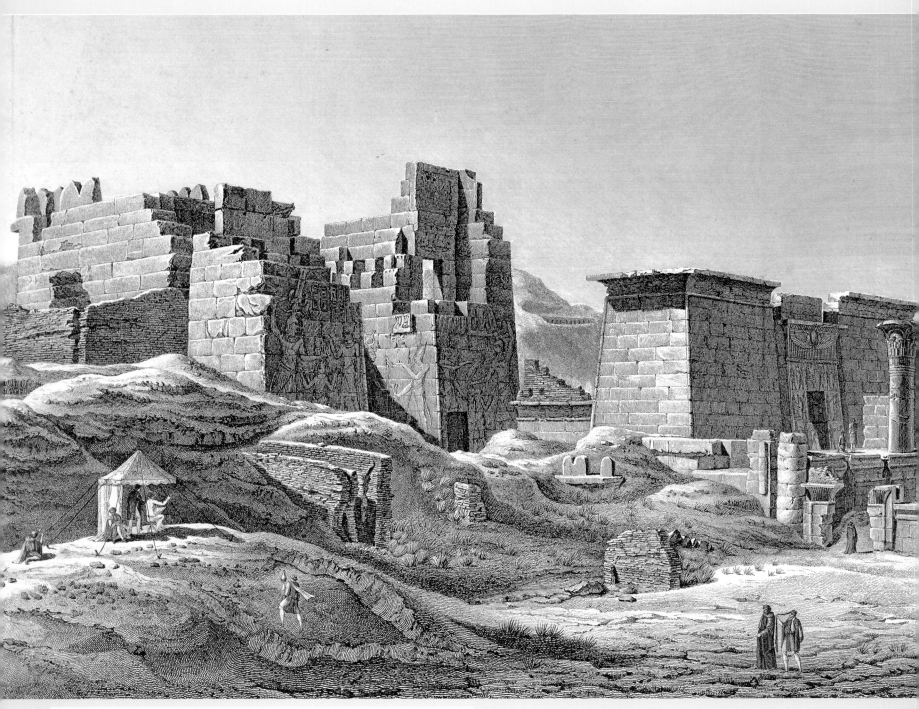

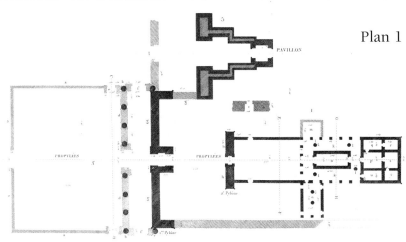

Plan 1

Elevation 2

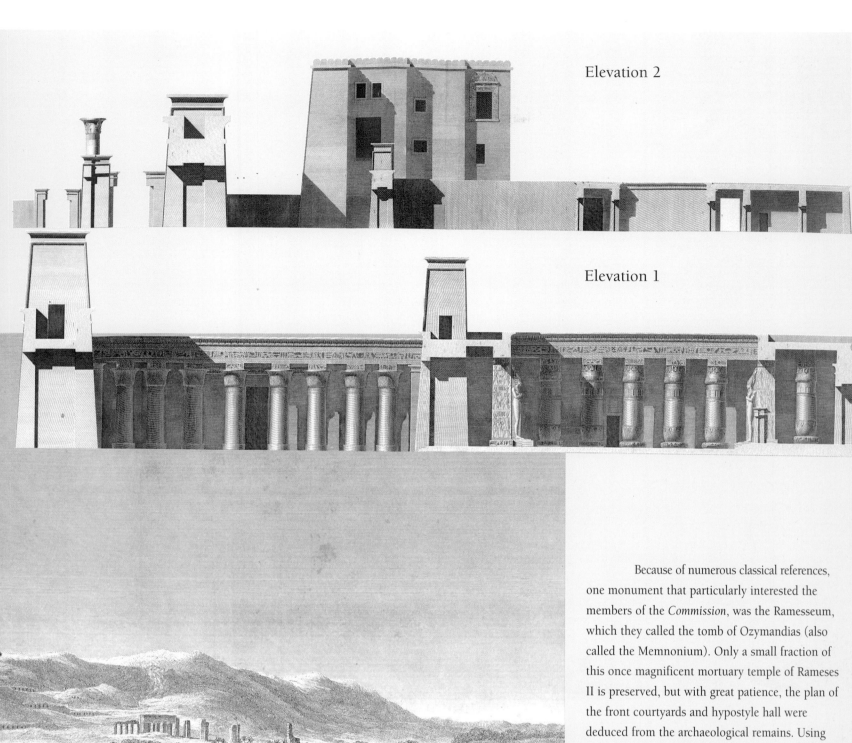

Elevation 1

Because of numerous classical references, one monument that particularly interested the members of the *Commission*, was the Ramesseum, which they called the tomb of Ozymandias (also called the Memnonium). Only a small fraction of this once magnificent mortuary temple of Rameses II is preserved, but with great patience, the plan of the front courtyards and hypostyle hall were deduced from the archaeological remains. Using this plan, an elevation along the axis of the temple could be drawn with some accuracy. The remainder of the temple was reconstructed from the description written down by Diodorus Siculus.

Great care was also taken in recording the structures at Medinet Habu including the unusual entrance gate, which was built to imitate an ancient near eastern architectural form; the small Eighteenth Dynasty temple with its large Ptolemaic period pylon and Roman propylon; and the magnificent temple of Rameses III, which the French identified as a palace. This well preserved temple was decorated with scenes executed in deeply carved sunk relief and painted with

Plan 2

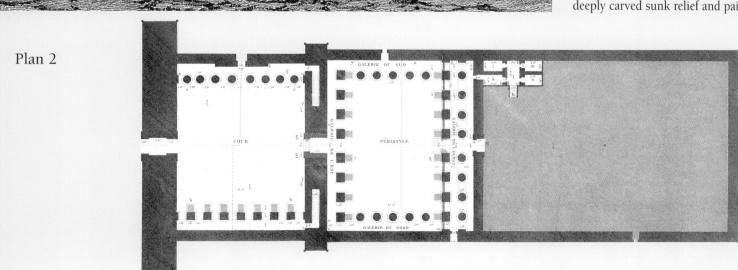

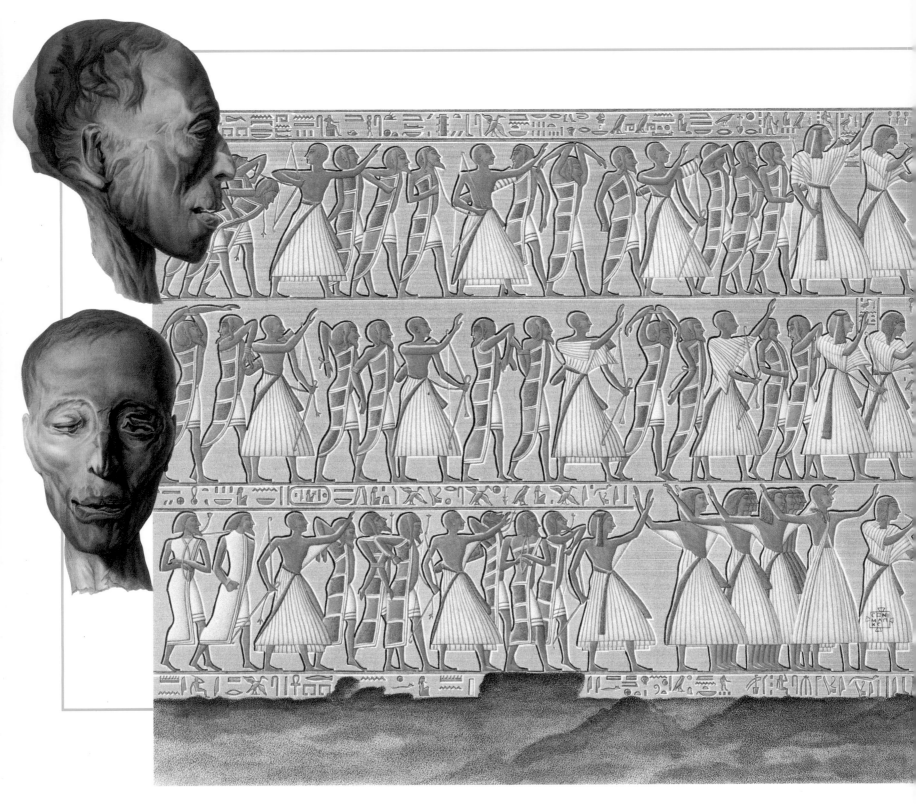

brilliant colors. A number of these scenes were reproduced, including a battle showing Rameses defeating the Sea Peoples, and a triumphal procession in which the huge figure of Rameses in his chariot preceeds a mass of much smaller Egyptians leading bound prisoners.

While making a topographic map of the huge wadi system that includes the main Valley of the Kings, Jollois and de Villiers ventured into the more remote and much larger arm of the wadi known as the West Valley. There they recorded the existence of a large royal tomb that had gone unnoticed by previous travelers. It belonged to Amenhotep III, the New Kingdom pharaoh who also erected the colossi of Memnon (ca. 1375 B.C.).

The publication of the *Description de l'Egypte* generated great interest among academics and the public alike. The original edition included thirteen volumes containing more than 3,000 plates illustrating the ancient and Islamic monuments, and the flora and fauna of Egypt. The plates were accompanied by nine volumes with more than 7,000 pages of descriptive text. Four volumes of text and five of plates were devoted to the ancient monuments making this the most systematic study of ancient Egyptian art and architecture ever produced. This is a particularly impressive achievement when one considers that, at the end of the eighteenth century, the study of ancient Egypt was in its infancy, and the hieroglyphic script was incomprehensible. The proportions and artistic conventions used in Egyptian art were still so foreign to the European sense of aesthetics that even the members of Napoleon's *Commission*—those well trained, observant, exacting scholars, artists, and draftsmen—were unable to make true facsimile copies of the wall paintings and reliefs they attempted to reproduce. Nonetheless, their copies are accurate in detail, and even the texts have been copied in a readable form that preserves a number of inscriptions that no longer exist.

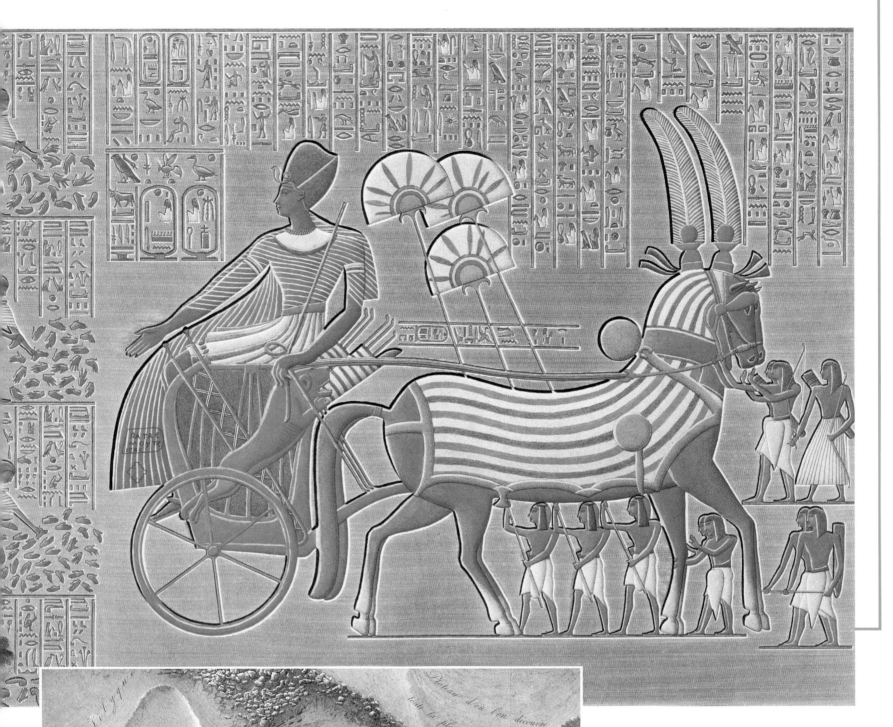

28 top left
In the course of their exploration of the private tombs near Qurna, the French uncovered numerous mummies and made engravings of the best preserved man (here) and woman. In the texts explaining these images, a description of mummification, first recorded by Herodotus, was repeated.

28-29
This scene, from the temple of Rameses III at Medinet Habu, shows the triumphant king preceeding a procession of prisoners and celebrating Egyptians. At the front of each row, a rather gruesome vignette shows scribes recording the number of dead enemies, represented by their lopped-off hands—symbolism that was easily understood by the French scholars even though they could not read the hieroglyphic text above.

29 bottom
This topographic map of the Valley of the Kings reveals the plans of tombs that were known at the time, thus indicating both their positions and relative sizes.

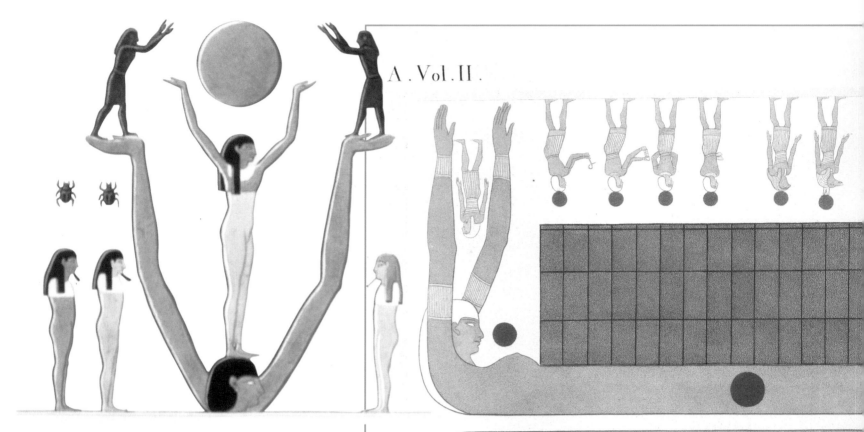

30 top
In the Valley of the Kings, French scholars and artists recorded many scenes that were probably better preserved in 1798-99 than they are today. This one is probably copied from the tomb of Rameses VI, though the vignette appears in a number of the Ramesside tombs.

30 bottom and 31 bottom
These plans and elevations of tombs in the Valley of the Kings that were accessible to the French expedition are some of the most accurate ever produced. The entrance shown at the left is the tomb of Rameses IV, with the elevation and plan at far right.

30-31 top
This ceiling, with its representations of the sky goddess Nut and various constellations was of great interest to the French scholars, who dubbed the tomb (KV 1, belonging to Rameses VII) the Catacombe Astronomique.

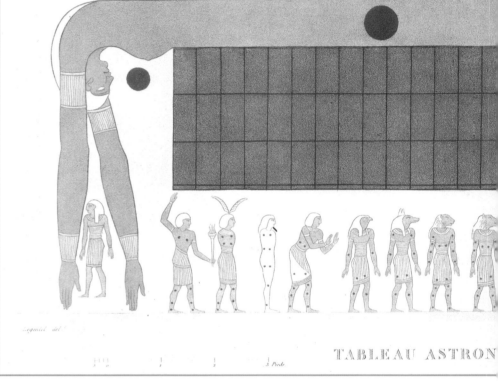

TABLEAU ASTRON

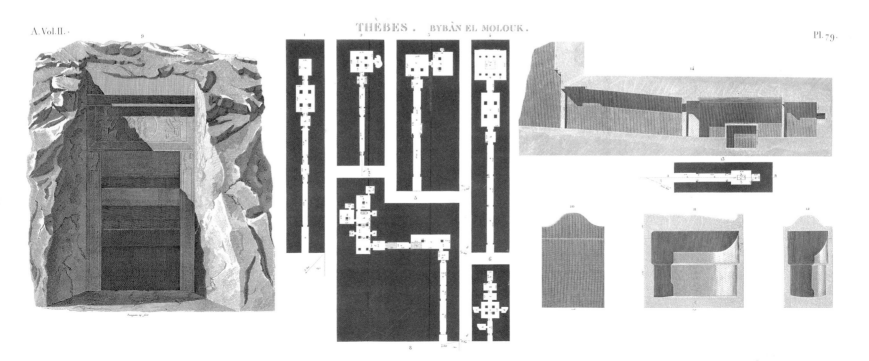

THÈBES . BYBÂN EL MOLOUK.

PL. 79.

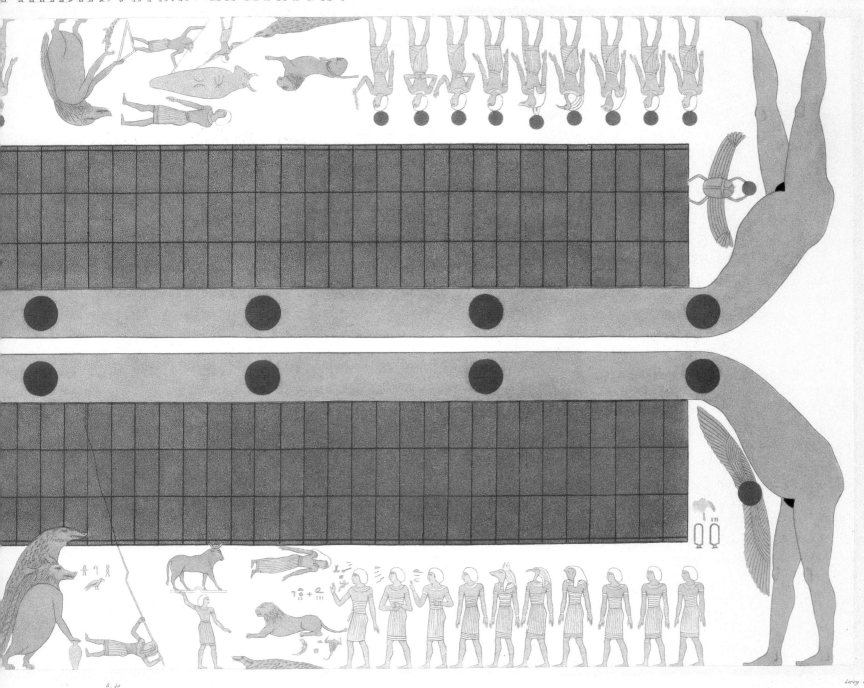

E PEINT AU PLAFOND DU 1.ᴱᴿ TOMBEAU DES ROIS A L'OUEST.

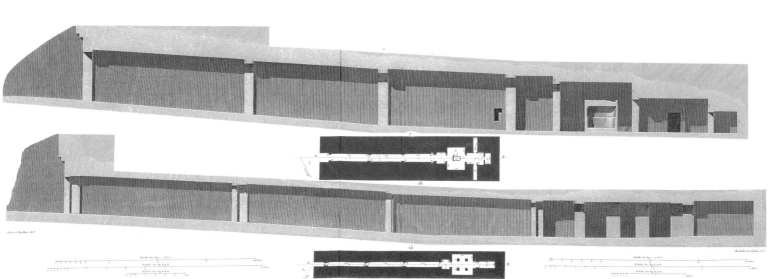

1.2.3.4 PLANS DES 3.ᵉ, 4.ᵉ ET 5.ᵉ TOMBEAUX DES ROIS À L'EST. 5 PLAN DU 5.ᵉ TOMBEAU À L'OUEST. 7 PLAN DU TOMBEAU ISOLÉ DE L'OUEST. 11 PLAN, COUPE ET DÉTAILS DE L'ENTRÉE ET DU SARCOPHAGE DU 2.ᵉ TOMBEAU À L'OUEST.
13.14 PLAN ET COUPE DU 4.ᵉ TOMBEAU À L'OUEST. 15.16 PLAN ET COUPE DU 6.ᵉ TOMBEAU À L'OUEST.

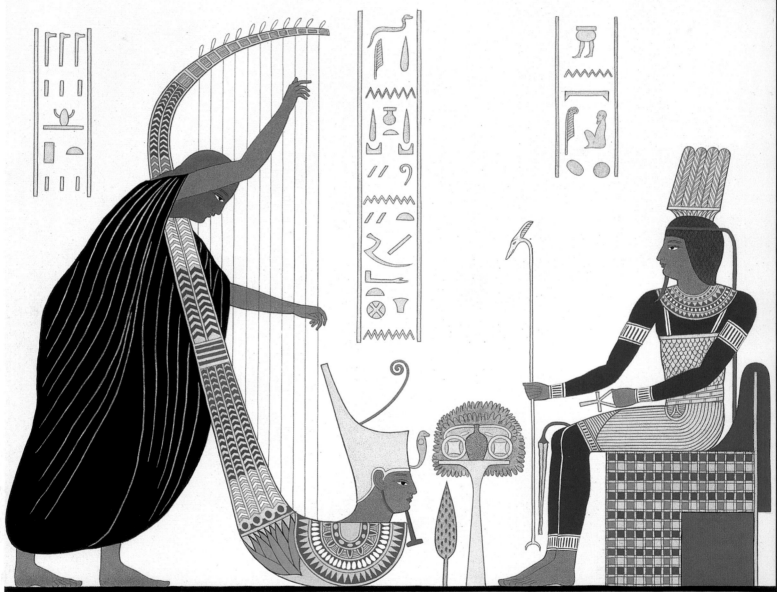

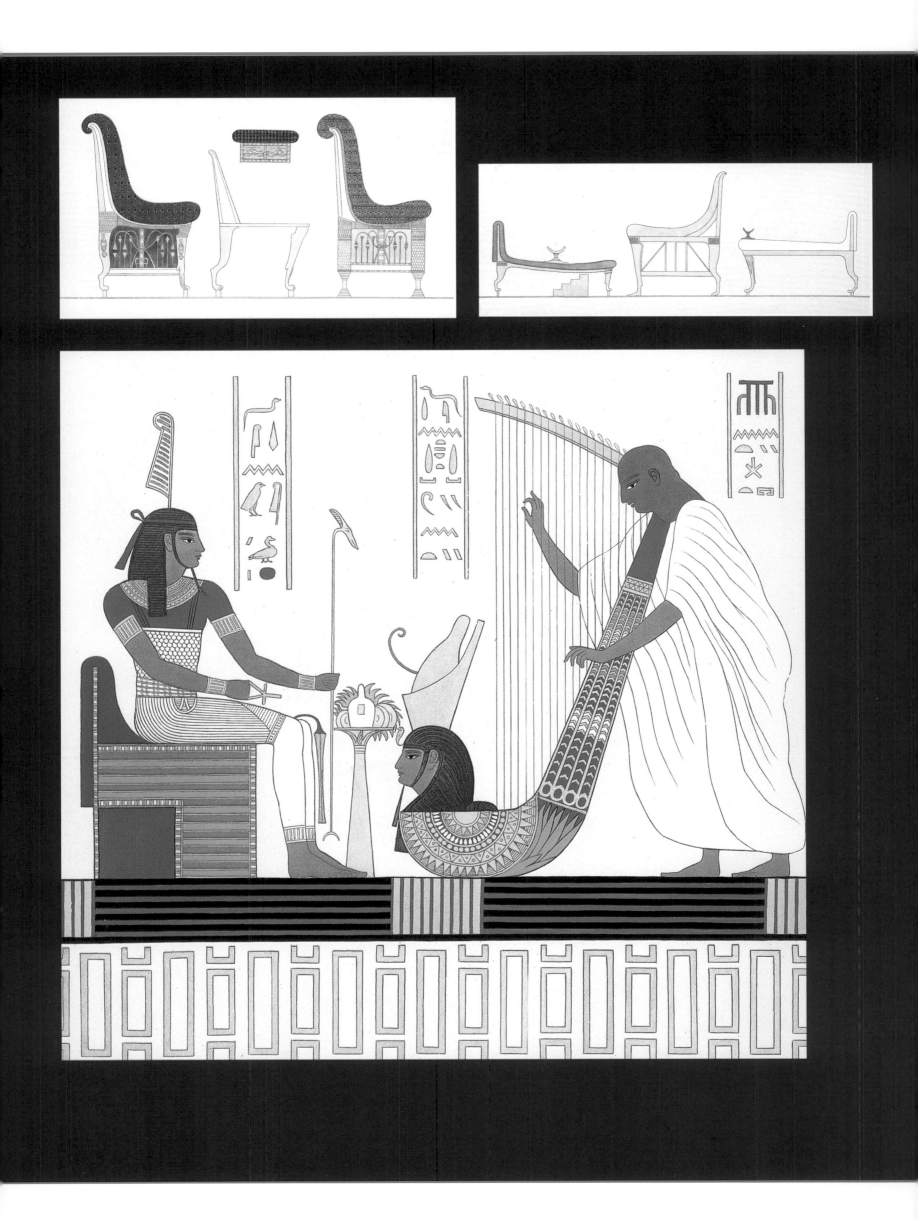

GIOVANNI BATTISTA BELZONI

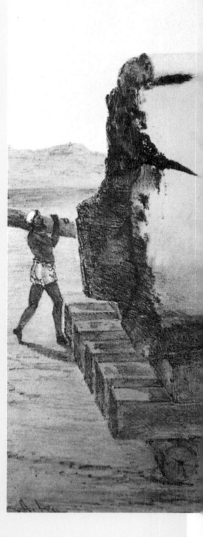

Giovanni Battista Belzoni (1787-1823) was born in Padua. He arrived in England in 1803, having acquired some knowledge of hydraulic engineering. To support himself, the nearly 2 meters tall (six foot seven inch) Belzoni demonstrated ornamental fountains of his own design, and performed feats of strength for the public as the "Pategonian Samson." He eventually married an Irish woman and became a British citizen. In 1815, Belzoni travelled to Egypt hoping to interest the Khedive, Mohammed Ali, in a new method for raising water. After failing in this venture, Belzoni made the acquaintance of Henry

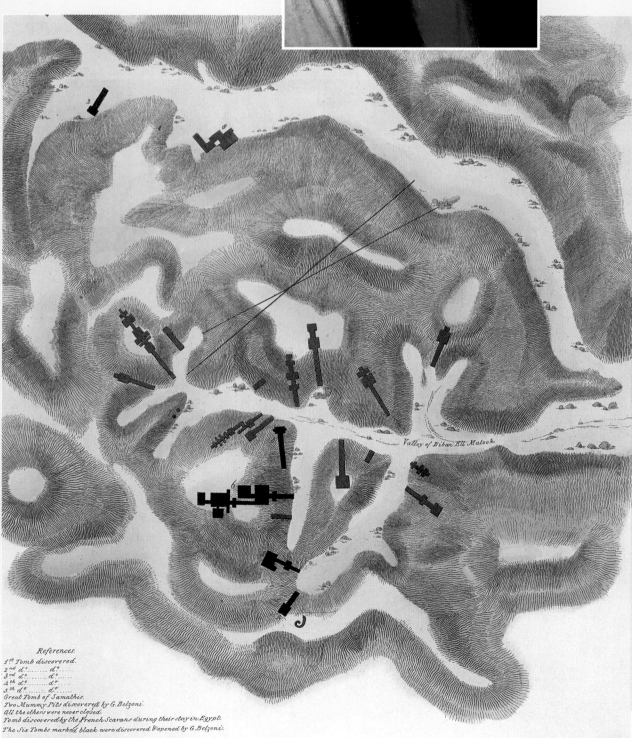

Valley of Biban Ell Malook.

References.
1st Tomb discovered.
2nd d°..... d°.....
3rd d°..... d°.....
4th d°..... d°.....
5th d°..... d°.....
Great Tomb of Samathis.
Two Mummy Pits discovered by G. Belzoni.
All the others were never closed.
Tomb discovered by the French Savans during their stay in Egypt.
The Six Tombs marked black were discovered & opened by G. Belzoni.

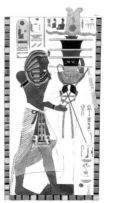

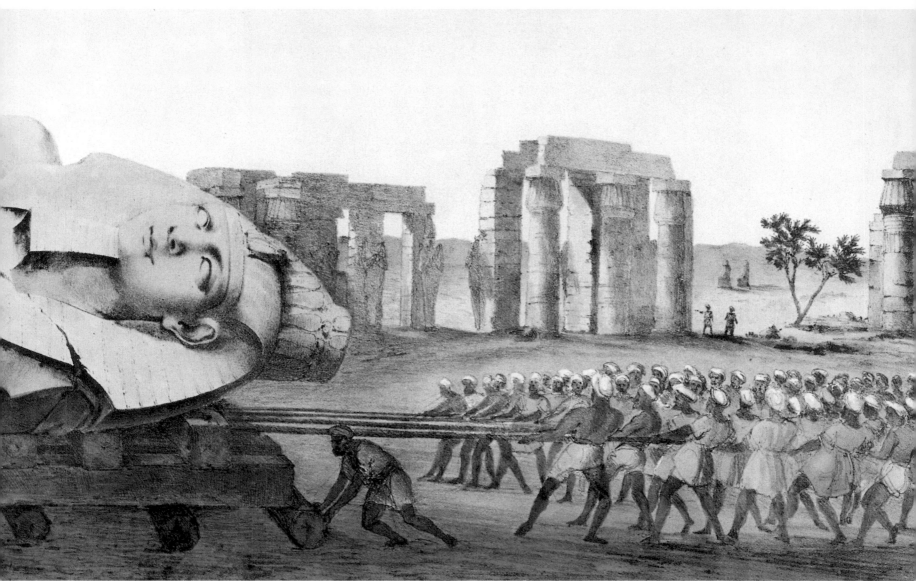

Salt, the British Consul General, who wanted to
acquire Egyptian antiquities. One piece in particular
interested Salt—the head and shoulders of a
colossal statue located in the Ramesseum, or
Memnonium as it was then known. This had proven
impossible for anyone to move, but Belzoni took
on the task and left for Upper Egypt at the end of
June 1816, arriving in late July. By August 12, using
dozens of local workmen, he had succeeded in
transporting the fragment to the edge of the Nile
where it waited for some time until a large enough
boat could be found to transport it to Cairo. The
next day, Belzoni made his first visit to the tombs of
western Thebes in order to see a sarcophagus that
he also hoped to send to Cairo. In order to confuse
Belzoni, his Egyptian guides took him in by a
circuitous route which he describes as follows:
"Previous to our entering the cave, we took off the
greater part of our clothes, and, each having a
candle, advanced through a cavity in the rock,
which extended a considerable length in the
mountain, sometimes pretty high, sometimes very

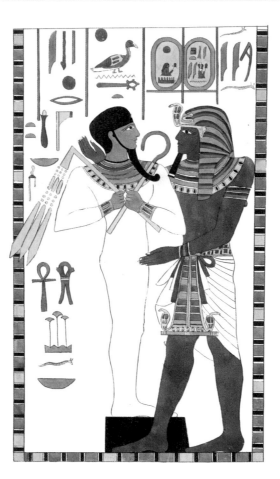

34 bottom
Belzoni's topographic map of the Valley of the Kings
shows the tombs he discovered in black. The largest one,
marked 6, belonged to Seti I. The one above this belonged
to his father, Rameses I.

35 top
Belzoni's published illustrations of the decoration in Seti's
tomb are not facsimile copies, however, they record many
scenes that are only partially preserved today such as this
pillar decoration showing the king embracing Osiris who
is depicted as a djed-pillar.

35 center
On his first visit to western Thebes, Belzoni succeeded in
transporting a 7 ton statue fragment from the Ramesseum
to the Nile.

35 bottom
This pillar decoration is still largely preserved in Seti's
tomb. Here the text is completely wrong and was perhaps
substituted mistakenly from another area of the tomb.

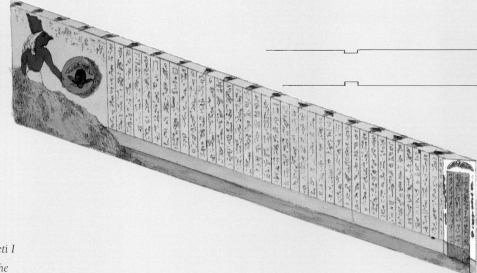

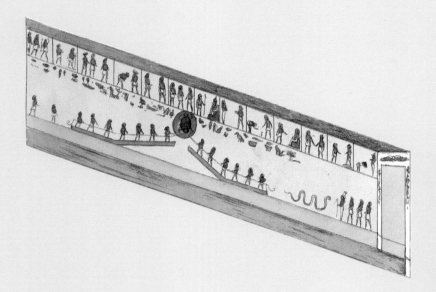

36 and 37
This elaborate elevation drawing of the tomb of Seti I gives a good idea of the placement and scale of the decoration throughout the tomb.

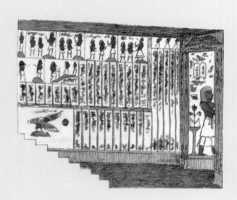

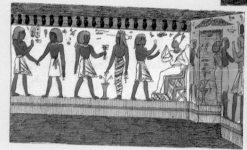

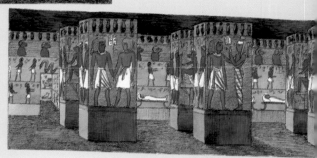

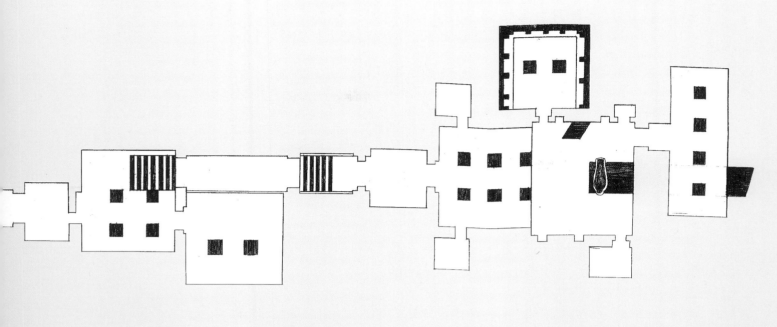

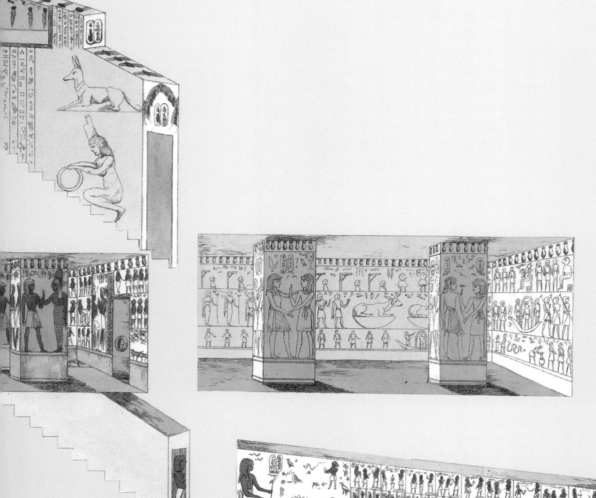

narrow, and without any regularity. In some passages we were obliged to creep on the ground, like crocodiles." Eventually, the party reached a juncture beyond which the huge Belzoni was unable to pass, but one of the guides and an interpreter succeeded, going on ahead. A few minutes later, Belzoni heard a loud noise and a cry of "Oh, My God! My God! I'm Lost!" Managing to retrace his steps to the entrance of the "cave," Belzoni met the interpreter, who had found his own way out through a second entrance. The guide had fallen into a deep pit, and had to be rescued.

Toward the end of 1816, Belzoni visited the Valley of the Kings. While exploring the remote section of the royal cemetery known as the West Valley, where Napoleon's expedition had found the tomb of Amenhotep III, he located the tomb of Ay, the immediate successor of Tutankhamen. Nearby, in the summer of 1817 he found an unfinished tomb containing several undisturbed mummies.

However, his most significant discoveries
were to come not long after this, when he began
exploring the main Valley of the Kings. Belzoni
was aware that the classical writers Strabo and
Diodorus Siculus had set the number of tombs at
between 40 and 47, 18 of which could still be
viewed in ancient times. He was able to identify
16 tombs plus the two he himself had discovered
in the West Valley, leaving a large number to be
accounted for, and in October 1817 he accounted
for four of them. First came the tomb of
Montuherkhepshef, a son of Rameses IX who
ruled at the end of the New Kingdom. One of the
last tombs carved in the valley, its painted
decoration was still bright, but the royal burial
had long since vanished. Belzoni's next discovery
was an undecorated tomb containing two
unwrapped mummies of women, but it provided
little else of interest. A few days later, however, on

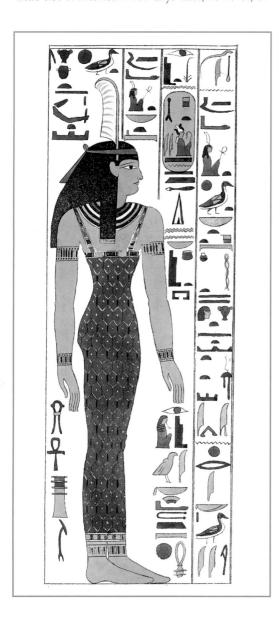

October 10, he found the entrance to the tomb of
Rameses I, founder of the Nineteenth Dynasty. The
burial chamber of this relatively small tomb
contained a sarcophagus of granite and a number
of magical figures carved of wood. The room was
decorated in expertly painted scenes and texts that
retained their original brilliant colors. On October
16, about 30 feet from the tomb of Rameses I,
Belzoni made his greatest discovery when he
uncovered the entrance to the tomb of Seti I, son

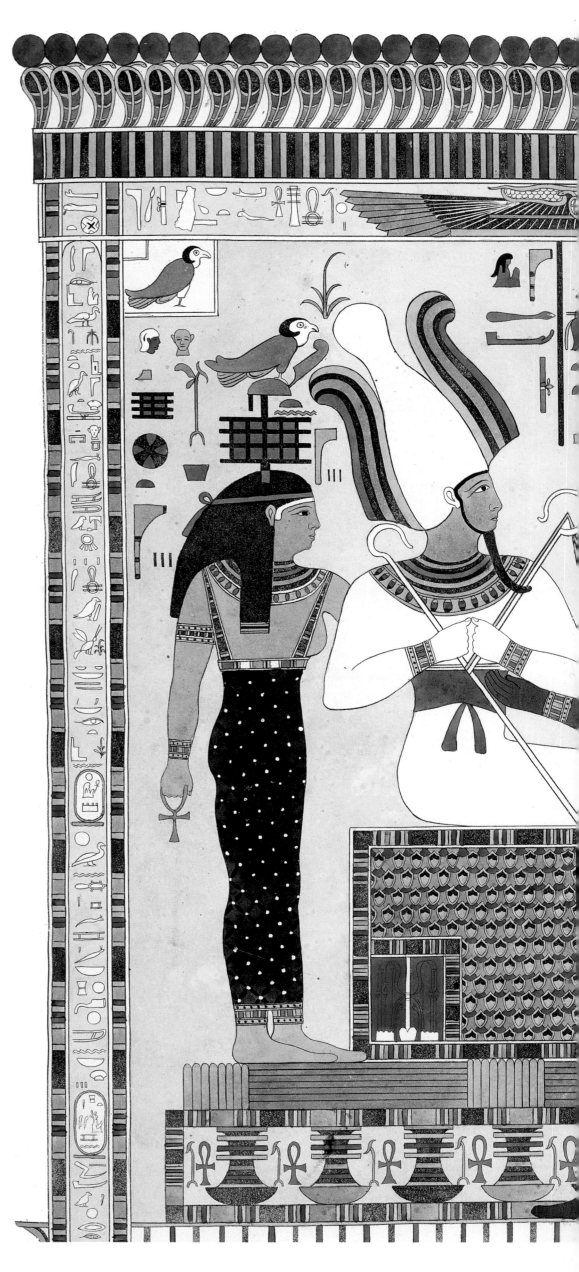

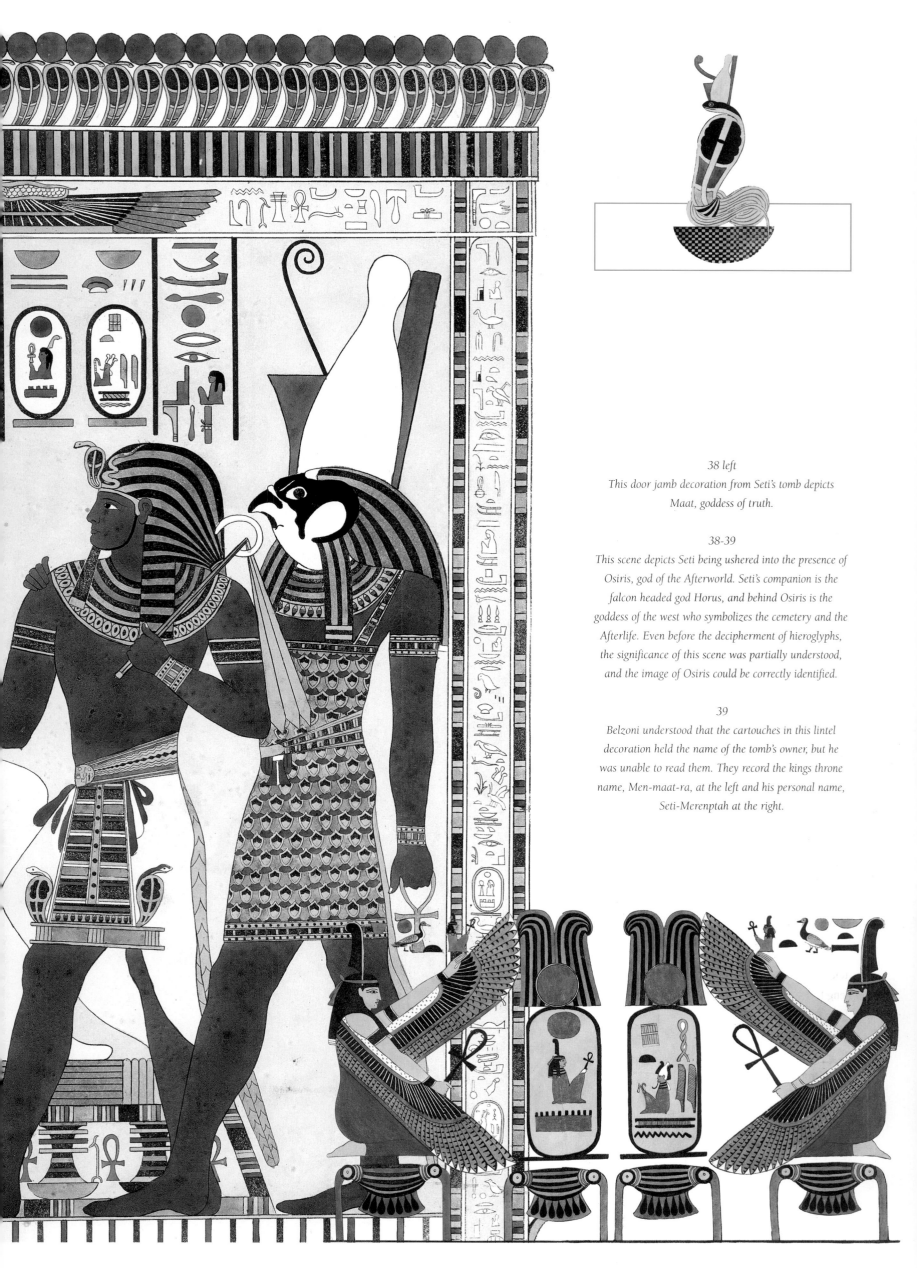

38 left
This door jamb decoration from Seti's tomb depicts Maat, goddess of truth.

38-39
This scene depicts Seti being ushered into the presence of Osiris, god of the Afterworld. Seti's companion is the falcon headed god Horus, and behind Osiris is the goddess of the west who symbolizes the cemetery and the Afterlife. Even before the decipherment of hieroglyphs, the significance of this scene was partially understood, and the image of Osiris could be correctly identified.

39
Belzoni understood that the cartouches in this lintel decoration held the name of the tomb's owner, but he was unable to read them. They record the kings throne name, Men-maat-ra, at the left and his personal name, Seti-Merenptah at the right.

of Rameses I, and father of Rameses the Great (Rameses II). Known for many years thereafter as "Belzoni's tomb," the tomb of Seti I is considered the jewel of the Valley of the Kings to this day. By far the largest of the Kings' tombs (a crudely cut corridor extends at least 90 meters—100 yards—beyond the burial chamber), this is the first to have been decorated from the burial chamber all the way to the entrance. This decoration was carved in the finest low relief and then painted with exquisite detail. An account of Belzoni's travels and discoveries in Egypt and Nubia was published in 1820. This was accompanied by a folio volume of plates that included illustrations of the wall decoration in Setis tomb. These copies, prepared with the assistance of Alessandro Ricci, are not facsimiles, but the scenes and texts are recognizable and they give an excellent idea of the

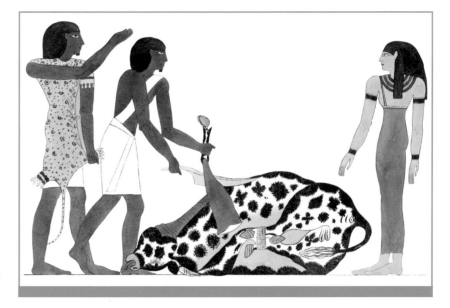

colors, though the ancient hues may not have been duplicated exactly.

In 1821, Belzoni opened an exhibition in London which included a scale model of Seti's tomb measuring about 15 meters (50 feet) in length. The tomb itself is roughly 90 meters (300 feet) long, excluding the corridor that extends off the burial chamber. Belzoni also recreated two chambers of the tomb at full scale, using casts made from molds taken of the original decoration—a process that unfortunately removed much of the original paint. The alabaster sarcophagus that was found in the burial chamber was removed and eventually sold to Sir John Soane, who installed it in a "crypt" in his London town house, where it still may be seen.

In his search for antiquities, Belzoni excavated at Theban sites other than the Valley of the Kings. In 1818-19, he worked in the area behind the colossi of Memnon, the statues that actually represent the Eighteenth Dynasty pharaoh, Amenhotep III, whose immense mortuary temple once stood behind them. Almost a century earlier, Richard Pococke had noted the remains of statues in this area. During his excavations, Belzoni unearthed a colossal head of Amenhotep III, which is now in the British Museum along with many of his other discoveries.

40 top and bottom
These two vignettes show a ritual sacrifice and a sacred bull.

40 center
This brightly painted text records the kings full titulary and is located above the door inside what Belzoni called the "sideboard room." This room opens off of the burial chamber and contains two pillars and a bench around three sides.

41
This scene depicts Seti with the goddess Hathor (thought by Belzoni to be Isis). It was removed from the tomb by Champollion and is now in the Louvre.

THE IMAGES REPRODUCED IN THIS SECTION ARE TAKEN FROM NARRATIVE OF THE OPERATIONS… IN EGYPT AND NUBIA…, BY GIOVANNI BATTISTA BELZONI (LONDON 1820).

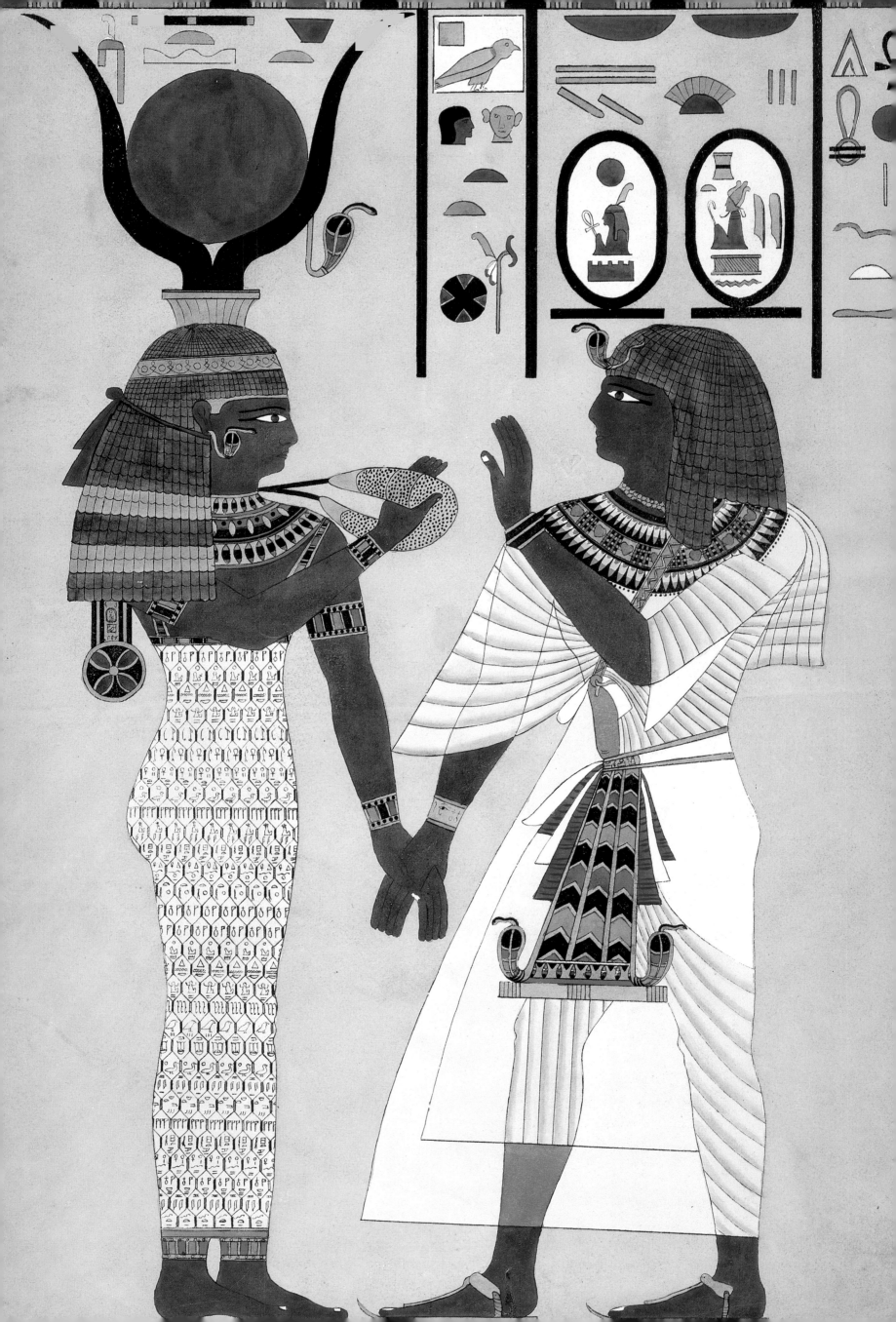

JEAN JACQUES RIFAUD

Born in Marseilles, Jean Jacques Rifaud (1786-1852) was originally trained as a sculptor. After serving for a time in the French army, he travelled extensively in the eastern Mediterranean beginning in 1805. Arriving in Egypt in 1813, Rifaud became acquainted with Bernardino Drovetti, an Italian who served both Napoleon and later Louis XVIII as consul-general for France in Egypt. By far the most politically astute of the European consuls, Drovetti became a close friend of Mohammed Ali, who was appointed Khedive of Egypt in 1805 and ruled the country until 1848 with only tenuous ties to his Ottoman overlords. Drovetti provided the Khedive with valuable advice on reorganizing Egypts military, updating agricultural and irrigation methods, and helping to develop industry. In return, Drovetti had great personal influence and was given a free hand in the business of collecting Egyptian antiquities, which had become much sought after since Napoleon's expedition and the publication of the *Description de l'Egypte*.

Rifaud settled in Luxor and became one of Drovetti's chief agents, supervising many excavations in the Theban area. Although his methods were far from scientific, he sometimes did excavate with care. While working at Karnak temple on the east bank of the Nile, Rifaud came across the superb head of a king. Whereas many of his contemporaries would have been satisfied with the head alone, Rifaud carefully searched the area for the other fragments of this magnificent seated statue of Rameses II. Thanks to his diligence, the statue could be reconstructed with minimal restoration and is now one of the masterpieces of the Egyptian Museum in Turin. During his sojourn in Egypt, which lasted some fifteen years, Rifaud was instrumental in helping to bring together Drovetti's two great collections of Egyptian antiquities. The first, having been rejected by Louis XVIII of France, was acquired in 1824 for the newly created antiquities museum in Turin. The second group of antiquities was acquired in 1827 by Charles X of France for the newly created section for Egyptian antiquities at the Louvre. The French collection was under the care of its first curator, Jean-François Champollion, who in 1826 had been instrumental in acquiring for the Louvre a collection of Egyptian art belonging to Henry Salt, the British consul-general in Egypt, who was one of Drovetti's rivals in the collection of antiquities.

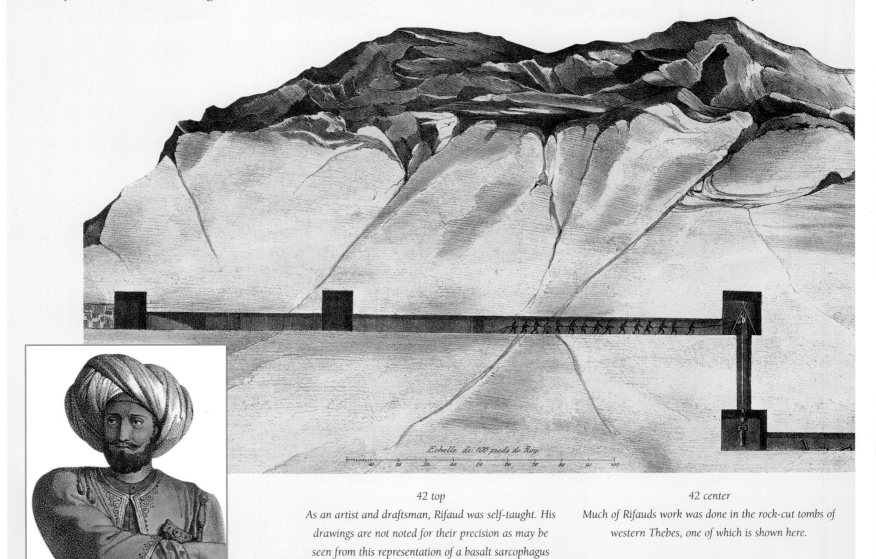

42 top
As an artist and draftsman, Rifaud was self-taught. His drawings are not noted for their precision as may be seen from this representation of a basalt sarcophagus discovered in western Thebes.

42 center
Much of Rifauds work was done in the rock-cut tombs of western Thebes, one of which is shown here.

THE IMAGES REPRODUCED IN THIS SECTION ARE TAKEN FROM *VOYAGE EN ÉGYPTE, EN NUBIE, ET LIEUX CIRCONVOISINS*, BY JEAN JACQUES RIFAUD (PARIS 1830).

42 bottom

Jean Jacques Rifaud spent about fifteen years in Egypt during which he carried out numerous excavations on behalf of Bernardino Drovetti, who was consul-general for France.

43

In 1830, Rifaud published an account of his extensive travels in Egypt, Nubia, and the eastern Mediterranean. This contained long descriptions of the places he had visited and was illustrated by his drawings.

JOHN GARDNER WILKINSON

Sir John Gardner Wilkinson (1797-1875) is generally regarded as the founder of British Egyptology. Educated at Harrow and continuing his studies at Oxford, Wilkinson set off in 1819 to see something of Europe before beginning a career in the army. While in Italy, he met Sir William Gell, an antiquarian with a keen interest in ancient Egypt. Knowing that Wilkinson planned to travel in Egypt, Gell suggested that the young man learn something of the antiquities to be found there and offered the resources of his personal library and his own considerable knowledge of the subject. During the summer and fall of 1821, Wilkinson studied with Gell, reading accounts of earlier travelers and learning what was then known about ancient Egyptian hieroglyphs. He also studied Arabic and when he sailed for Egypt in late October, Wilkinson was better prepared than any of his predecessors. After spending some months in Egypt, he abandonned the idea of a military career. He remained in Egypt for twelve years, working on his own and living on a small independent income.

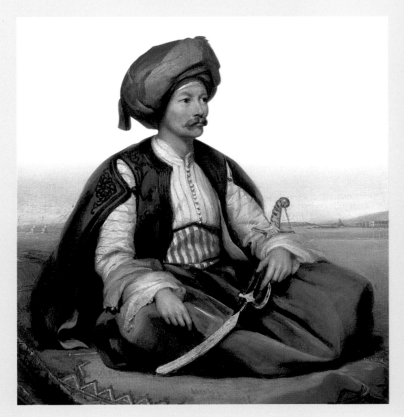

44 top
This detail was copied from the tomb of the vizier Rekhmire (TT 100) who oversaw gifts presented by foreigners from ancient Nubia and Kush (to the south of Egypt), and from western Asia.

44 center
When he reached Cairo in December of 1821, Wilkinson provided himself with Turkish dress, having been advised that this would make his journey both easier and safer.

44-45 bottom
These boats are from a funerary scene in the tomb of Neferhotep (TT 49). Although not facsimiles from the point of view of artistic style, the placement of the figures, their gestures and modes of dress are copied with great accuracy.

45 top
Wilkinson's map of the Theban area shows his intimate knowledge of the archaeological sites, many of which went unrecognized by the Napoleonic expedition.

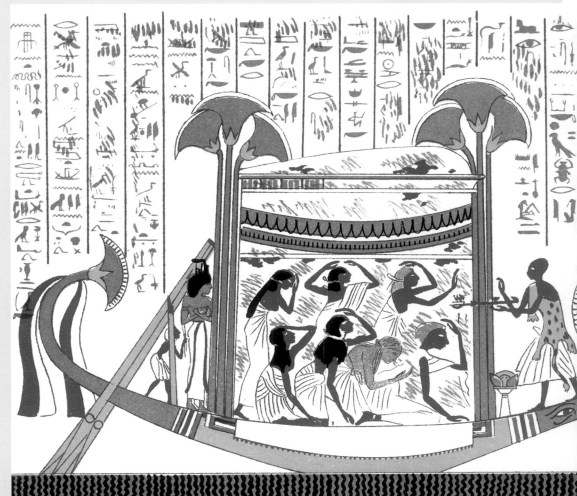

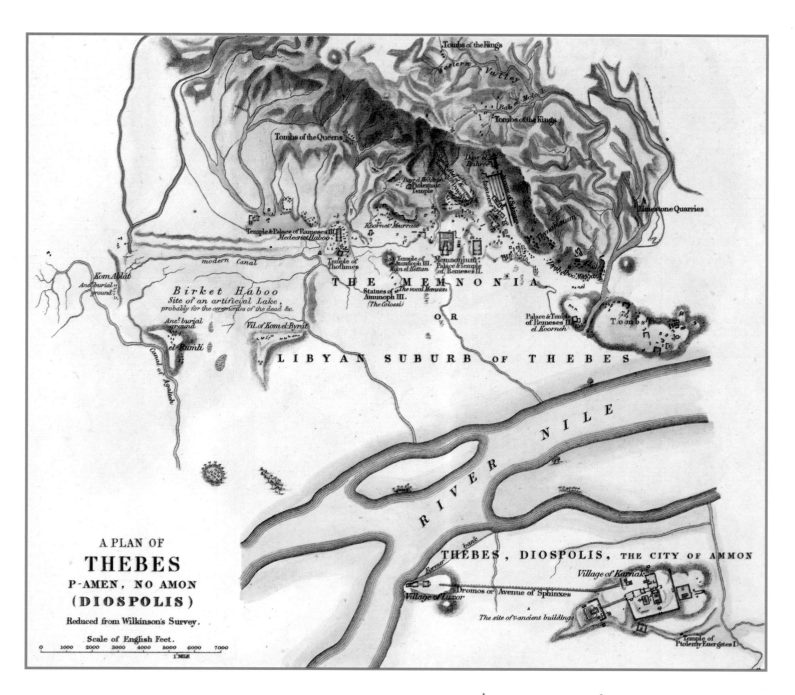

A PLAN OF
THEBES
P-AMEN, NO AMON
(DIOSPOLIS)

Reduced from Wilkinson's Survey.

Scale of English Feet.

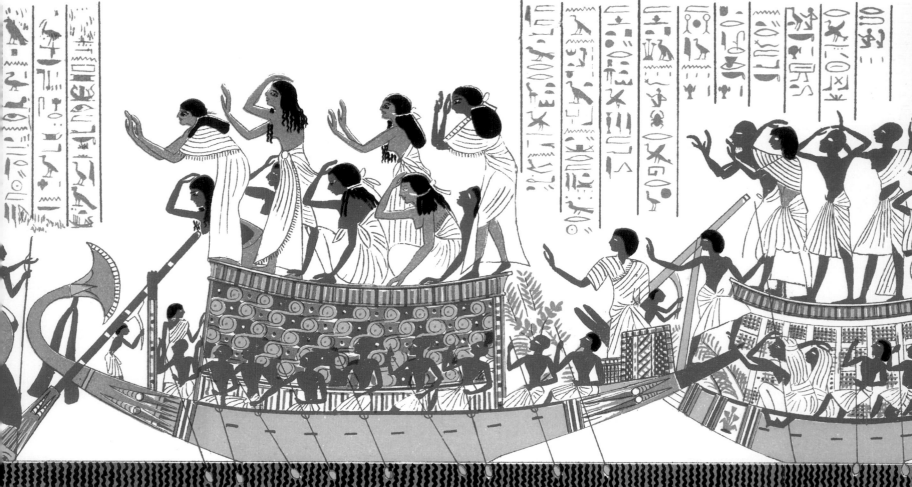

Thanks to his association with William Gell, Wilkinson was the first European scholar/traveler who was able to read Egyptian royal names with some accuracy and assign the ancient monuments to their proper owners, rather than following unquestioningly the often incorrect interpretations of the classical authors. While in Egypt, he added to his knowledge by incorporating the ground-breaking advances of Jean-François Champollion as these were published. Beginning in 1824, a large part of Wilkinsons time was spent at Thebes, where he lived on Sheikh Abd el-Qurna hill in a house that included the courtyard and rock-cut chambers of an ancient tomb.

One of his early interests was to establish a chronology of the ancient rulers of Egypt. To determine the succession of the New Kingdom pharaohs he systematically studied the tombs in the Valley of the Kings, where he assigned numbers to the known tombs, twenty-one in the main valley and four in the west valley. This numbering system has been used ever since, with each successive discovery receiving the next number. Thus, the tomb of Tutankhamen is no. 62. Wilkinson's chronology was published in 1828-30, and a topographical survey of Thebes and other sites appeared in 1830.

Although he recorded the scenes on temple walls and in kings tombs, some of Wilkinson's

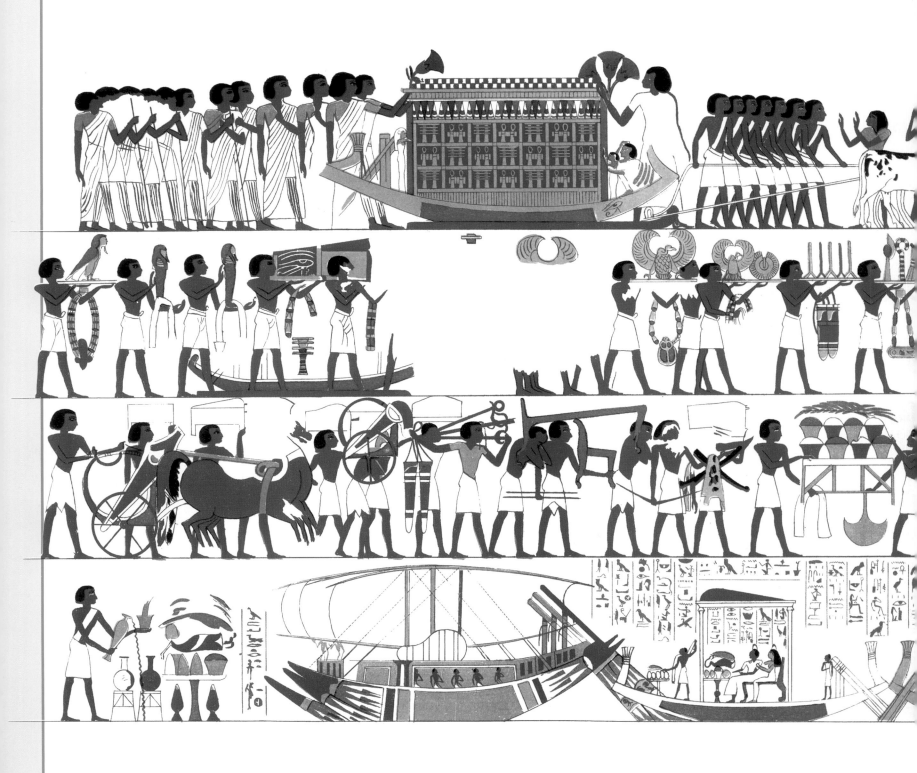

most important work was done in the tombs of officials on Sheikh Abd el-Qurna hill and other non-royal cemeteries in western Thebes, which had been virtually ignored by earlier visitors. He was particularly interested in the evidence these provided for the day to day lives of the ancient Egyptians. Thus, he recorded dress and hairstyles, scenes of agricultural work and scenes showing the manufacturing of furniture, jewelry, sculpture, etc. The information he gathered during his long sojourn in Egypt led, in 1837, to the publication of his magnum opus, the title of which aptly explains its comprehensive nature: *The Manners and Customs of the Ancient Egyptians, Including Their Private Life, Government, Laws, Arts, Manufactures, Religion, and Early History; Derived from a Comparison of the Paintings, Sculptures, and Monuments Still Existing, with the Accounts of Ancient Authors.* This monumental work, the only one of its kind ever produced, remains an important reference. Wilkinson's fifty-six volumes of notes and drawings, many of them unpublished, are now in the Bodleian Library at Oxford.

46-47
During his years living in western Thebes, Wilkinson concentrated on recording information that could help him reconstruct the lives of the ancient Egyptians. To this end, he recorded many scenes from the tombs of New Kingdom officials. This one depicts a funerary procession in the tomb of Horemheb (TT 78), large portions of which are now missing.

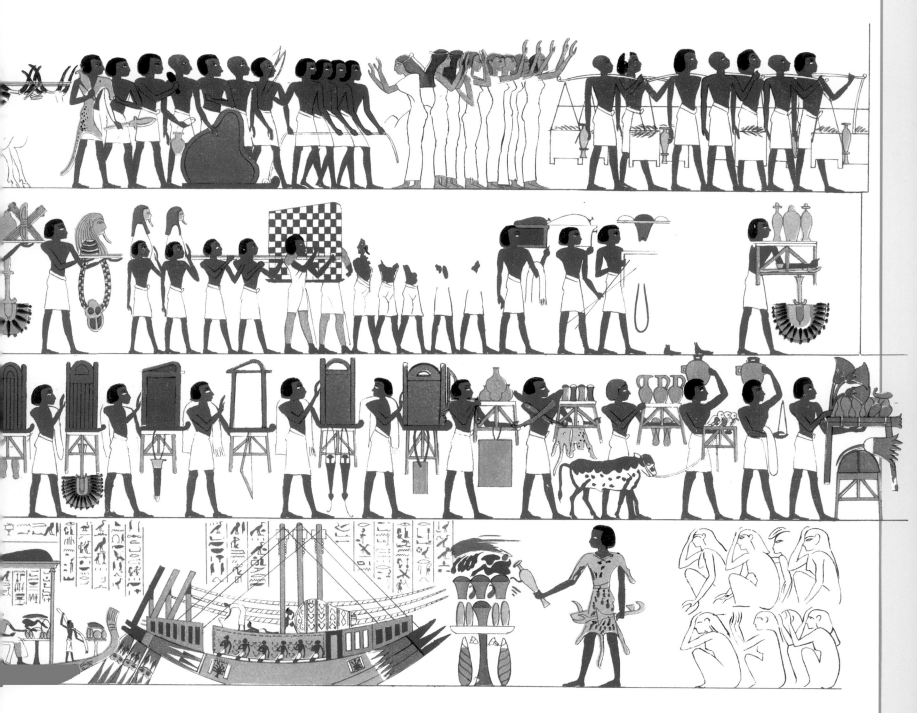

THE IMAGES REPRODUCED IN THIS SECTION ARE TAKEN FROM *THE MANNER AND CUSTOMS OF THE ANCIENT EGYPTIANS*, BY JOHN GARDNER WILKINSON (LONDON 1878).

FRANCO-TUSCAN EXPEDITION

 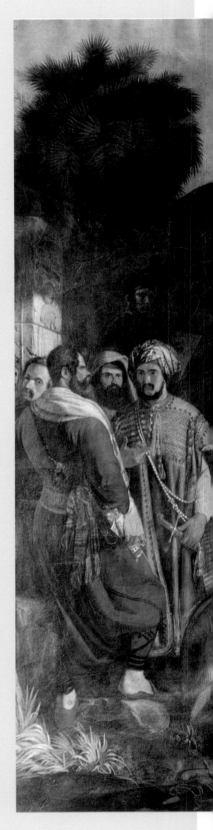

In 1828, twenty years after the first volumes of the *Description de l'Egypte* were published, a second expedition of scholars embarked for Egypt, this one jointly sponsored by Charles X of France and Leopold II of Tuscany. The Franco-Tuscan expedition was led by the great French Egyptologist, Jean-François Champollion (1790-1832), and his younger Italian colleague, Niccolo Francesco Ippolito Baldessare Rosellini (1800-1843).

Champollion, at age 38, was already a monumental figure in the developing field of Egyptology because of his contribution to the decipherment of ancient Egyptian hieroglyphs. Born in the small town of Figeac, Champollion had developed a love of books and languages as a child. He was encouraged in this by his much older brother and mentor, Jacques-Joseph (1778-1864). The elder Champollion (who later adopted the name Champollion-Figeac while his brother was called Champollion le Jeune) had asked to accompany Napoleon's *Commission des arts et des sciences* to Egypt in 1798, but was refused. In spite of this disappointment, Jacques-Joseph maintained his interest in ancient Egypt, authoring a number of important works on the subject. His most significant contribution to Egyptology, however, was undoubtedly the life-long encouragement and support that he gave to his talented younger brother.

After his brother moved to Grenoble, the younger Champollion studied at the Lycée that had just been established there. From there he went to Paris where he concentrated on language studies at the Collège de France and l'École Pratique des Langues Orientales. In Paris he also learned Coptic, the language used in the liturgy of the Egyptian Christian church. He came to the conclusion that this was a surviving form of the ancient Egyptian language, and his knowledge of Coptic was instrumental in his later success in deciphering the Egyptian hieroglyphic writing system. In 1809, at the age of 18, Champollion became a professor of history at the newly formed University of Grenoble and also worked on the Egyptian collection at the Bibliothèque. In the next few years, he authored books on Egyptian history and religion. His primary area of study, however, was the decipherment of ancient Egyptian hieroglyphs. This problem had interested European scholars for several centuries, but real progress had only been made since 1799, when Napoleons troops discovered the Rosetta stone, a bilingual text written in Egyptian hieroglyphs, Demotic (another form of Egyptian), and ancient Greek. Using a copy of the Rosetta stone, Champollion eventually was able to assign phonetic values to some hieroglyphs. Later, having received copies of another bilingual text that had been transported to Britain by Giovanni Belzoni in 1819, Champollion was able to confirm and expand on his earlier work.

48 top
*Detail of a painting by Rosellini showing Amenemesse,
pharaoh of the nineteenth Dynasty.*

48 bottom left
*In spite of having spent most of his life studying ancient
Egypt, Jean-François Champollion had never visited
Egypt before leading the Franco-Tuscan expedition in
1828.*

48 bottom right
*Ippollito Rosellini was a young professor of oriental
languages at Pisa when he first met Champollion in
Florence. Ten years younger than Champollion, Rosellini
was second in command of the Franco-Tuscan expedition.*

48-49
*This painting of the Franco-Tuscan expedition was executed
by Giuseppe Angelelli, one of the members. Rosellini stands
at the center, with Champollion seated to the right. Salvatore
Cherubini, Rosellinis brother-in-law, reclines at the front.*

49 bottom
*This scene decorates the lintel above the entrance to the
tomb of Rameses X (KV 18). The original drawing was
done by Nestor L'Hôte, a young member of the
expedition.*

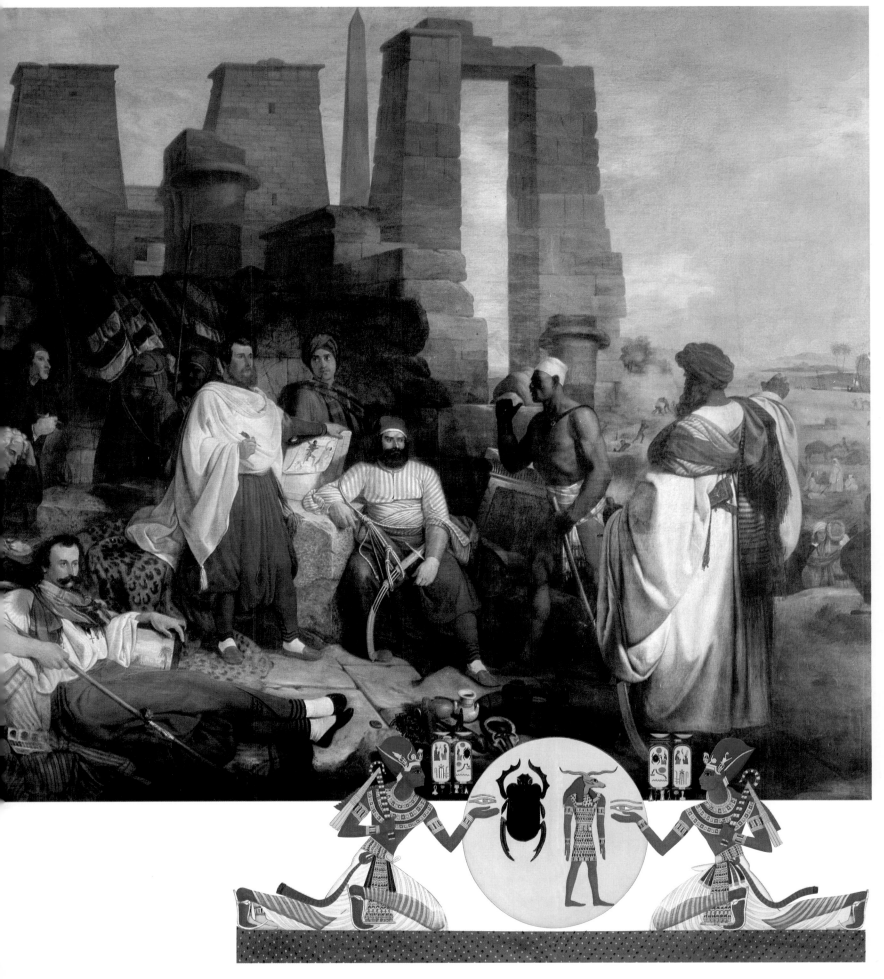

50

The original drawing for this image was done by Alexandre Duchesne in the tomb of Merenptah (KV 8). This scene, showing the king before Ra-Horakhty, is just inside the entrance on the left.

In 1822, he published his discoveries for the first time in his *Lettre à M. Dacier* which was addressed to the secretary of the prestigious Académie Royale des Inscriptions et Belles-Lettres in Paris. In 1824, Champollion received funds for an extended study tour of the Egyptian collections in Italy. His purpose was to test his system of translation on new material, especially in the extensive collection of Egyptian art in Turin. This collection had been acquired in 1821 from Bernardino Drovetti, France's consul-general in Egypt, and was being put on display in the city's new Egyptian Museum. Champollion's work in this collection confirmed his theories and led to the publication of his *Précis du système hiéroglyphique* in which he explained the rudiments of the hieroglyphic writing system.

During his travels in Italy, Champollion visited Florence where he was asked to evaluate a collection of Egyptian art belonging to the Grand Duke, Leopold II. He also made the acquaintance of Ippolito Rosellini, a young professor of Oriental Languages at Pisa. While Champollion is justly known as the father of Egyptology, Rosellini was the founder of Egyptology in Italy. In 1827, in order to improve his knowledge of the ancient Egyptian language, Rosellini spent a year in Paris studying with Champollion who had been appointed Curator in charge of the newly created section for Egyptian antiquities at the Louvre. It was during this time that Champollion and Rosellini prepared for their joint expedition to Egypt, a land that neither had yet visited.

The Italian segment of the expedition was approved by the Grand Duke in August 1827, but Champollion, who was in the middle of installing the Egyptian collections at the Louvre, had a bit more difficulty persuading the French

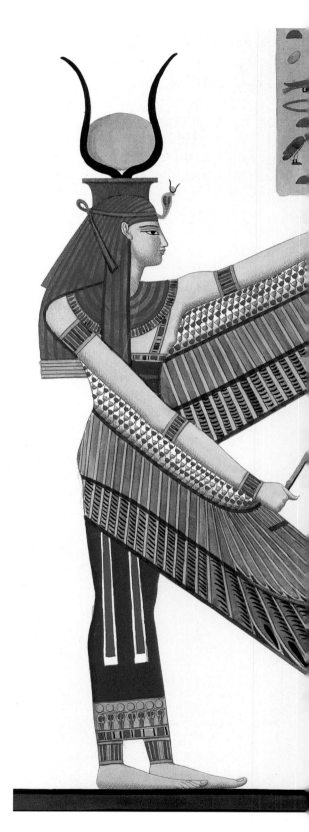

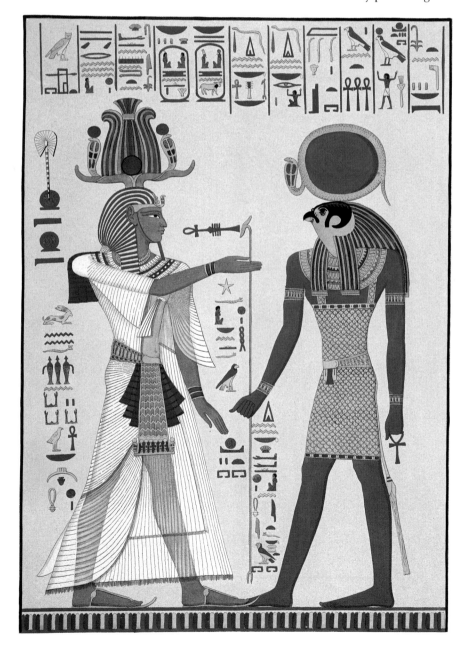

51 bottom
This vignette shows the jackal-headed Anubis tending the mummy of the deceased with the goddesses Isis (left) and Nephthys (right). It was copied from a side chamber in KV 14, the tomb of Tausert, that was later usurped by Setnakht.

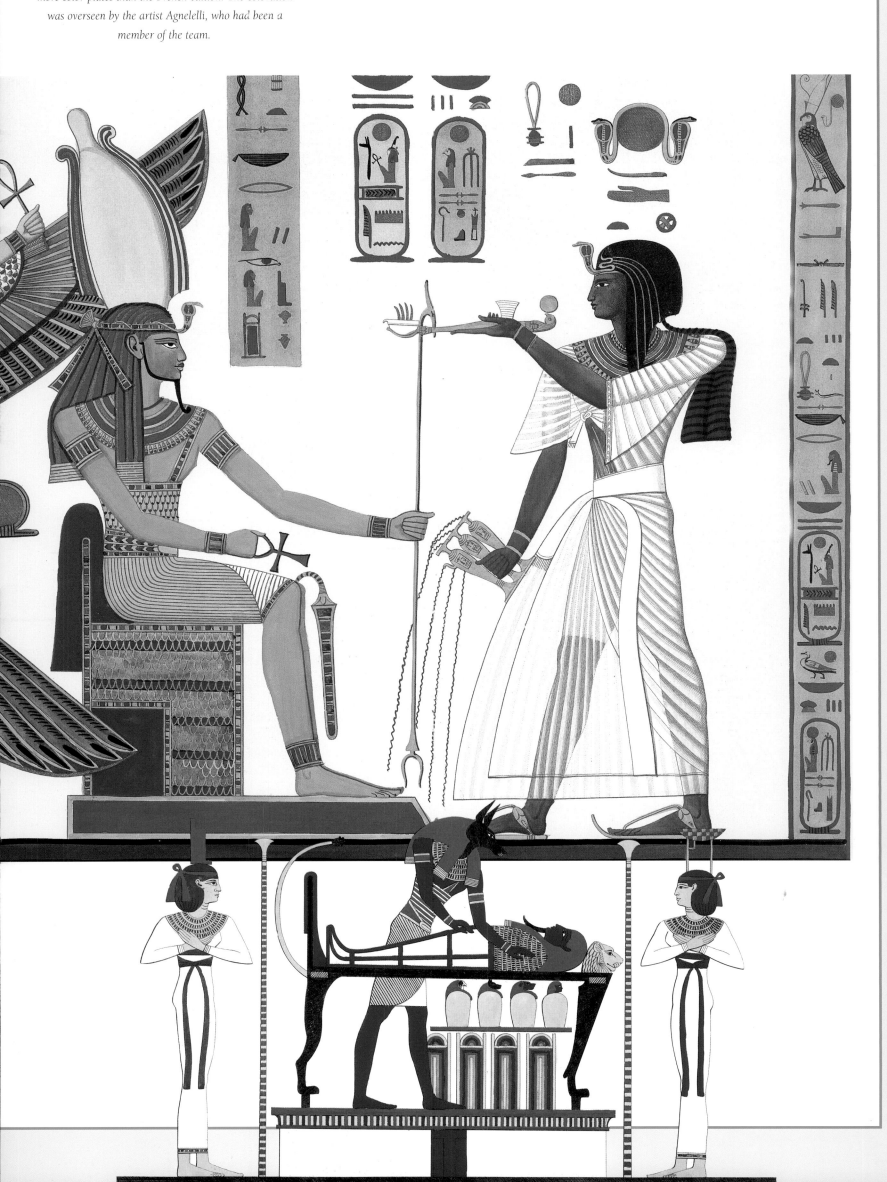

50-51

This scene, from the tomb of Rameses III (KV 11), shows the king offering to Ptah-Sokar-Osiris, with a winged figure of Isis behind. Rosellini's publication contained more color plates than the French edition. The coloration was overseen by the artist Agnelelli, who had been a member of the team.

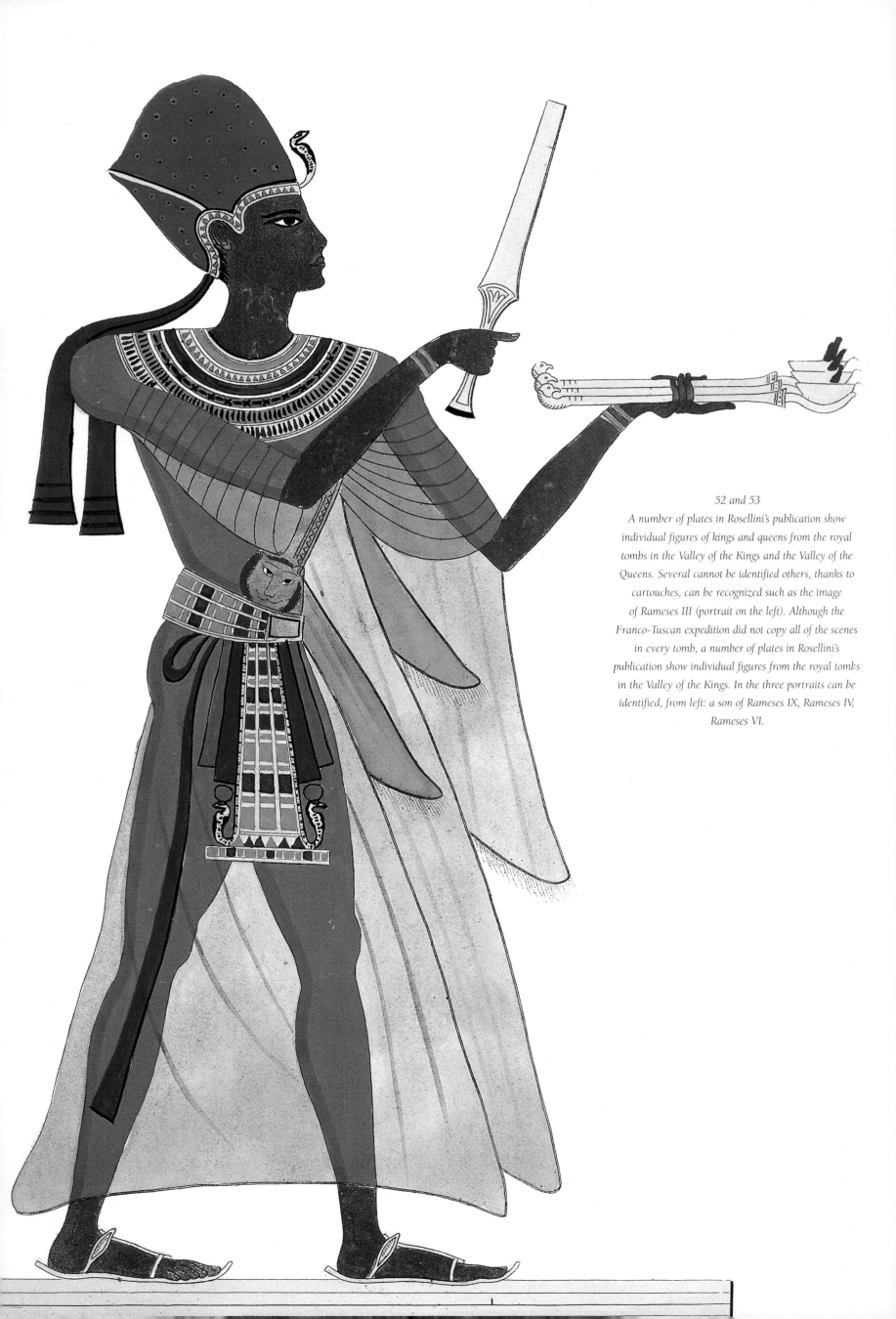

52 and 53

A number of plates in Rosellini's publication show individual figures of kings and queens from the royal tombs in the Valley of the Kings and the Valley of the Queens. Several cannot be identified others, thanks to cartouches, can be recognized such as the image of Rameses III (portrait on the left). Although the Franco-Tuscan expedition did not copy all of the scenes in every tomb, a number of plates in Rosellini's publication show individual figures from the royal tombs in the Valley of the Kings. In the three portraits can be identified, from left: a son of Rameses IX, Rameses IV, Rameses VI.

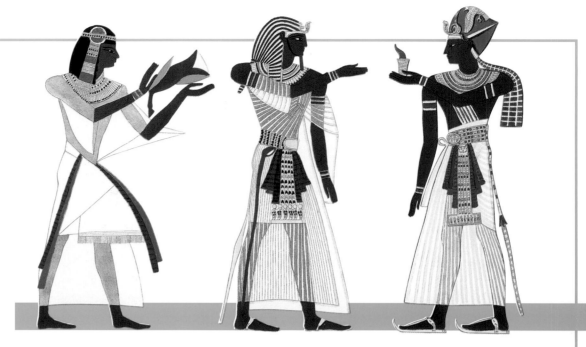

government to support an Expedition to Egypt. In order to gain support, Champollion explained that, because of its great scope (covering natural history as well as the ancient and Islamic monuments), the famous *Description de l'Egypte* had provided European scholars with merely a taste of what was available. A new expedition concentrating on the ancient monuments alone, and carried out by scholars with an understanding of the ancient texts, would provide essential information for the study of ancient Egypt.

Authorization from the King of France finally came in April 1828. The expedition embarked at the end of July arriving in Alexandria

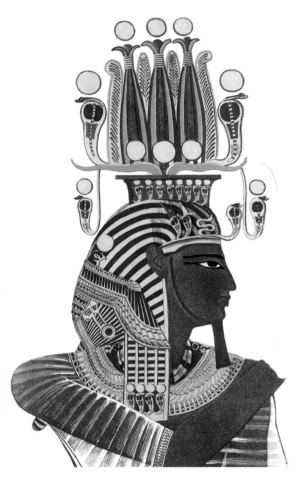

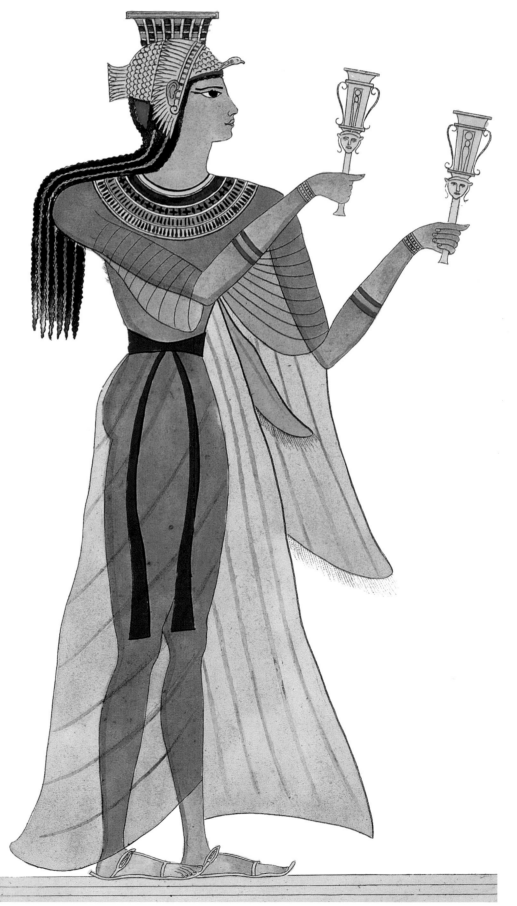

in mid-August. Unlike the Napoleonic expedition, which had been accompanied by a conquering army, Champollion and Rosellini had to obtain official permission to carry out their research. This had to come from the Khedive, Mohammed Ali, who had been ruling Egypt since 1805. Permission was eventually obtained with the aid of Bernardino Drovetti who still represented the French as consul-general. Leaving Alexandria in mid-September, the expedition made a number of stops in Cairo, Giza, Beni Hassan, Asyut, and Dendera. Finally, after several days of contrary winds, they arrived at Thebes on the morning of November 20 and spent the next four days exploring the ruins before continuing on up the river as far as Wadi Halfa and the second cataract. On November 25, Nestor L'Hôte, a young artist on the expedition wrote to his parents: "I write you from the most ancient and most magnificent capital of the world; we arrived here on the 20th, and since then I have explored everything that can be explored in four

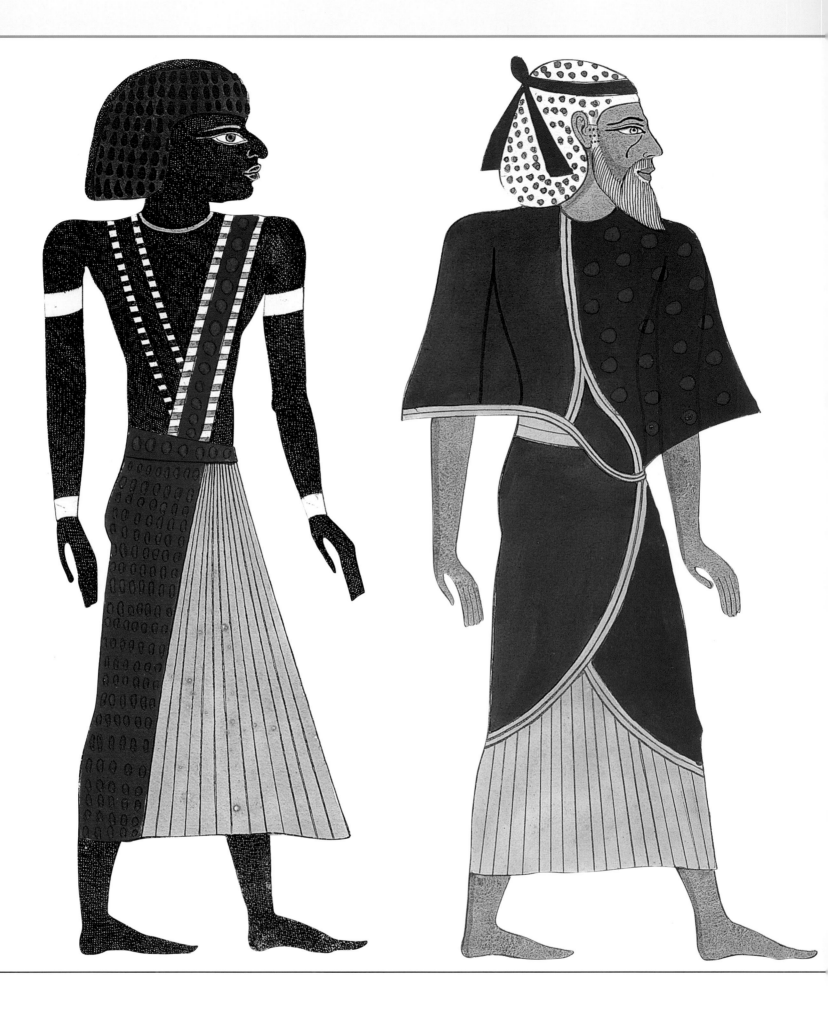

or five days; my admiration is transported to the greatest heights, it is exhausted and I am overwhelmed by wonders."

On the return voyage, the expedition made a prolonged stay at Thebes, from March 8 to September 4, 1829. After two weeks on the east bank, they established themselves in the Valley of the Kings, where they set up camp in the tomb of Rameses IV (KV 2). According to L'Hôte, Champollion had estimated a stay of two weeks, but they worked in the valley for two and a half

months. L'Hôte's description of the tombs in a letter dated March 22 explains why: "In their own way, the tombs of the kings are as gigantic as the temples and palaces situated on the Theban plain. What an enormous wealth of sculpture, painting, and decoration. They are vast subterranean museums where the ancients seem to have assembled, as though to perpetuate it in memory, all that concerns their religion, arts, sciences, furniture, arms, the most curious details of their customs, the history of the pharaohs, their funerary practices, etc."

By the middle of May, the temperature in the sun reached 47 degrees Celsius, but in the tombs it remained a comfortable 20-22 degrees. Although they made copies in most of the accessible tombs, the majority of their drawings were done in those of Rameses III (KV 11) and Seti I (KV 17). By June 7, the expedition was established in a house at Gurna where they remained for nearly two months, copying the scenes at Medinet Habu and at the Ramesseum which they now could identify as belonging to Rameses II.

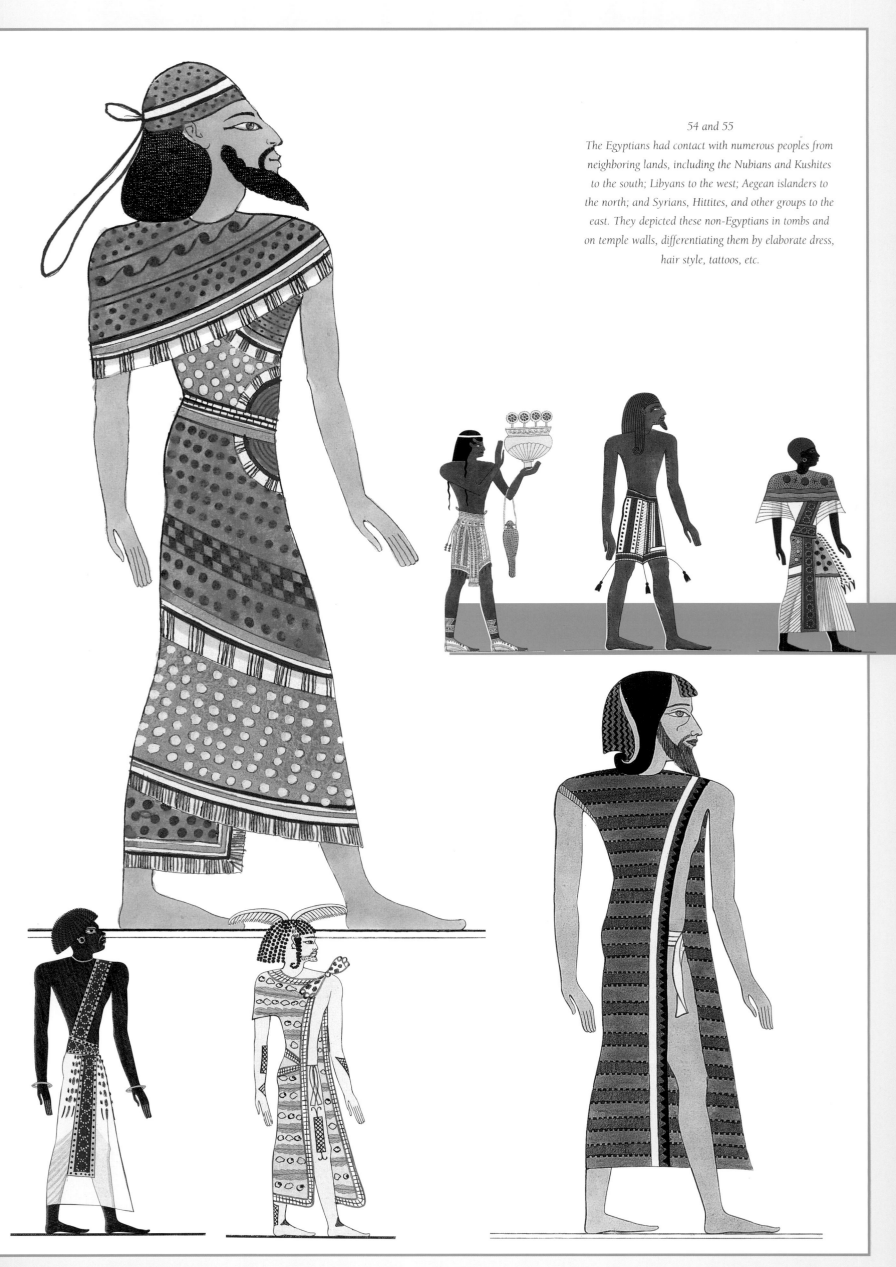

54 and 55
The Egyptians had contact with numerous peoples from neighboring lands, including the Nubians and Kushites to the south; Libyans to the west; Aegean islanders to the north; and Syrians, Hittites, and other groups to the east. They depicted these non-Egyptians in tombs and on temple walls, differentiating them by elaborate dress, hair style, tattoos, etc.

By the end of July they had finished their work in western Thebes and proceeded to Karnak before returning to Cairo and finally Europe.

The joint expedition left Egypt with a wealth of information in the form of drawings, watercolors, and notes. They also returned with antiquities that are now in the Louvre in Paris and the Archaeological Museum in Florence. The results of the work were eventually printed in both Italian and French. Rosellinis Italian version *Monumenti dell'Egitto e della Nubia* began to appear in 1832, the final volume being printed in 1844, the year after his death. Champollion had died in 1832, and the French version of the work, *Monuments de l'Egypte et de la Nubie d'après les dessins exécutés sur les lieux, sous la direction de Champollion le jeune*, was published by his brother, Champollion-Figeac between 1835 and 1847. The text for the French version appeared between 1844 and 1889. The plates for both publications were produced from the same drawings and are quite similar, but the hieroglyphic texts, though identical in their content, have been drawn in different styles.

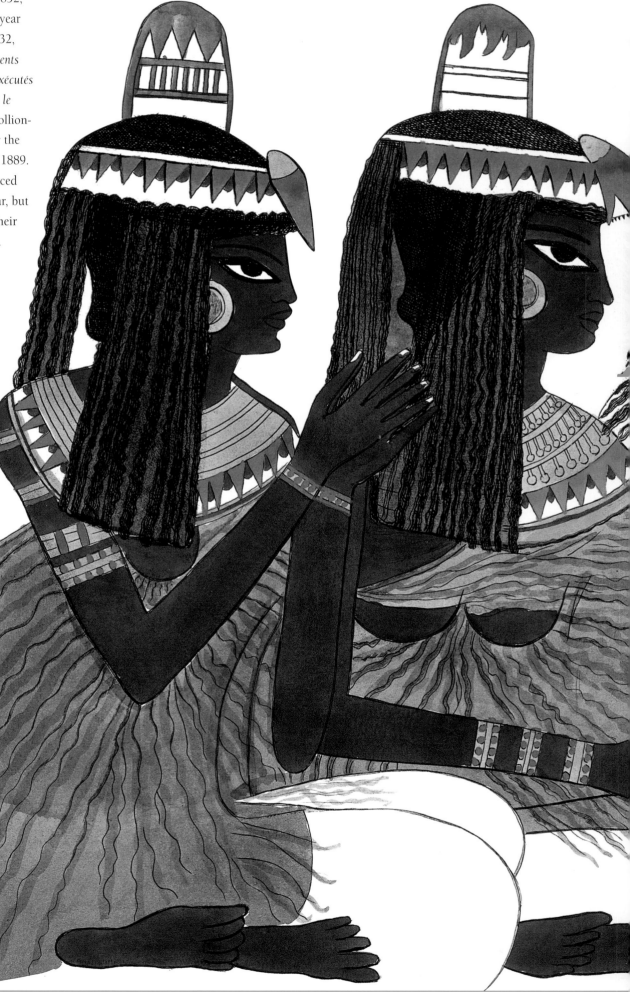

56 and 57

All of these images of musicians and dancers were copied by Ricci, some in the royal tombs and some in the private tombs of officials. The painting below, showing the four female musicians, is now in the British Museum.

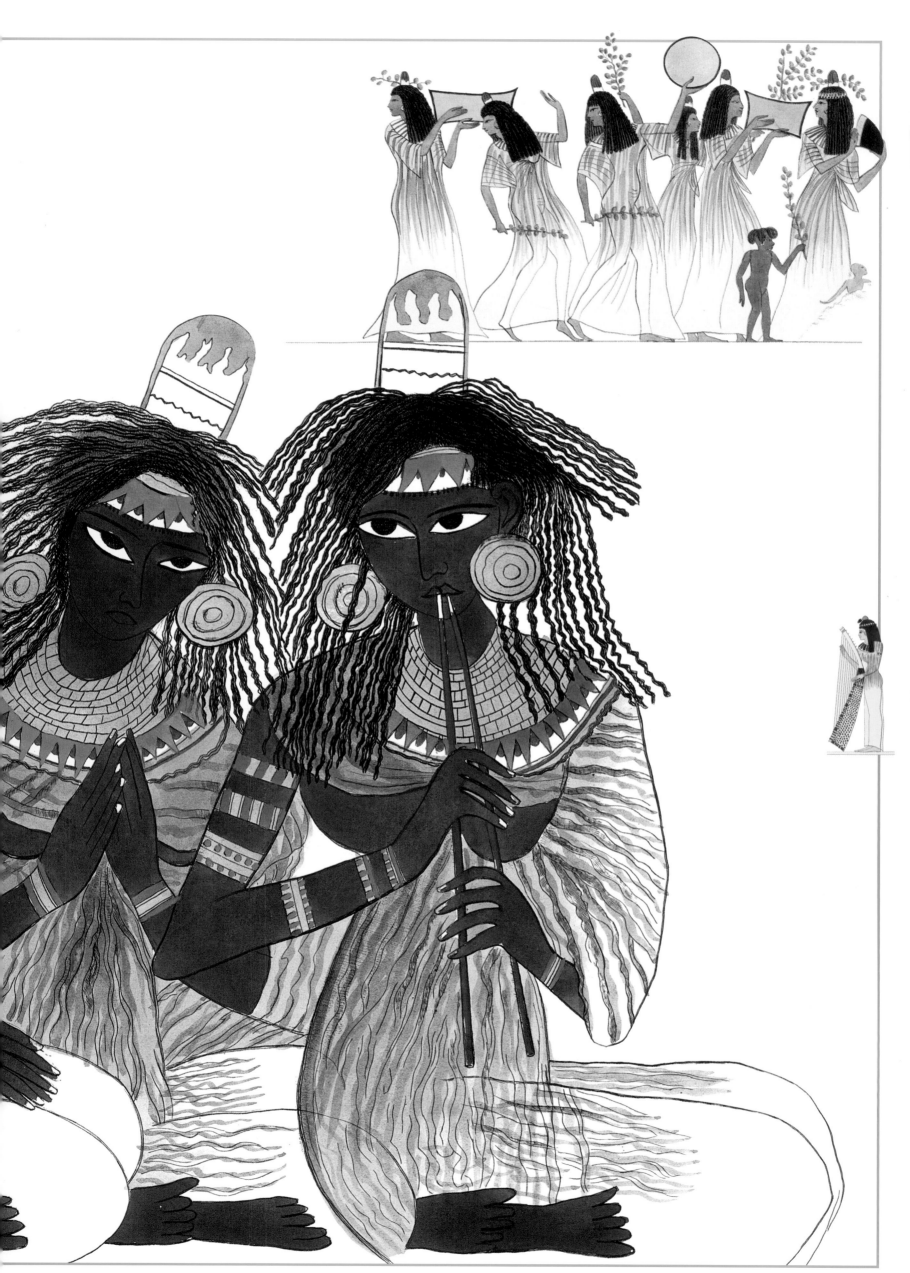

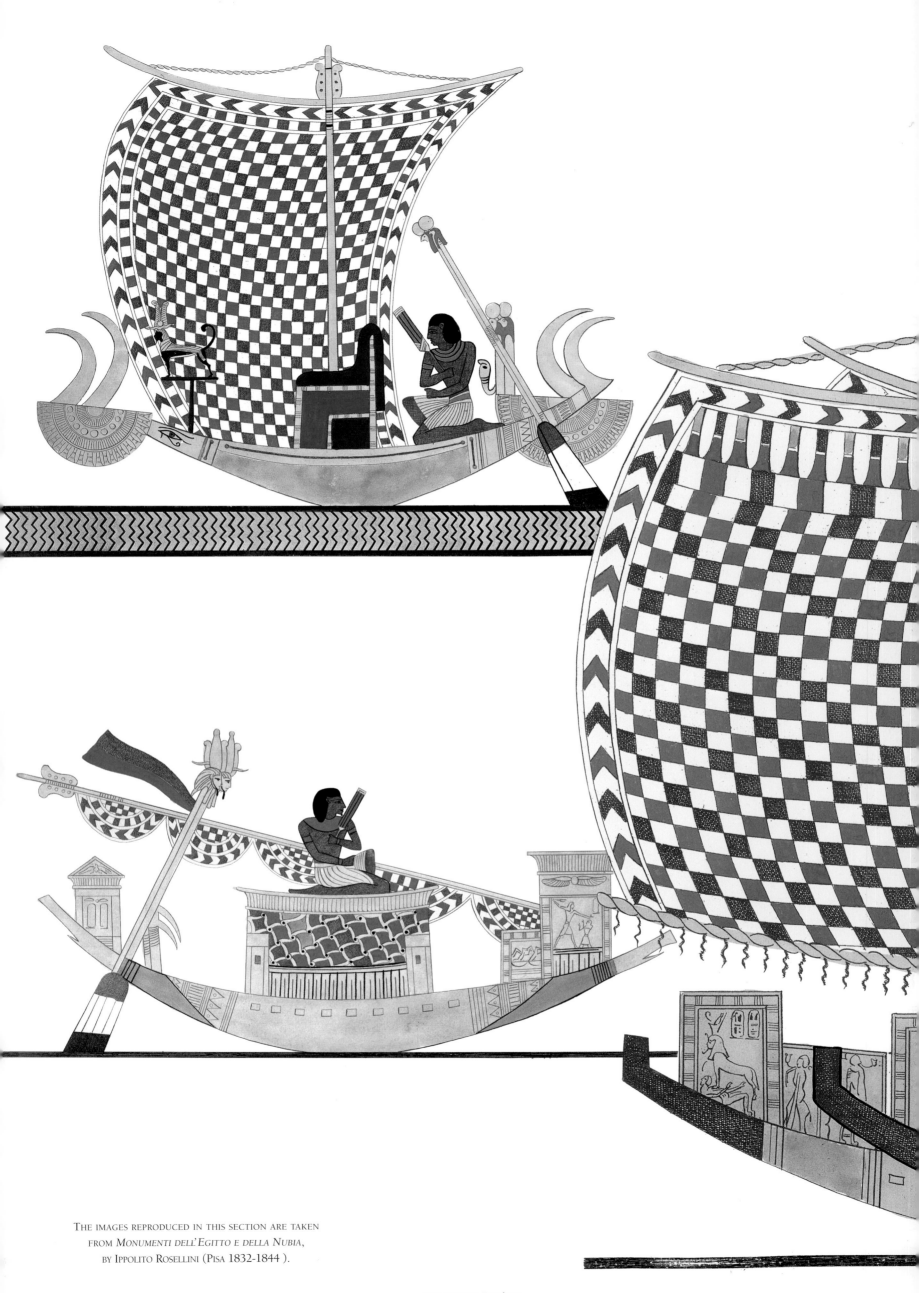

THE IMAGES REPRODUCED IN THIS SECTION ARE TAKEN
FROM *MONUMENTI DELL'EGITTO E DELLA NUBIA*,
BY IPPOLITO ROSELLINI (PISA 1832-1844).

58 and 59
These brilliantly painted boats from the tomb of
Rameses III were all copied by Albert Bertin during
the many weeks the Franco-Tuscan expedition spent
in the Valley of the Kings.

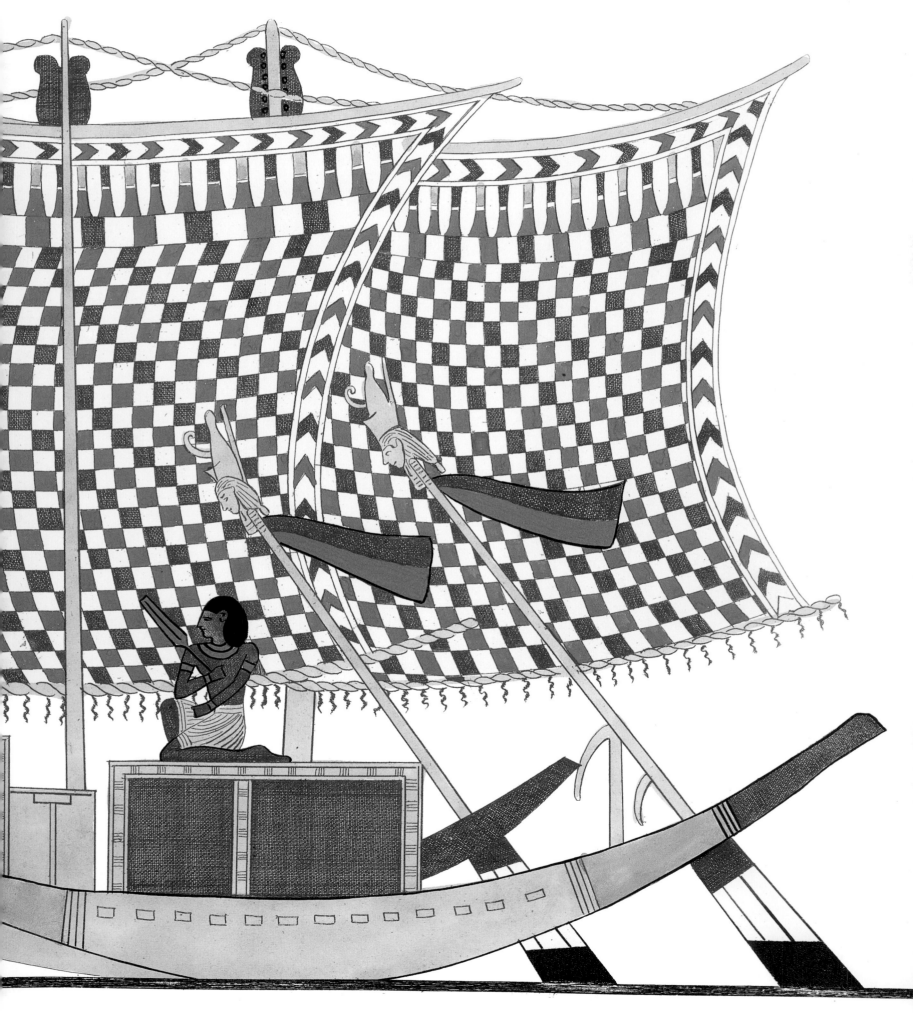

ÉMILE PRISSE D'AVENNES

Educated as an engineer-architect, Achilles Constant Théodore Émile Prisse d'Avennes (1807-1879) went to Greece in 1826 to participate in the war for independence from Turkey. In 1827 he traveled to Egypt, where the Khedive, Mohammed Ali offered him a position as a lecturer at the military academy.

During the next decade, Prisse d'Avennes learned fluent Arabic and began studying Champollion's work on hieroglyphs, gaining a proficient knowledge of the ancient language. In 1836, he resigned his teaching position, and devoted the next eight years of his life to copying the ancient monuments, settling in Thebes in 1838 and making it his home until 1843. Although much of his time in Upper Egypt was spent copying the reliefs of Karnak temple on the east bank of the Nile, he devoted himself to the monuments of western Thebes as well. An excellent draftsman, Prisse d'Avennes also possessed an artistic sense that is evident in his copies which reproduce ancient Egyptian relief and painting more accurately than those published by professional Egyptologists such as Champollion, Rosellini, and Lepsius.

Prisse left Egypt in 1844, but returned in June 1858 for a two year expedition sponsored by the French Ministry of Public Education.

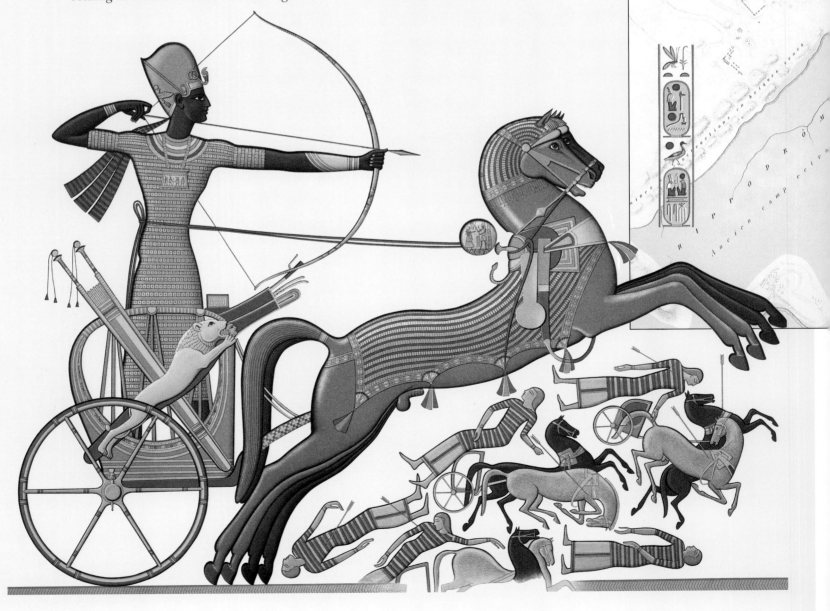

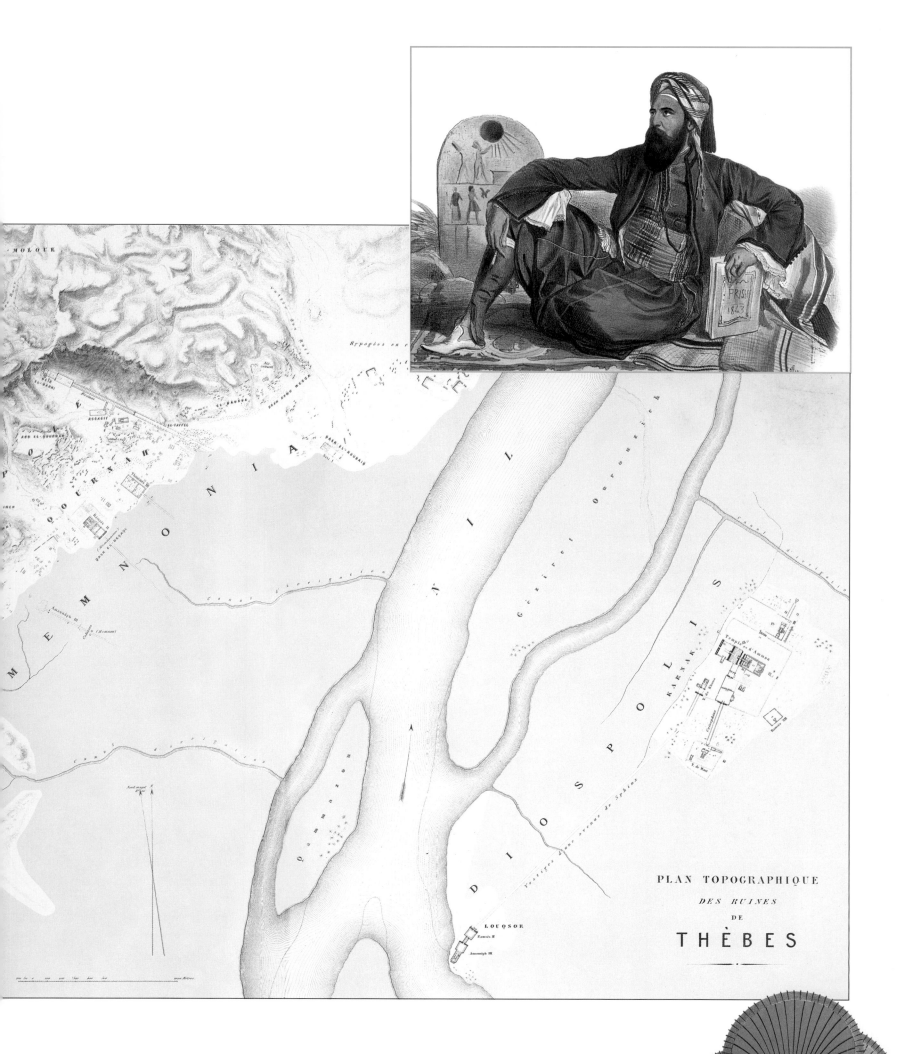

PLAN TOPOGRAPHIQUE
DES RUINES
DE
THÈBES

60

*This battle scene from the second pylon of the Ramesseum,
depicts Rameses II at the battle of Qadesh, a city on the
Orontes River. In this battle, Rameses claims a great
victory over the Hittites, some of whom are seen lying
dead on the battlefield beneath the king's horses.*

61 top

*Like many Europeans who lived and worked in Egypt during
the first half of the nineteenth century, Prisse d'Avenne's
wore Turkish dress. He also adopted the name Idriss Effendi.*

61 center

*Prisse d'Avennes map is based on the one published
by Wilkinson in 1835. During his years working
at Thebes, Prisse corresponded with Wilkinson,
informing him of new discoveries, especially at
Karnak temple.*

61 bottom

*Like Wilkinson before him, Prisse d'Avennes
was a keen observer of details, which he recorded
in his drawings.*

Émile Prisse d'Avennes

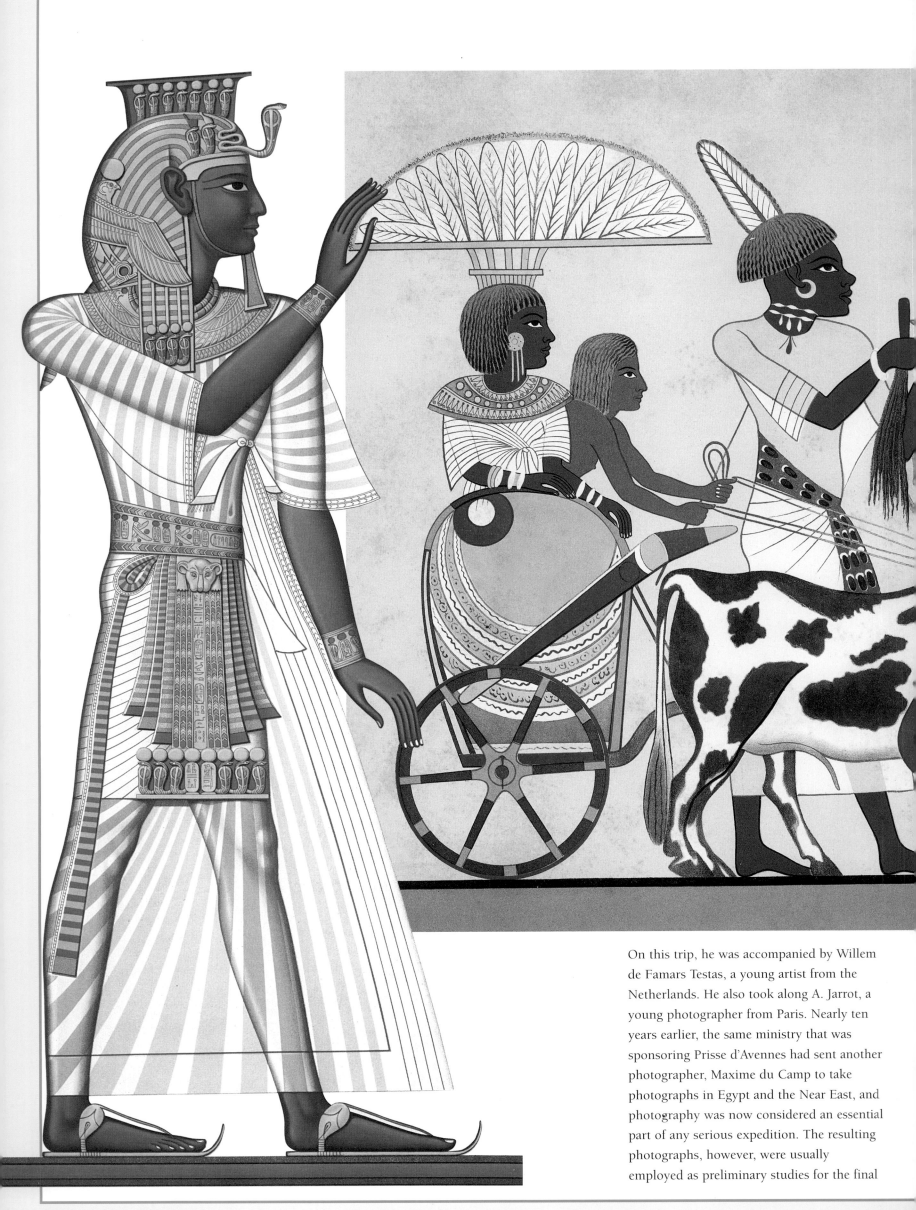

On this trip, he was accompanied by Willem de Famars Testas, a young artist from the Netherlands. He also took along A. Jarrot, a young photographer from Paris. Nearly ten years earlier, the same ministry that was sponsoring Prisse d'Avennes had sent another photographer, Maxime du Camp to take photographs in Egypt and the Near East, and photography was now considered an essential part of any serious expedition. The resulting photographs, however, were usually employed as preliminary studies for the final

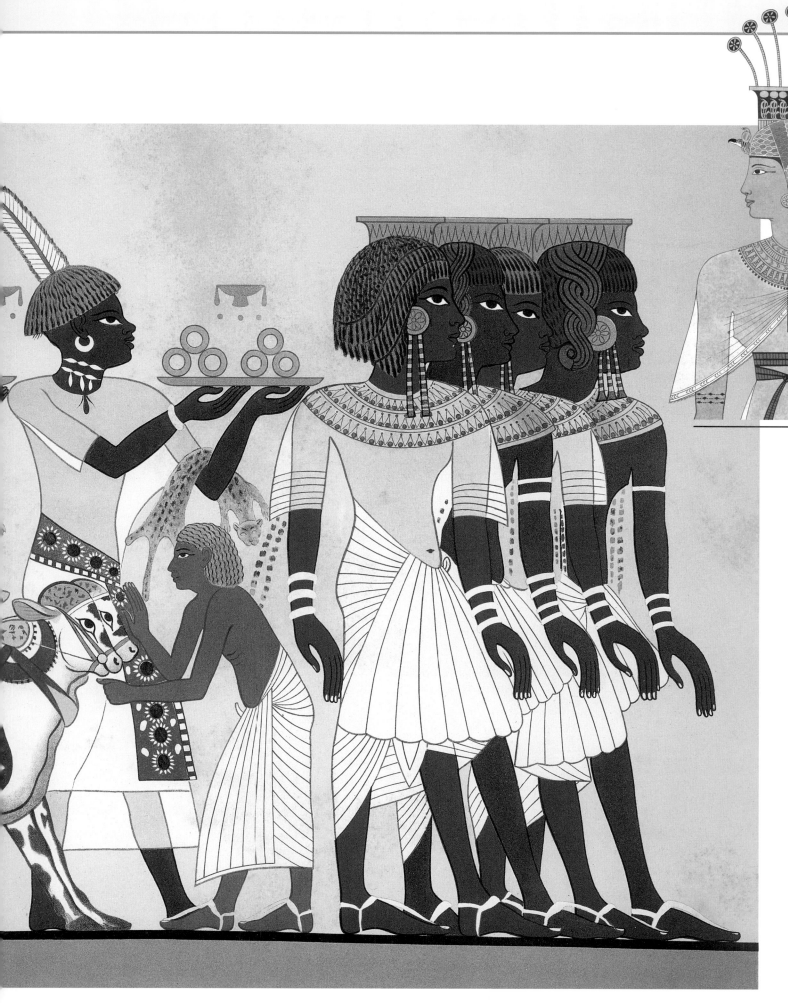

lithographs rather than as illustrations in their own right.

Prisse d'Avennes produced a number of publications based on his work in Egypt. The first of these was *Les Monuments égyptiennes* which appeared in 1847.

His most significant contribution to the study of Ancient Egypt was his two volume *Atlas de l'histoire de l'art égyptien, d'après les monuments, depuis les temps les plus reculés jusquà la domination romaine* (1868-78).

62
In this image of Rameses III, from his tomb in the Valley of the Kings (KV 11), Prisse has attempted to reproduce the effect of the sunk relief decoration found at the entrance of the tomb.

62-63
Amenhotep Huy was a Viceroy of Kush, the Egyptian name for one of the lands to the south of Egypt. In his tomb (TT 40), Huy is shown accepting tribute from the southern lands. Although not quite a facsimile, this detail published by Prisse is more accurate than the copy published by Richard Lepsius.

63 top right
Nebet-tawy was a daughter of Ramesses II, who may have performed the ceremonial duties of queen during the last years of her fathers reign. This image was copied from her tomb in the Valley of the Queens (QV 60).

Although he is best known for his copies of the ancient monuments, the name Prisse is also associated with two significant antiquities. One is the Papyrus Prisse, now in the Bibliothèque Nationale, Paris. Purchased in western Thebes, this nearly 4000 year old papyrus preserves the only complete copy of one of the great works of wisdom literature from ancient Egypt, "The Instructions of Ptah-hotep."

Prisse is also responsible for the removal from Karnak temple of the Table of Kings, a lengthy historical document carved on stone blocks that are now in the Louvre. Having recognized the importance of this inscription which dates to the reign of the Eighteenth Dynasty pharaoh, Tuthmosis III (ca. 1450 B.C.), Prisse spirited it away, practically under the nose of Richard Lepsius, who had received official permission to take it to Berlin.

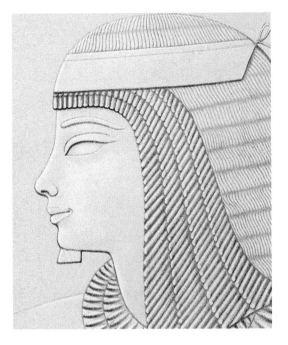

64 top

His artistic sense allowed Prisse d'Avennes to copy with some accuracy the differences in artistic styles that are found in tombs of the Theban necropolis. This detail of relief in the tomb of Kha-em-hat (TT 57) is easily recognizable as dating to the reign of Amenhotep III.

64 bottom

Some of Prisse d'Avennes finest copies were made in the tomb of Ramose (TT 55), who served as vizier during the reigns of Amenhotep III and his son Amenhotep IV, who later called himself Akhenaten. Here, foreigners make obeisance to Amenhotep IV.

65

The distinctive style of Amenhotep IV/Akhenaten is visible in this group of foreigners in the tomb of Ramose. Prisse d'Avennes was the first to recognize a similar artistic style on blocks found in one of the pylons at Karnak, which he mentioned in his letters to Wilkinson.

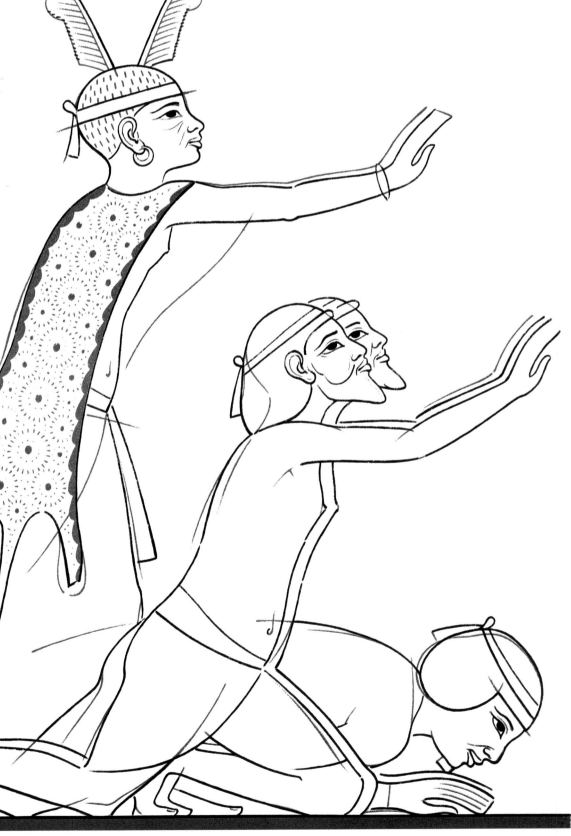

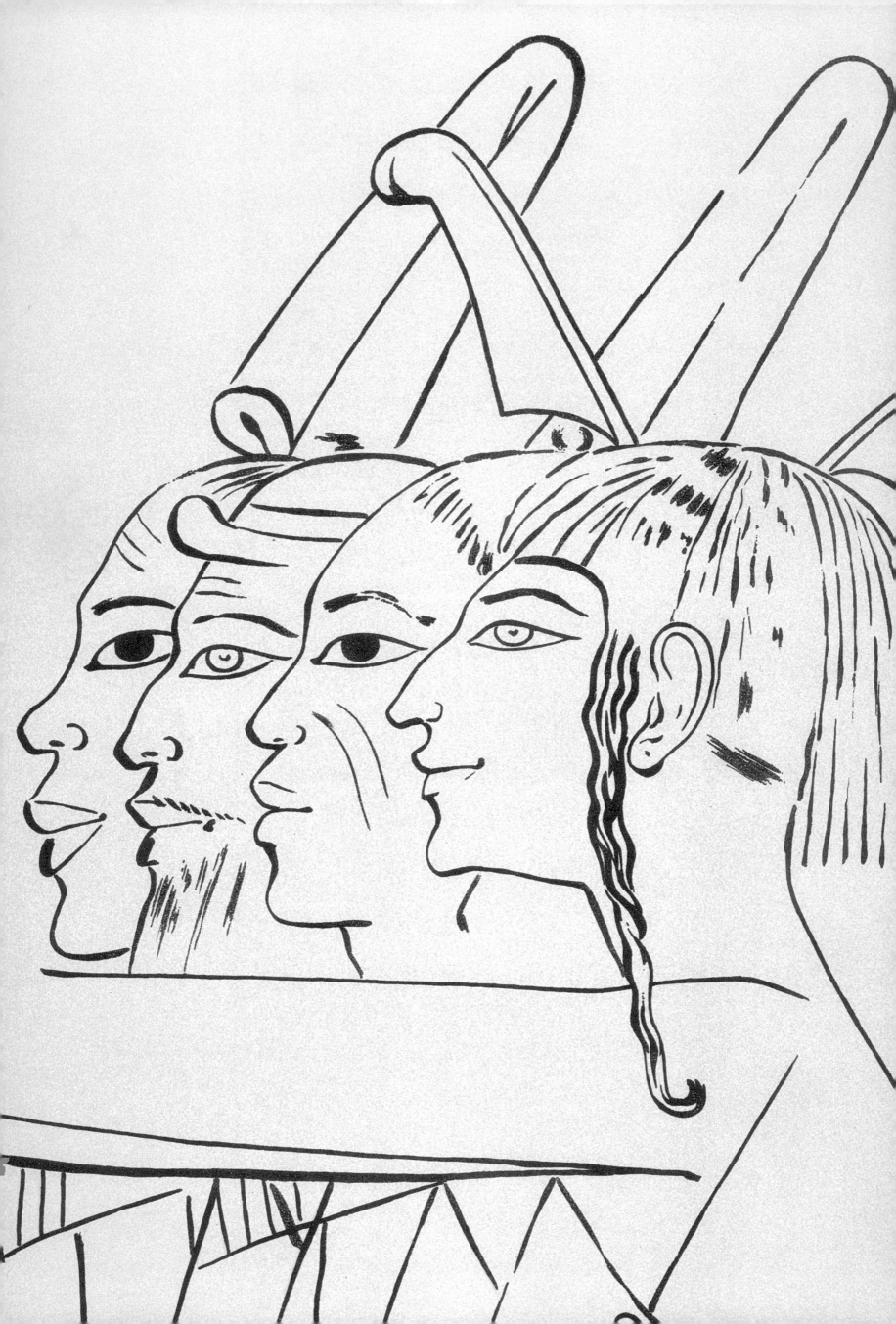

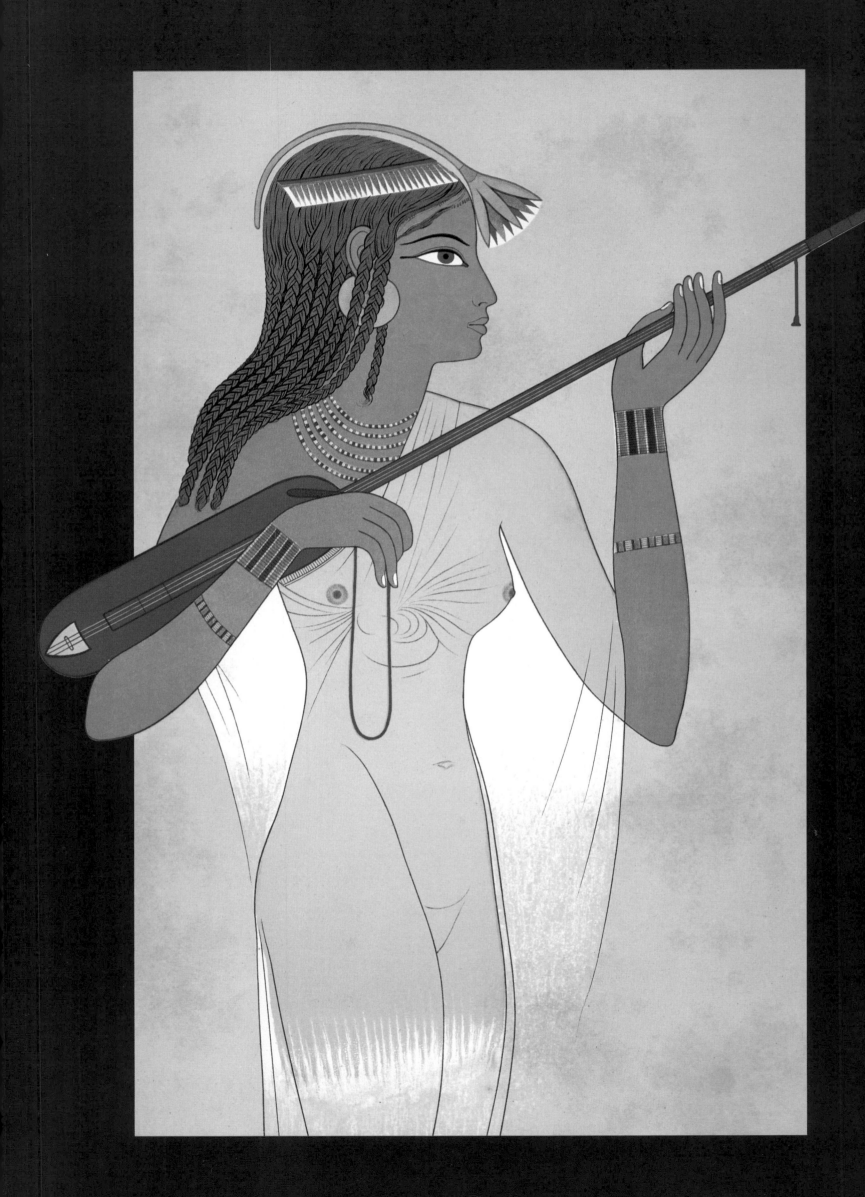

66

Although the position of this young womans left hand is slightly different than the original, other details of this figure from the tomb of Kenamen (TT 93), including the wisp of hair on her forehead, demonstrate Prisse d'Avennes keen sense of observation.

67 left

This scene, depicting a native of Punt, a land believed to have been somewhere on the horn of Africa, was copied in 1859. It is from the temple of the female pharaoh, Hatshepsut, which was partially uncovered at this time.

67 right

Like a number of scenes that Prisse copied during his residence in Thebes, this one was missing when he returned in 1859.

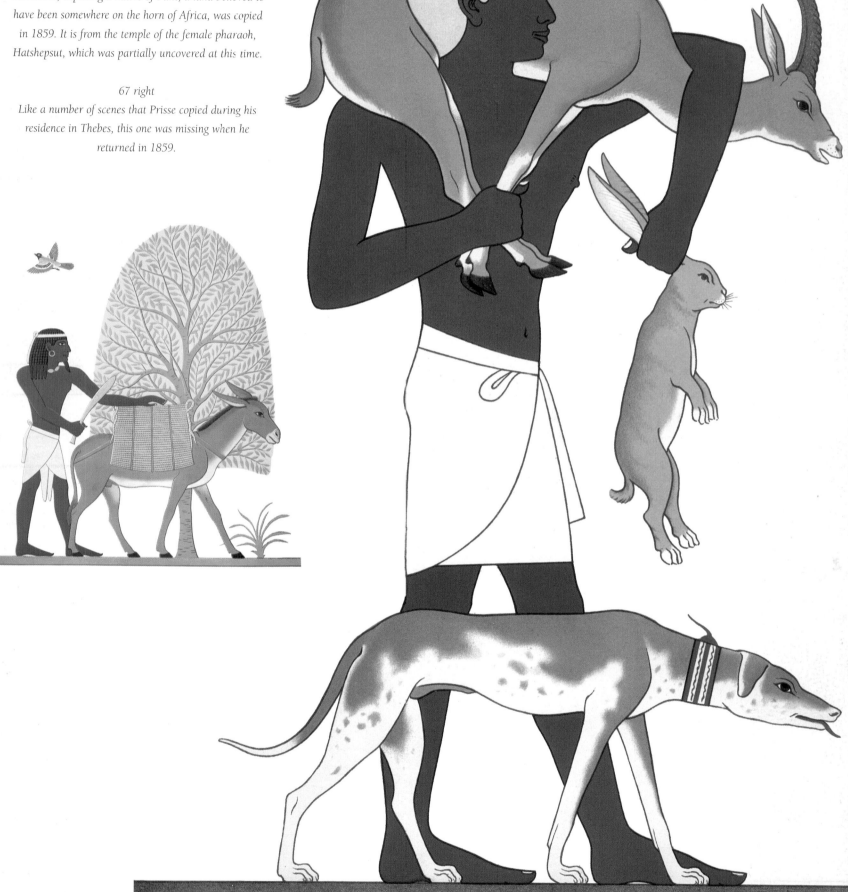

68 top
Queen Tyti was probably a daughter of Rameses III.
This image from her tomb in the Valley of the Queens
(QV 52) shows her wearing the vulture crown worn
by queens and goddesses.

68 bottom
These two offering bearers from an unknown Theban
tomb bring offerings of fruit and lotus flowers to the
deceased.

69
Even when Prisse copied this charming scene from the
tomb of Kenamen (TT 93), the head and front paws of
the dog were missing. This is indicated by the dotted
outline and the slightly different color. This unusual scene
shows the pharaoh, Amenhotep II, seated on the lap of
his nurse, Amenemopet, who was Kenamen's mother.

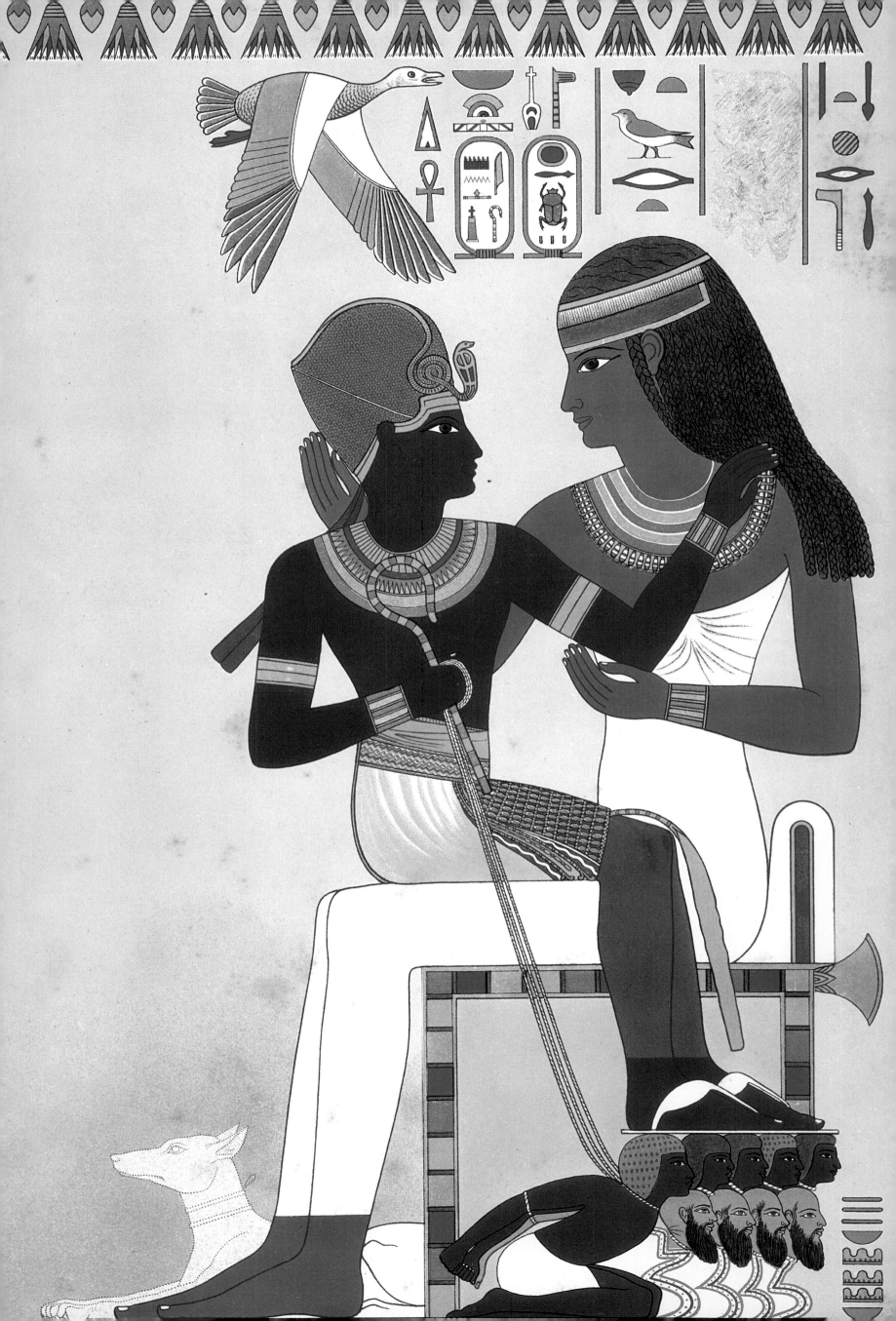

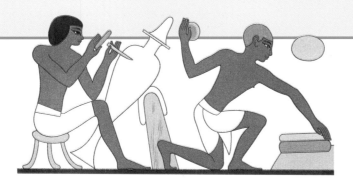

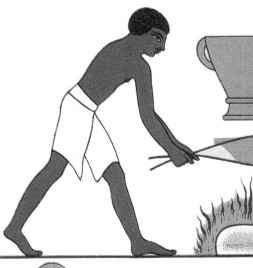

70 top and 71 bottom
These metalworkers from Rekhmire's tomb are making various types of vessels. Like Wilkinson, Prisse was careful to note differences in the dress and hairstyles of the figures.

70-71 top and bottom
These scenes of metal workers are from the tomb of Rekhmire (TT 100) who was vizier in the reign of Tuthmosis III. The men in the lower scene are casting a pair of doors from bronze imported from Retjenu, a land in western Asia.

71 center right
As vizier, Rekhmire was in charge of goods produced in various parts of Egypt and imported from abroad. Here, wine, papyrus, and oil are brought to be stored.

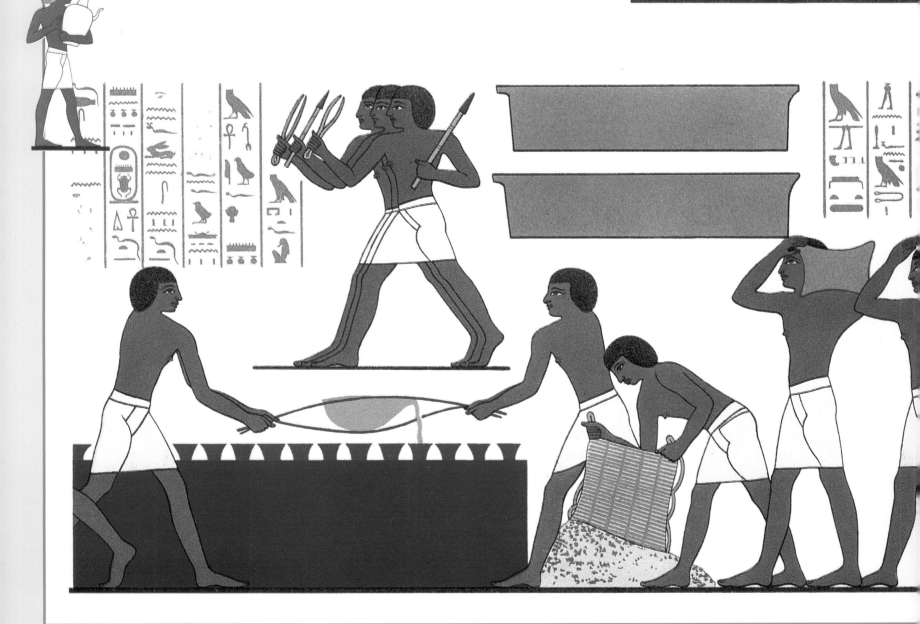

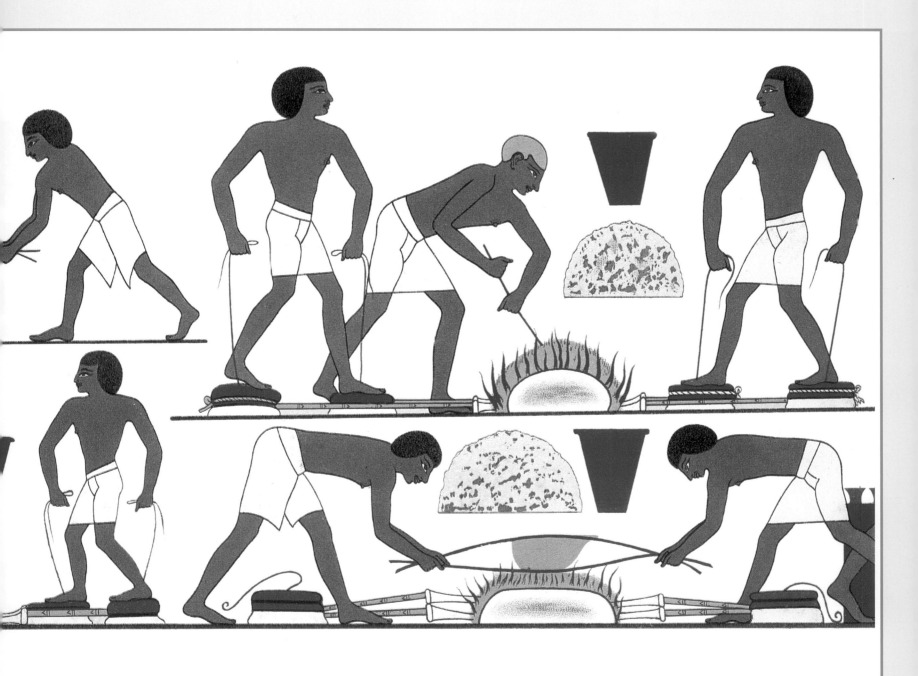

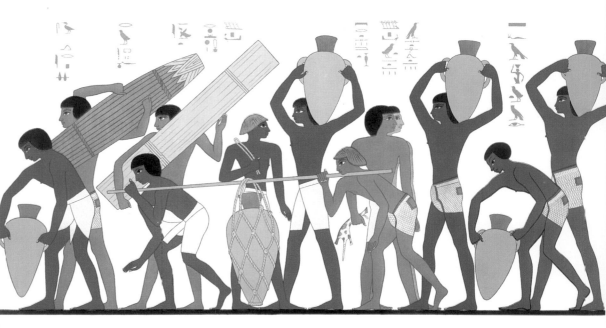

OWEN JONES

The son of a Welsh antiquarian, Owen Jones (1809-1874) was trained as an architect. At the age of 23, he set out on a journey through Greece, Turkey and Egypt, where he arrived in 1833. Jones traveled up the Nile as far as the second cataract, making sketches along the way. In 1843, he published *Views on the Nile from Cairo to the Second Cataract*, which included thirty lithographs made from his drawings.

Although Jones visited Egypt only once, his experience of the ancient monuments had a long lasting influence. In his most famous work, *The Grammar of Ornament*, published in 1856, he included nine plates showing multiple examples of ornamental patterns copied from wall paintings in tombs—many from Thebes. These included ceiling decoration, mat and textile patterns, border decorations, and floral patterns. Jones was also interested in the use of color and pattern in architecture: "The architecture of Egypt is thoroughly polychromatic—they painted everything; they dealt in flat tints and used neither shade nor shadow, yet found no difficulty in poetically conveying to the mind the identity of the object they desired to represent." To demonstrate this, he included two plates illustrating various types of column capitals, taking many of these from Theban temples."

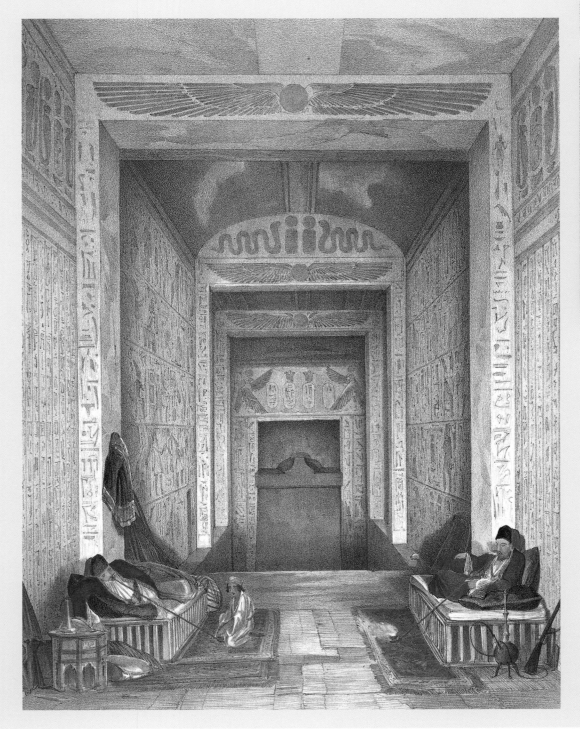

72

In the mid-nineteenth century, the tomb of Rameses IV, with its decorated walls and its huge, nearly complete granite sarcophagus, was one of the favorite stops for European travelers. The exotic figures smoking pipes are seated some distance from the tombs entrance. The brightness of the light on the successive door jambs and back wall of the burial chamber suggests early morning in the Valley of the Kings.

72-73

The pyramidal end of the Qurn, the highest point in western Thebes, dominates this view of the Valley of the Kings as seen in the early morning. The entrance of the tomb of Rameses IV, the second on the right as one enters the Valley is probably indicated by the flag at the right.

73 bottom

This unusual view of the Valley of the Kings in the mid-afternoon was drawn looking north from the branch of the wadi that contains the tombs of Seti II and Tausert/Setnakht, both of which were accessible in Jones's day.

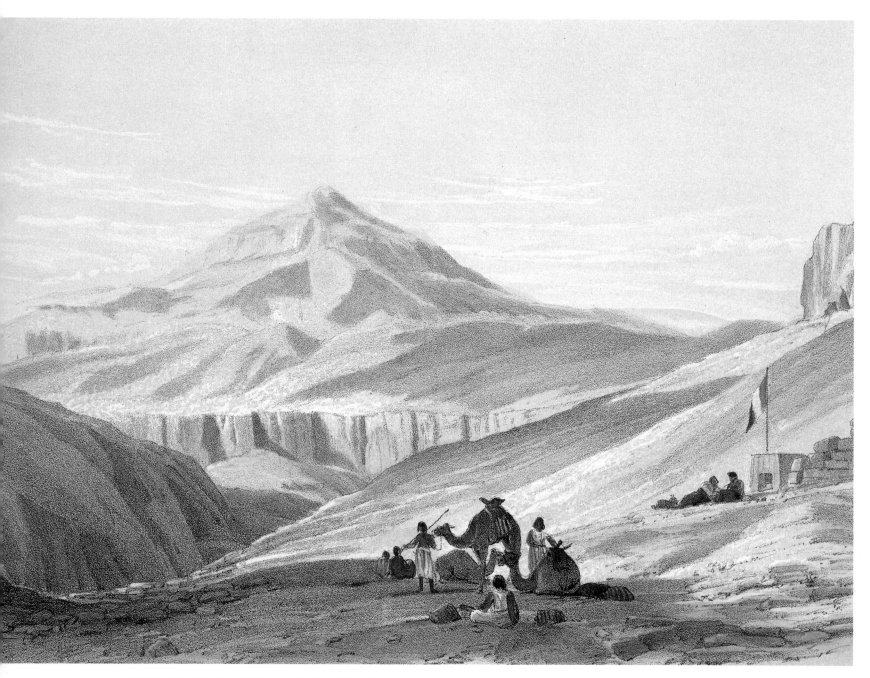

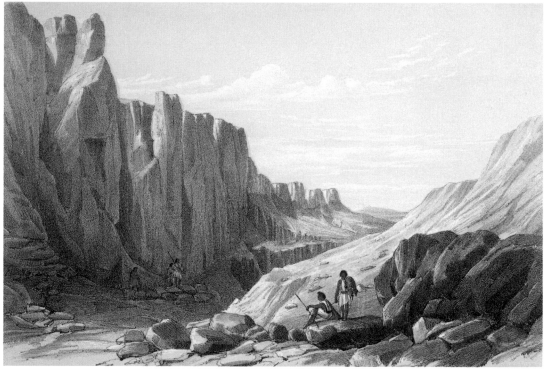

Jones's sketch of the Ptolemaic addition to Medinet Habu
shows the ruined entrance in the early morning sun.
As with most of his illustrations, Jones includes human
figures for scale and local color.

Like most European travelers, Jones visited the colossi of
Memnon at dawn. In the distance at the right is the
Ramesseum. Although he describes the faces of the
statues as "perfect wrecks," Jones thought them
beautifully executed, based on the areas that had been
protected from erosion.

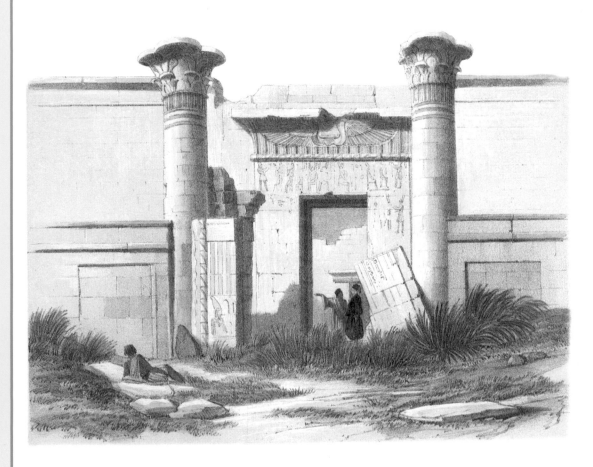

74-75
This view shows the Osiride pillars of the Ramesseum
in the late afternoon sun. At the far right, beyond the
fallen colossus, are the colossi of Memnon. At the left,
the spreading waters of the Nile flood approach the
temple ruins.

75 bottom
During his stay on the west bank, Jones visited Medinet
Habu, which he ranked "among the magnificent remains
of Thebes." In this interesting view, Jones includes some
of the mud-brick ruins of the Coptic town of Djeme,
which was constructed on and around the great
enclosure wall of the earlier pharaonic temple.

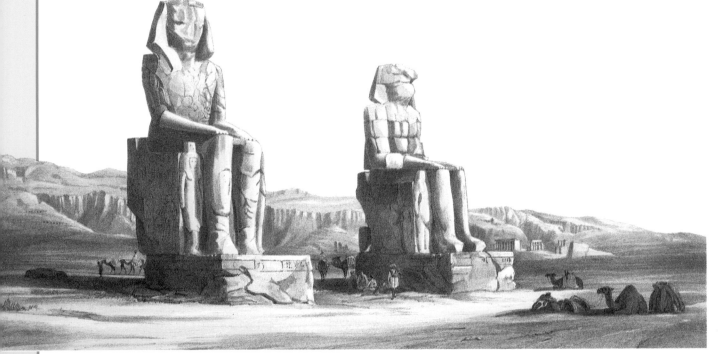

THE IMAGES REPRODUCED IN THIS
SECTION ARE TAKEN FROM *VIEWS
OF THE NILE FROM CAIRO TO THE
SECOND CATARACT*, BY OWEN JONES
(LONDON 1843).

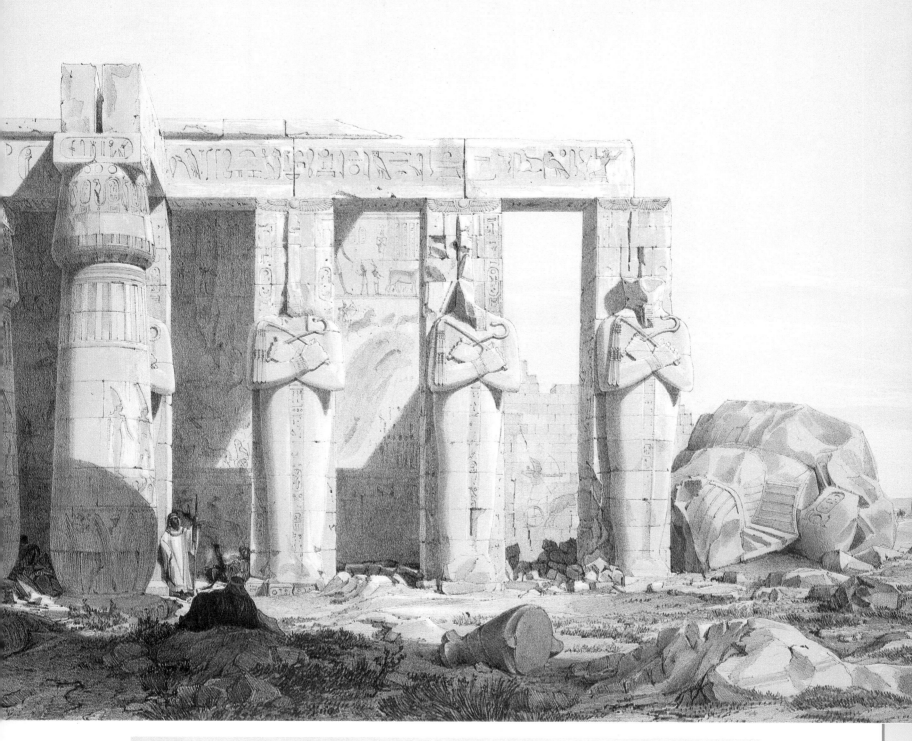

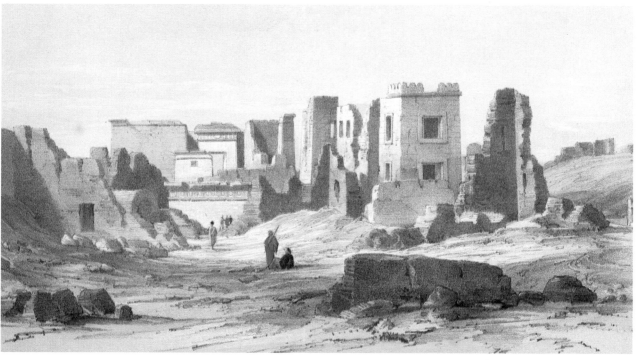

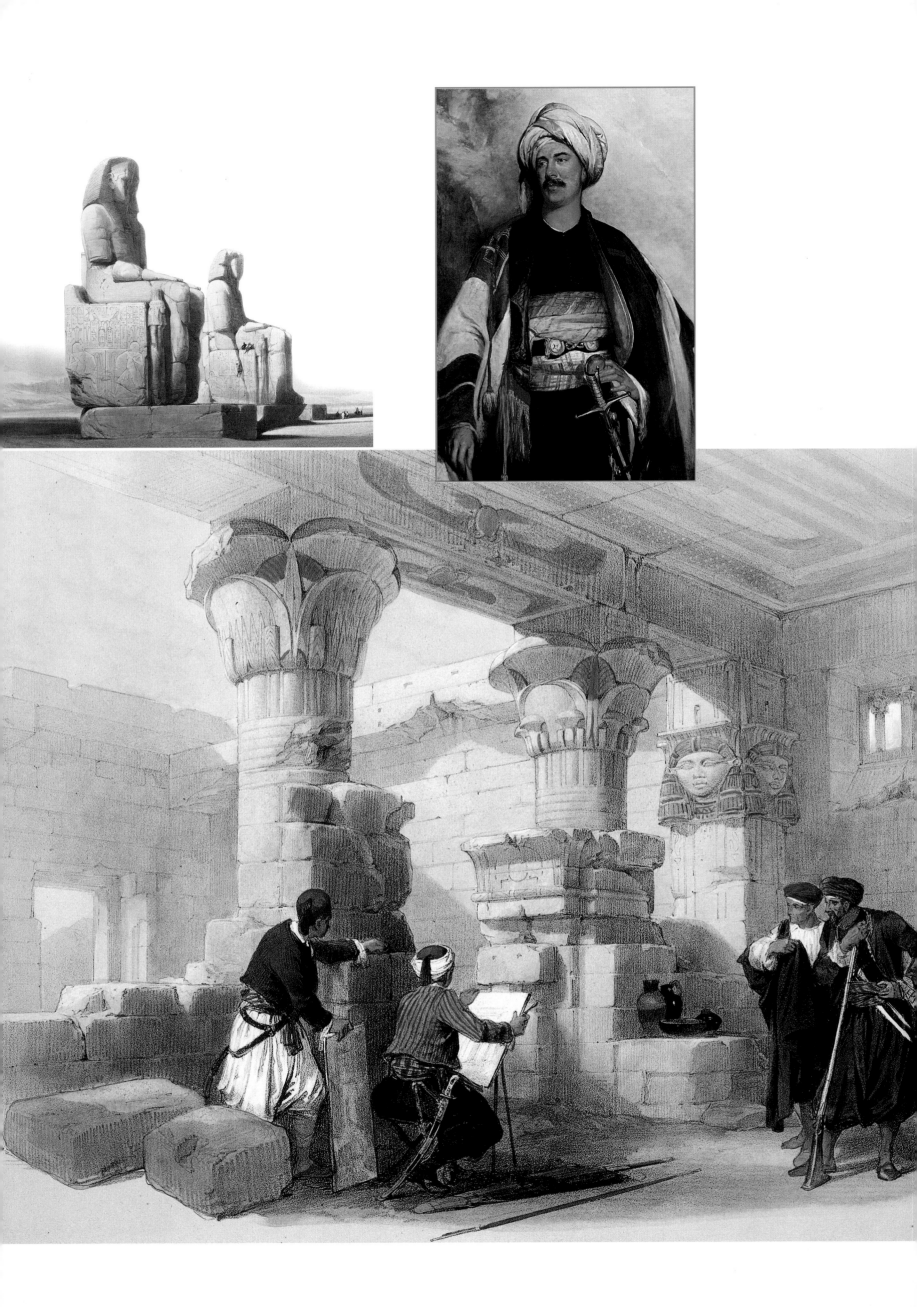

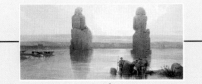

DAVID ROBERTS

In his early career, David Roberts (1796-1864) worked as a scene painter at the Royal Theater in Glasgow, later moving to London where he eventually gave up theatrical work to concentrate on his skills as an artist. His great passion was for architectural painting and he travelled extensively in Europe and North Africa, in order to expand his subject matter. His introduction to the Moorish architecture of Spain and Morocco inspired Roberts to plan a voyage to Egypt, Nubia, and the Holy Land. Arriving in

76 top left

Unlike his scholarly contemporaries, Roberts was interested in Egyptian monuments as works of art, not merely for the texts that they bore. This view of the colossi of Memnon is one of the few in which they are recognizable as ruined statues made in the time of Amenhotep III. For effect, Roberts has also made the statues far larger than they are in reality.

76 top right

The Scottish romantic painter David Roberts became justly famous for his lithographs of Egyptian and Near Eastern scenes. This portrait, by Robert Scott Laundler, was painted in 1840, shortly after Roberts returned from the east.

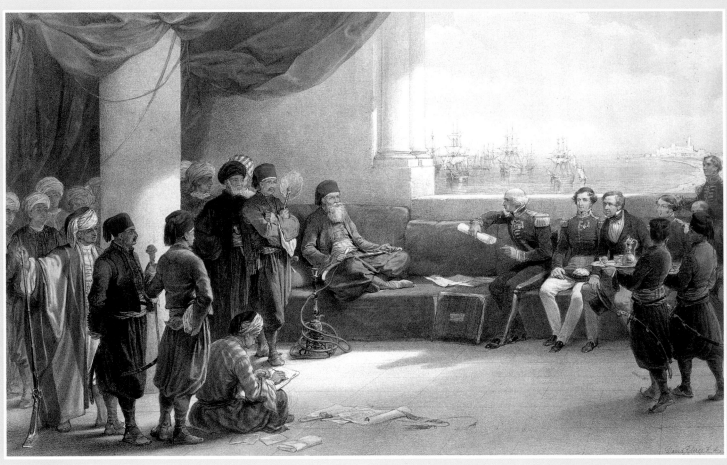

Alexandria in late September 1838, Roberts hired a boat for the journey up the Nile at the cost of thirteen Egyptian pounds. Roberts and his companions approached Thebes on October 21, but remained only three days before proceeding up the Nile as far as Abu Simbel. On the return trip, they stopped in Thebes for ten days, between November 26 and December 5.

Roberts was particularly impressed by the light in Egypt, commenting that the sunrises and sunsets were among the most glorious anywhere in the world. This is evident in his drawings, many of which were

76 bottom

Roberts adopted local dress during his travels in Egypt. Here, he shows himself sketching in the porch of the Ptolemaic temple near the village at Deir el-Medina.

77 top

In this view, the colossi of Memnon are set against the rising sun.

77 bottom

On May 12, 1839, Roberts was given an audience with Mohammed Ali, the Khedive (Viceroy) of Egypt. Roberts is the gentleman in civilian dress, sitting with his compatriots at the right. This scene, drawn from memory, is the frontispiece of his volume on the Islamic architecture of Egypt.

done in the rosy light of early morning and late afternoon. Among his greatest talents was his ability to choose the most striking vantage point for his subject—the back of the colossi of Memnon against sunrise; or the view of western Thebes from atop the colonnade of Luxor temple. Such choices make Roberts lithographs the most memorable to come from the Victorian Era. Unlike many European visitors, Roberts had not gone to Egypt to study and record the ancient monuments, or to collect antiquities. His purpose was to gather material for his own artistic endeavors. In his drawings of Egyptian scenes, he seeks to convey the contemporary atmosphere, rather than an exact documentation of the ancient structures, but his artists eye often captures more accurately the grandeur of a ruined temple, or the artistic style of a monumental statue than do the carefully measured drawings of his scholarly contemporaries.

After returning to London in 1839, Roberts prepared his drawings for publication in a series of six folio volumes. The majority of his Egyptian drawings appeared in three volumes containing 125 lithographs and entitled *Egypt and Nibia, from drawings made on the spot by David Roberts, R.A.* The first two volumes were dedicated to ancient Egyptian monuments and the third to Islamic monuments. These volumes, which appeared between 1846-1849, were a great success and published in two types. In the less expensive edition, the lithographs were printed in black, white and ocher, with one other color added in a few. The lithographs of the deluxe edition were hand painted with colors matching those in the original drawings. The colors used do not necessarily conform to reality, but were chosen for artistic effect.

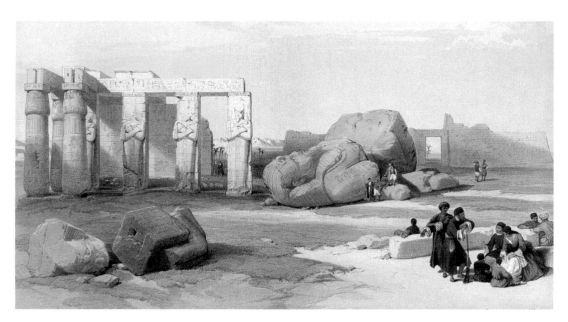

THE IMAGES REPRODUCED IN THIS SECTION ARE TAKEN FROM *EGYPT AND NUBIA*, BY DAVID ROBERTS (LONDON 1846-1849).

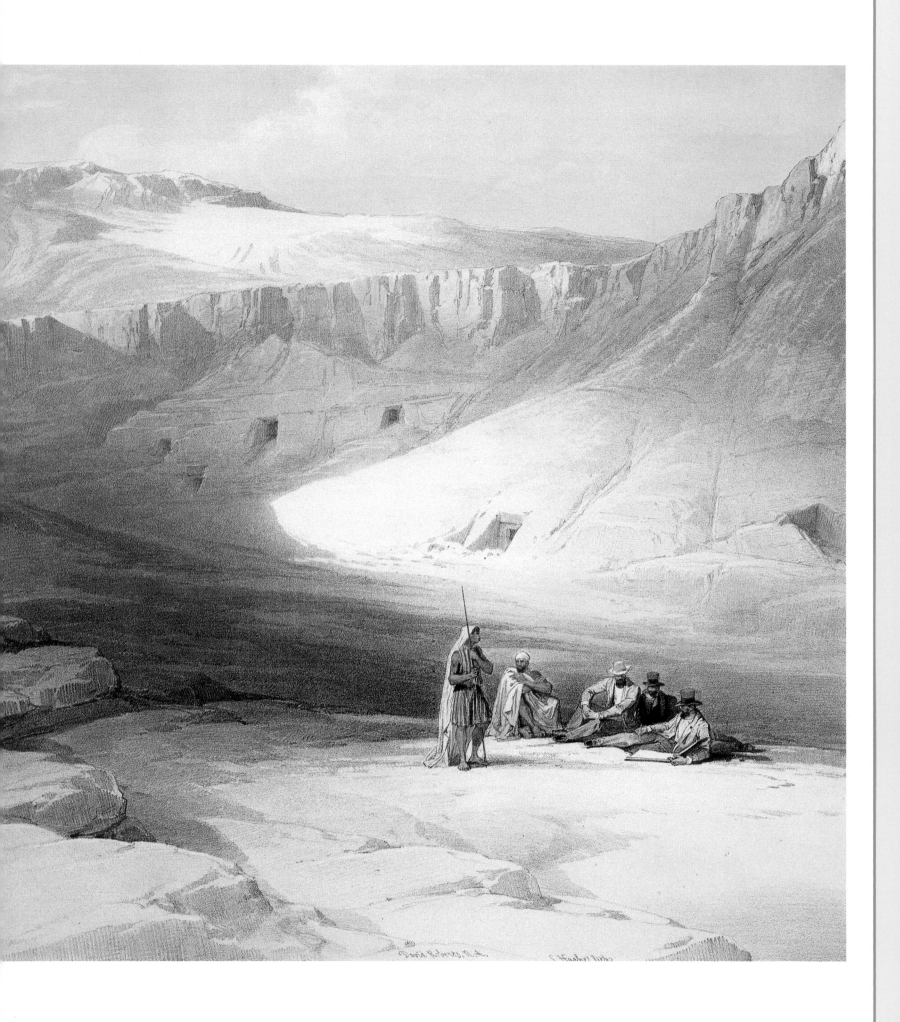

78 top
One of Roberts most famous paintings shows the great
fallen colossus of "Ozymandias" (Rameses II) at the
Ramesseum.

78 bottom
In his landscapes, Roberts made excellent use of unusual
vantage points. In this early morning scene, he has
climbed to the top of the colonnade at Luxor temple to
get the full view of the west bank. In the distance one
sees Medinet Habu at the left, the colossi of Memnon,
the Ramesseum in the center, and the temple of Seti I
at the far right.

78-79
This view of the Valley of the Kings, probably sketched
from atop the hill overlooking the tomb of Rameses VI
(above the standing man) gives an excellent impression
of the desolate landscape seen just after sunrise. It is not
particularly realistic, however, the tomb entrances
having been placed for artistic effect rather than
accuracy.

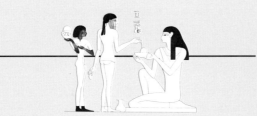

KARL RICHARD LEPSIUS

In 1842, King Friedrich Wilhelm IV of Prussia sponsored an expedition to Egypt for the purpose of documenting the ancient monuments and collecting antiquities for a new state museum to be built specially for the display of Egyptian art. The organizer of this great undertaking was Karl Richard Lepsius (1810-1884) who had just been appointed as temporary professor of Egyptology at the University of Berlin. Trained in Germany and later in France and Italy, where he studied with Ippolito Rosellini, Lepsius was a brilliant young scholar whose contributions to the

developing field of ancient Egyptian language studies earned him a reputation as the "German Champollion."

In preparation for the expedition, Lepsius gathered a group of scholars, artists, draftsmen, architects, and engravers. On a diplomatic level, the Prussian King contacted Mohammed Ali, the Khedive of Egypt, thus gaining almost *carte blanche* for the expedition's endeavors both in documentation and collection. Lepsius and his colleagues arrived in Egypt in September 1842. They worked for many months in the Old Kingdom cemeteries of Giza and Sakkara, and the Middle Kingdom sites not far south, none of which had been thoroughly explored or documented by previous expeditions.

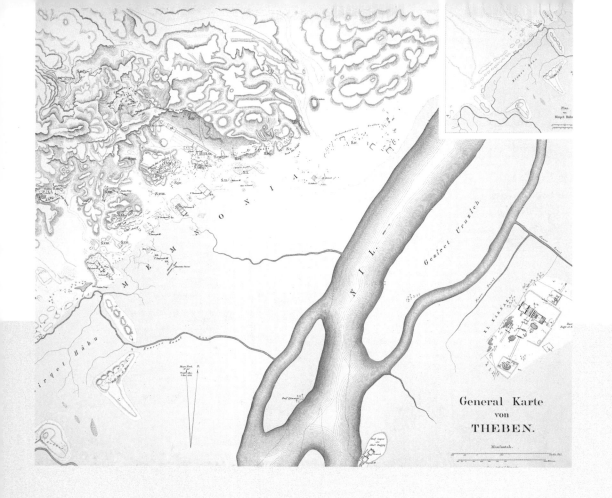

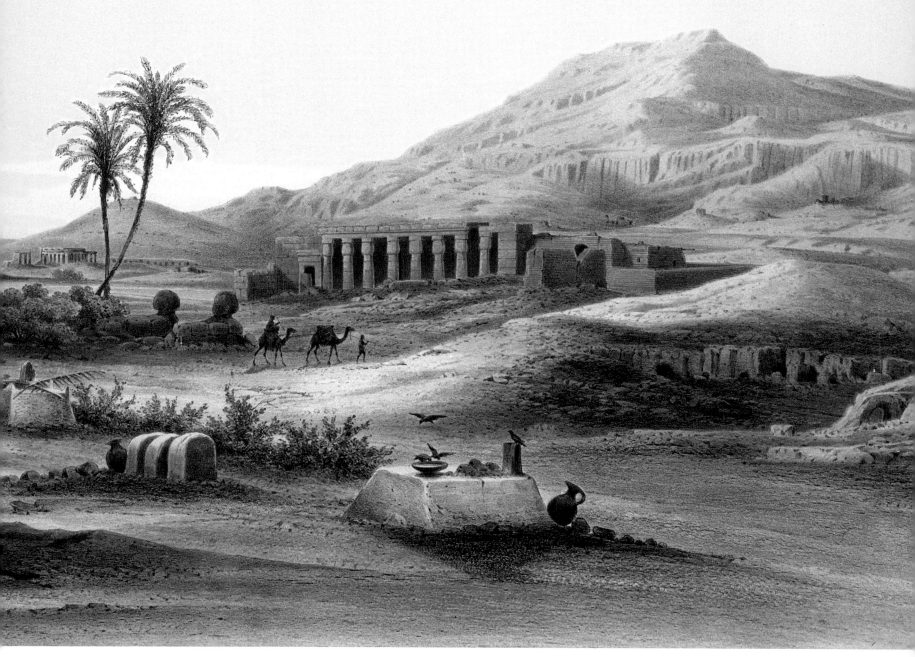

80 top
This copy of a vignette in the tomb of the vizier Rekhmire (TT 100) contains a number of errors.

80 bottom
Lepsius was a brilliant philologist who improved upon Champollions methods of translating ancient Egyptian and earned himself a reputation as the "German Champollion."

81 top
The map of Thebes printed in the Denkmäler improves on the one published by Wilkinson, adding new discoveries and more details. But it omits the limestone quarries at the northern end of western Thebes, and the avenue of sphinxes that connects the temples of Luxor and Karnak on the east bank, both of which were noted on Wilkinson's map.

80-81
This view of western Thebes was drawn from the area of Tarif looking toward the temple of Seti I, with the Qurn in the background. In the center distance is the Ramesseum, and to the left are the Colossi of Memnon surrounded by water from the Nile flood.

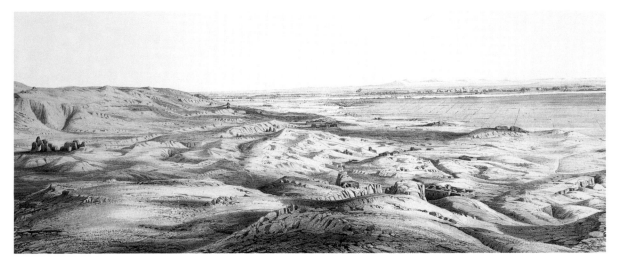

Lepsius finally moved his operations to Thebes in November 1844. After two years working in other parts of Egypt and in Nubia, Lepsius found Thebes inspirational, as he wrote in a letter dated Nov. 24: "Here, where the mighty pharaohs of the eighteenth and nineteenth dynasties meet me in all their splendor and magnificence, I feel once more as fresh as at the beginning of the journey." (trans. Underhill) Lepsius himself made a trip to Sinai early in 1845, but most of his colleagues remained at work in Thebes until he rejoined them in April.

Building on information gathered by previous scholars, particularly Champollion and Rosellini, but including John Gardner Wilkinson and others, the members of the Prussian team were able to accomplish a great deal of work in a relatively short amount of time. The expedition concentrated on architecture which Lepsius felt had been neglected by the Franco-Tuscan expedition. The precise plans and reconstructions of the ancient ruined temples that were made by Lepsius and his team are among the best ever produced, and their copies of texts are generally correct and easy to read, improving on those of their predecessors. This is partly because Lepsius perfected the technique of making paper molds (called squeezes) of the texts that were carved on stone. These exact copies could then be transferred to the appropriate drawings after the expedition returned to Berlin. However, with all their correctness, the texts, whether painted or carved, are reproduced in a standard hieroglyphic script that usually ignores differences in the writing styles among ancient scribes and artists. This is largely because Lepsius had gone to Egypt with a specific goal in mind, one that he states in a letter written from Thebes on February 25, 1845. "The great end which I have always had before my eyes, and for which I have principally made my selections, has been history. When I thought I had collected the

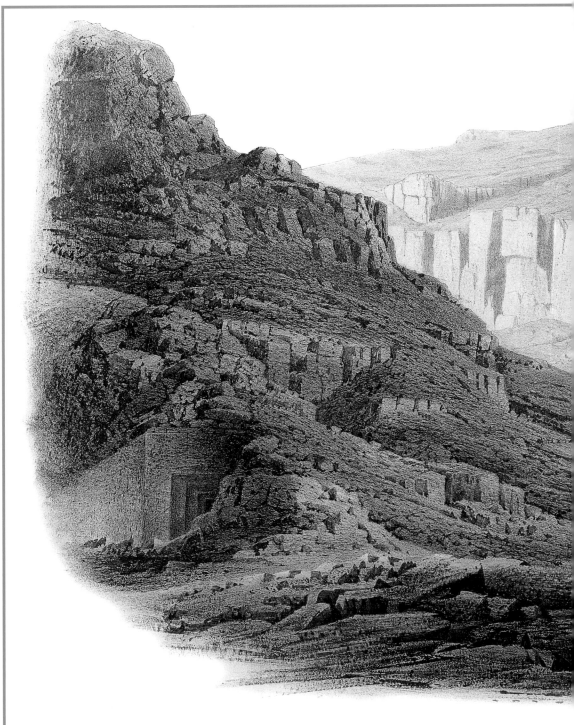

82-83 top

These two illustrations show a panoramic view from the top of Sheikh Abd el-Qurna hill facing east towards the Nile valley and the plain of western Thebes. From north (left) to south (right) one sees the remains of the mud-brick superstructure of the tomb of Montuemhat (Dynasty 26) in the valley known as Assasif (far left).

The Prussian headquarters is the building in the foreground of the second print (lower left), just below where the artist sat to do his drawings. Above this, at the edge of the desert is the Ramesseum, the Colossi of Memnon are visible in the cultivated fields, and Medinet Habu temple is at the far right. Karnak and Luxor temples are just visible in the distance on the east bank of the Nile.

82-83 center
This view of the Valley of the Kings seems to have been drawn from a point above the still unknown tomb of Tutankhamen. To the right is the entrance of the tomb of Rameses VI (KV 9); to the left is probably the tomb of Amenmesse (KV 10), or perhaps the tomb of Rameses III (KV 11); in the distance, beyond the people, is the tomb of Tausert/Setnakht (KV 14).

83 bottom
This drawing shows the view looking west, across the top of Sheikh Abd el-Qurna hill toward the Qurn, the highest point on the west bank.

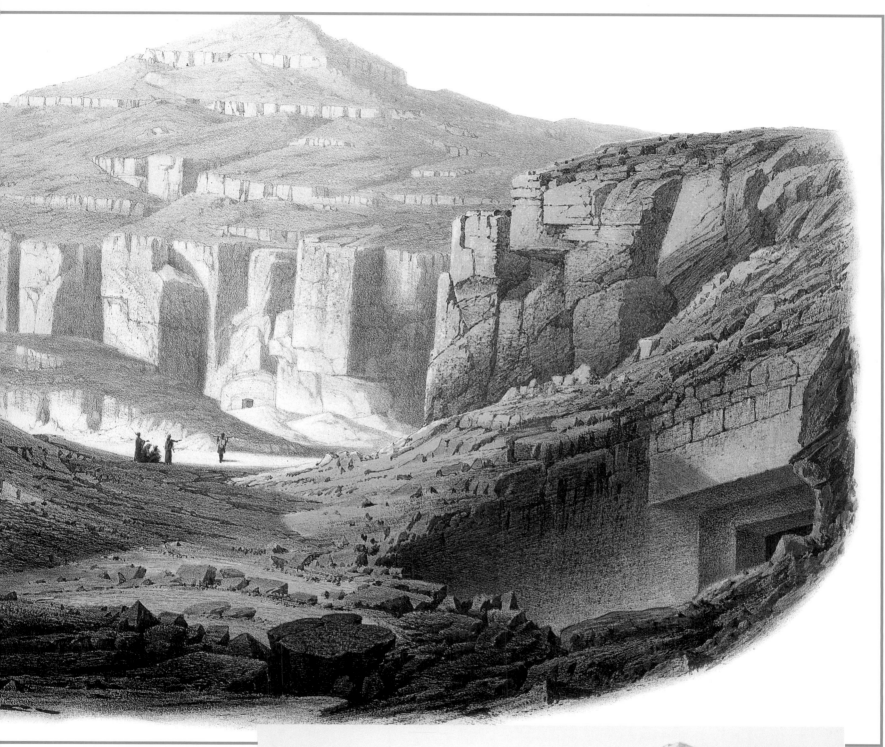

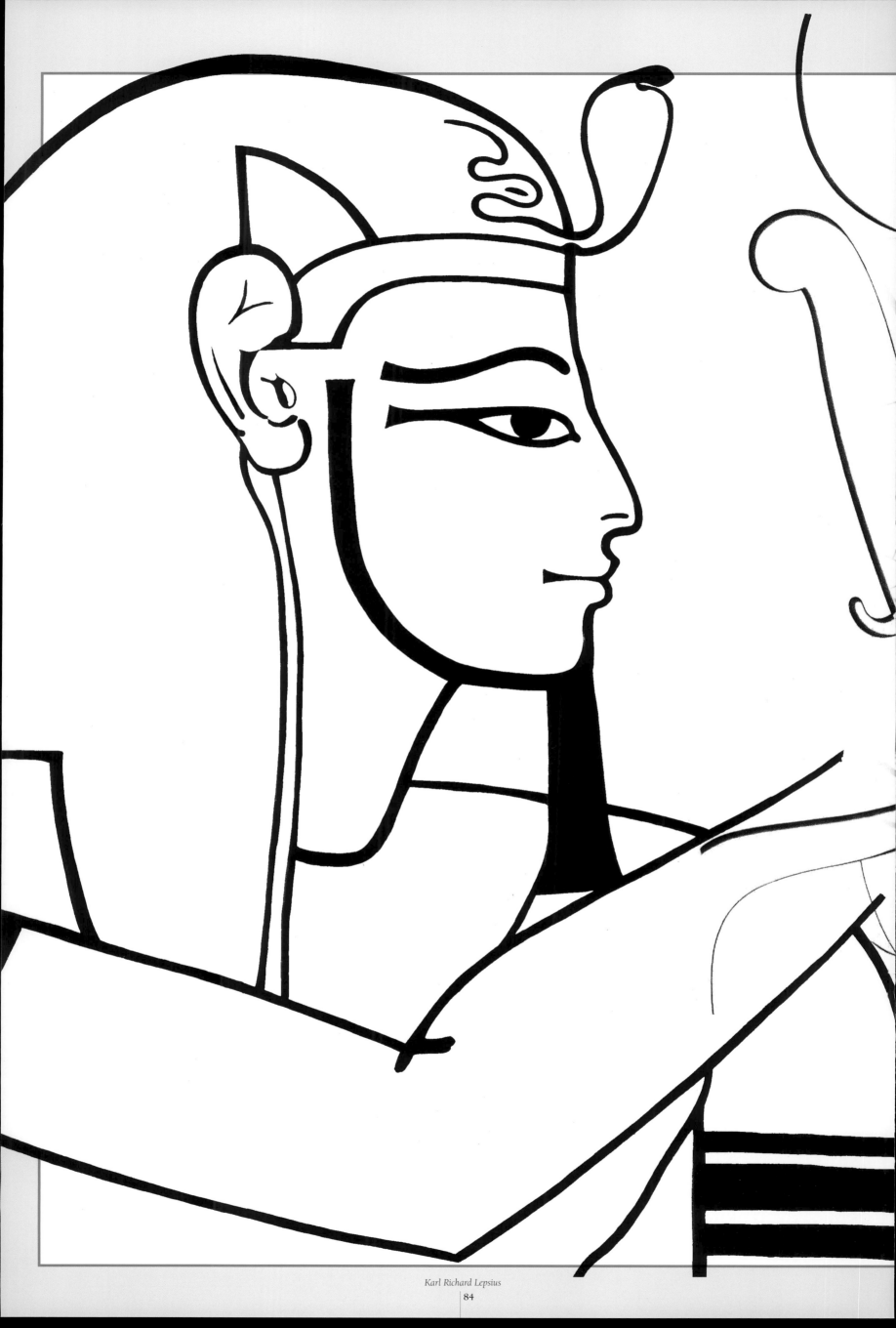

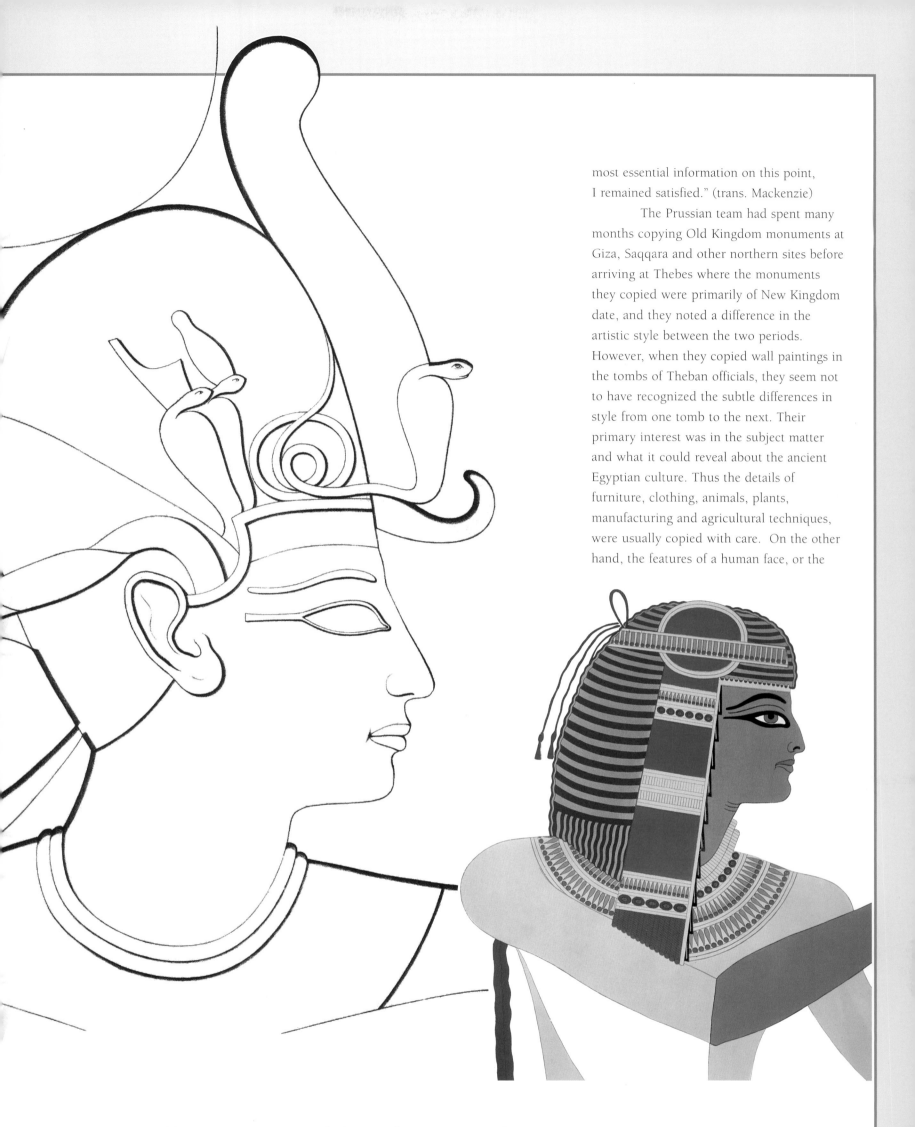

most essential information on this point, I remained satisfied." (trans. Mackenzie)

The Prussian team had spent many months copying Old Kingdom monuments at Giza, Saqqara and other northern sites before arriving at Thebes where the monuments they copied were primarily of New Kingdom date, and they noted a difference in the artistic style between the two periods. However, when they copied wall paintings in the tombs of Theban officials, they seem not to have recognized the subtle differences in style from one tomb to the next. Their primary interest was in the subject matter and what it could reveal about the ancient Egyptian culture. Thus the details of furniture, clothing, animals, plants, manufacturing and agricultural techniques, were usually copied with care. On the other hand, the features of a human face, or the

84 and 85
Some of the best copies made by the Prussian expedition were a group of drawings illustrating individual figures from tombs in the Valley of the Kings. The drawing on the left copies an outlined figure of the pharaoh Setnakht on a pillar in the burial chamber of Tausert in KV 14, which Setnakht extended for his own use.

The drawing at the center is a portrait of Rameses III that was carved in sunk relief near the entrance of his tomb, KV 11. The figure on the right depicts Prince Montuherkhepshef. It is an excellent copy of one of the representations KV 19—one of the tombs discovered by Giovanni Belzoni more than 25 years before the Prussian expedition worked in the Valley.

exact position of a hand or foot were often drawn incorrectly, either because these details didnt matter, or because they were unnoticed by the nineteenth century copyist. In a few exceptional cases, however, individual representations were treated as true works of art. There are a number of plates in which a specific figure, usually a king, has been copied with great care. These drawings were done on a 1:1 scale and are near facsimiles of the originals.

After three years in Egypt, the Prussian expedition returned with a wealth of information in drawings, watercolors, squeezes of inscriptions, and notes. They also arrived with some fifteen hundred antiquities that form a significant part of the collections of the Egyptian Museum in Berlin. In the report he made to the ministry after returning to Berlin in January of 1846, Lepsius compared his own efforts with the earlier Franco-Tuscan expedition: "The expedition most immediately comparable with ours was Champollions, but that was more a voyage of discovery, and necessarily suffered from the very deficiencies which we were easily able to supply. The advantages which he had as founder of the science and from his incomparable ability as a student of monuments, were for us more than counterbalanced by the firmer and broader foundations of the science... Added to this was our greater previous knowledge of the interesting localities which we had to investigate." (trans. Underhill)

The scholarly results of the expedition were published in the truly monumental *Denkmäler aus Ägypten und Äthiopien*. This eventually included twelve huge volumes of plates that appeared between 1849-1859. More than a decade after Lepsius died, five volumes of notes on the illustrations were finally published between 1897 and 1913.

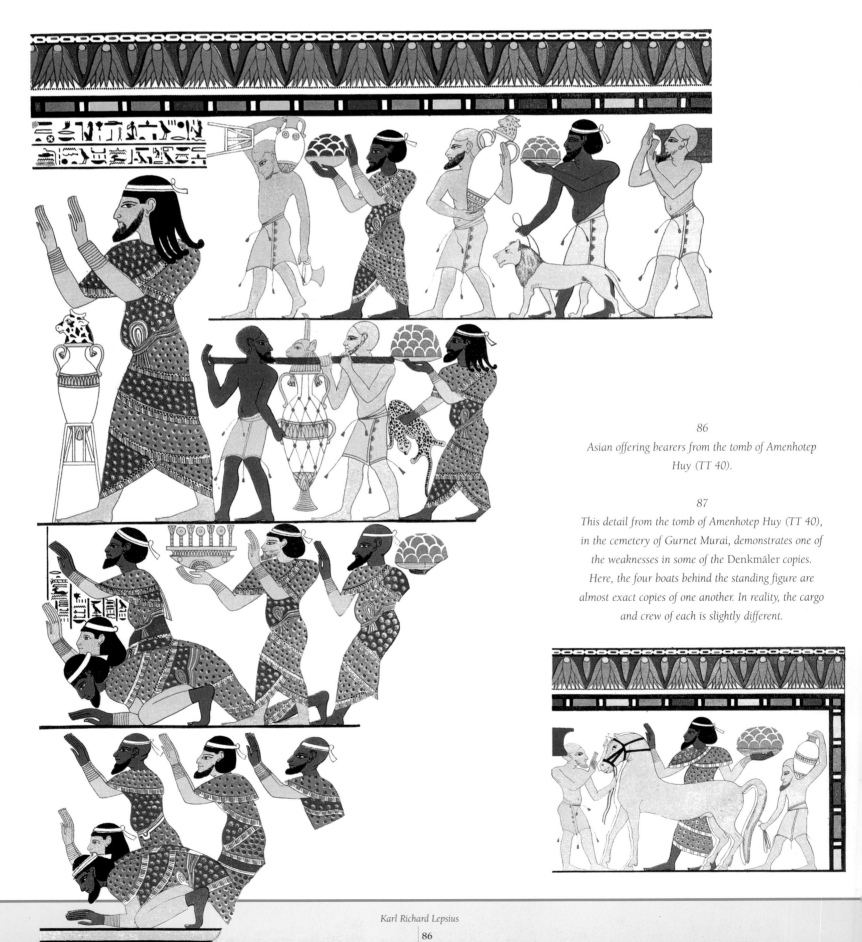

86
Asian offering bearers from the tomb of Amenhotep Huy (TT 40).

87
This detail from the tomb of Amenhotep Huy (TT 40), in the cemetery of Gurnet Murai, demonstrates one of the weaknesses in some of the Denkmäler copies. Here, the four boats behind the standing figure are almost exact copies of one another. In reality, the cargo and crew of each is slightly different.

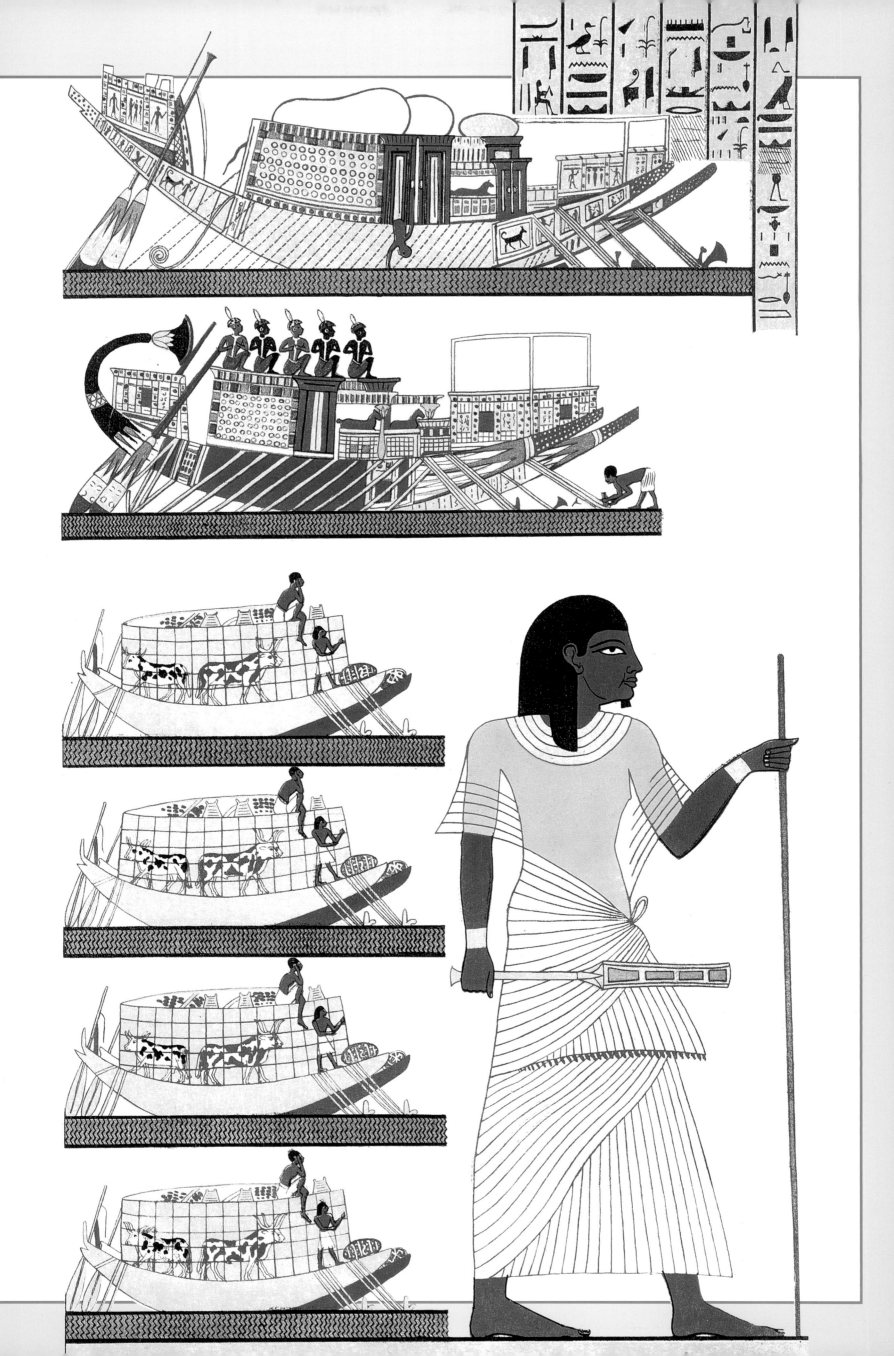

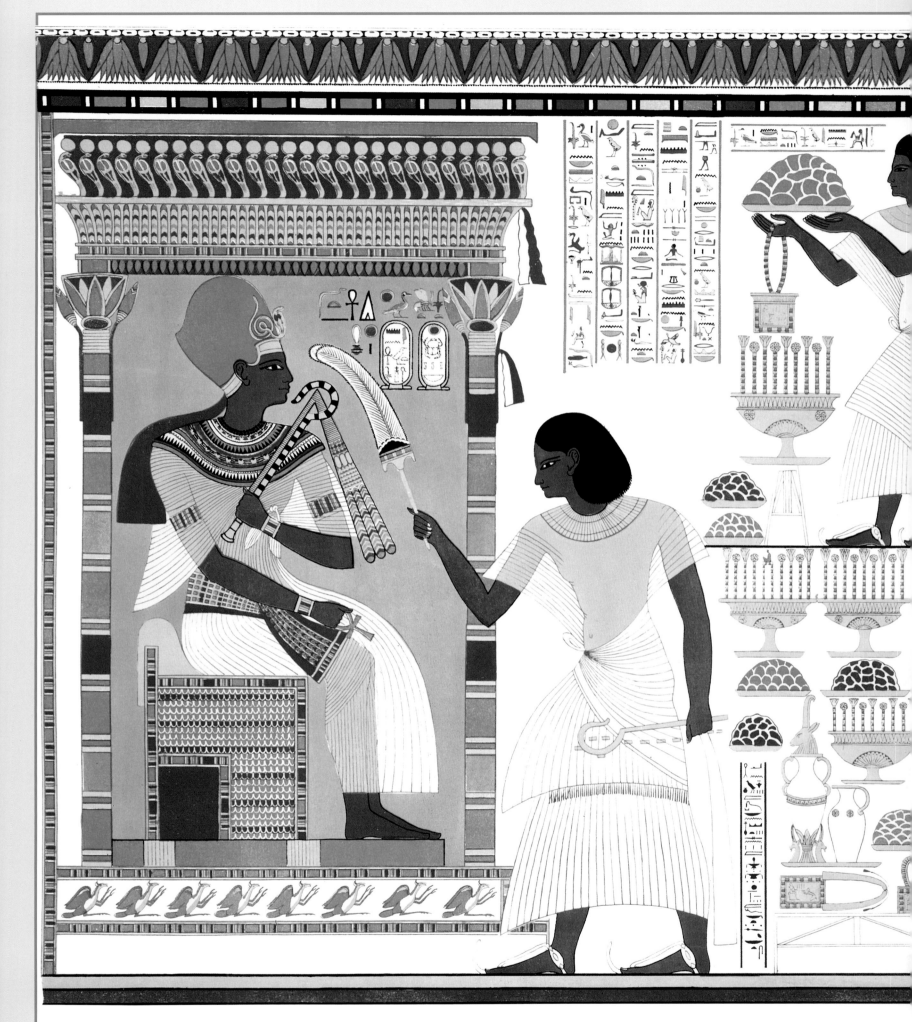

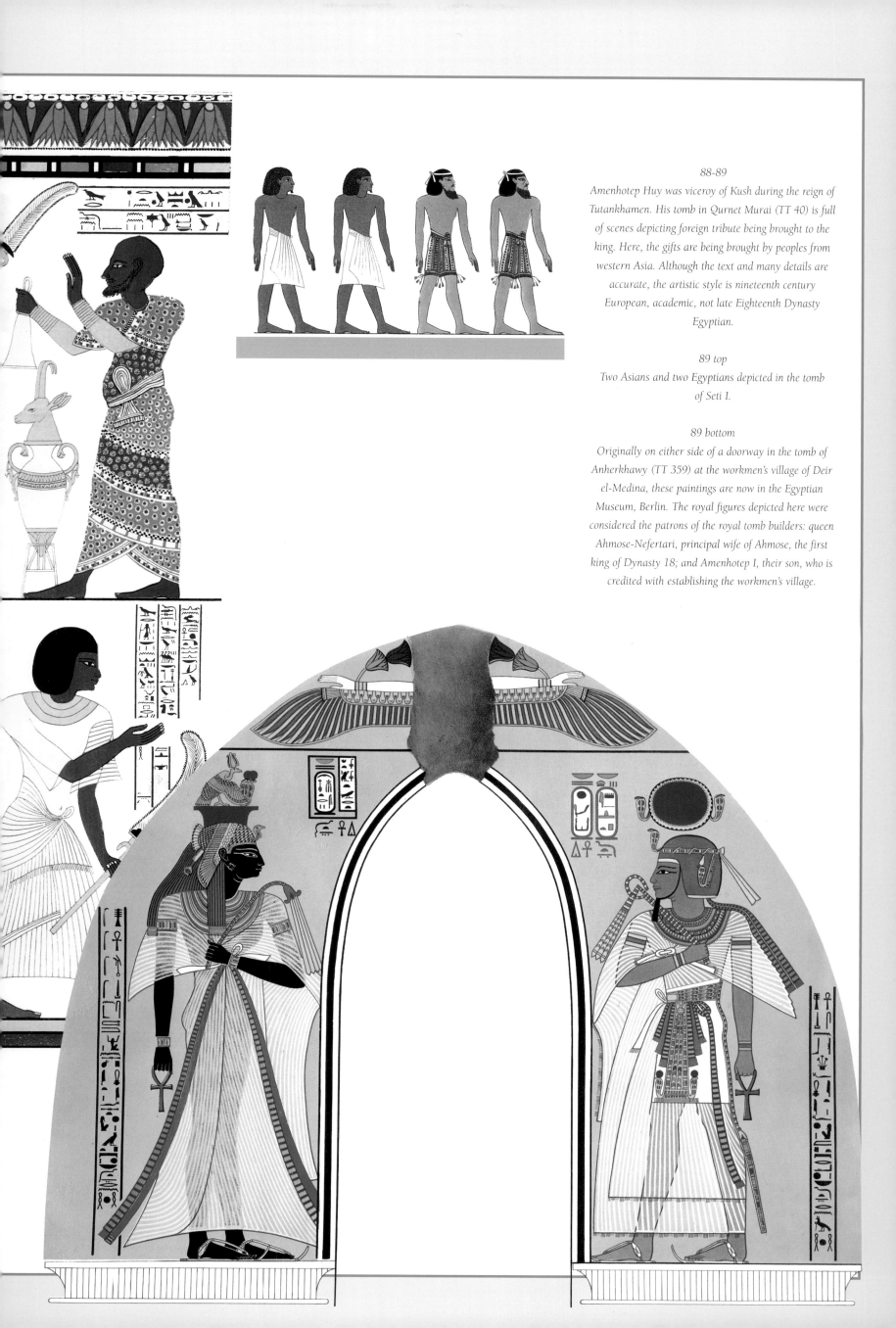

88-89

Amenhotep Huy was viceroy of Kush during the reign of Tutankhamen. His tomb in Qurnet Murai (TT 40) is full of scenes depicting foreign tribute being brought to the king. Here, the gifts are being brought by peoples from western Asia. Although the text and many details are accurate, the artistic style is nineteenth century European, academic, not late Eighteenth Dynasty Egyptian.

89 top

Two Asians and two Egyptians depicted in the tomb of Seti I.

89 bottom

Originally on either side of a doorway in the tomb of Anherkhawy (TT 359) at the workmen's village of Deir el-Medina, these paintings are now in the Egyptian Museum, Berlin. The royal figures depicted here were considered the patrons of the royal tomb builders: queen Ahmose-Nefertari, principal wife of Ahmose, the first king of Dynasty 18; and Amenhotep I, their son, who is credited with establishing the workmen's village.

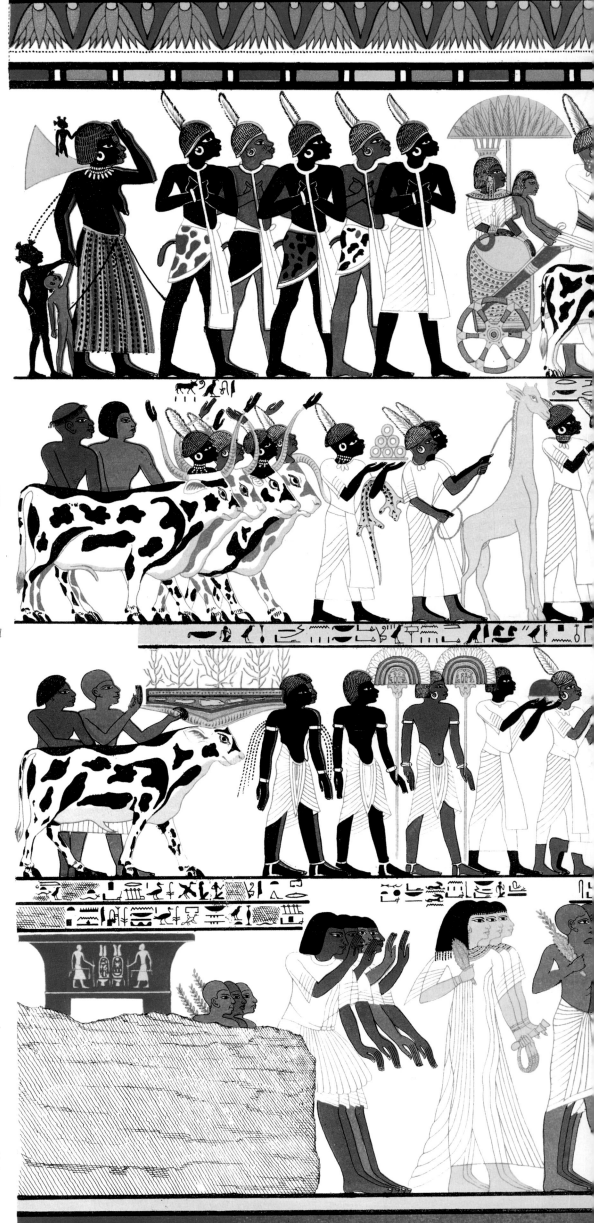

90 left
Two Nubians from the tomb of Seti I.

90-91
Parts of this scene in the tomb of Amenhotep Huy (TT 40) were copied by both the Prussian expedition and by Prisse d'Avennes. A comparison shows that, while Lepsius and his colleagues copied the texts and many details with a standardized accuracy, Prisse was able capture the style of the ancient artists.

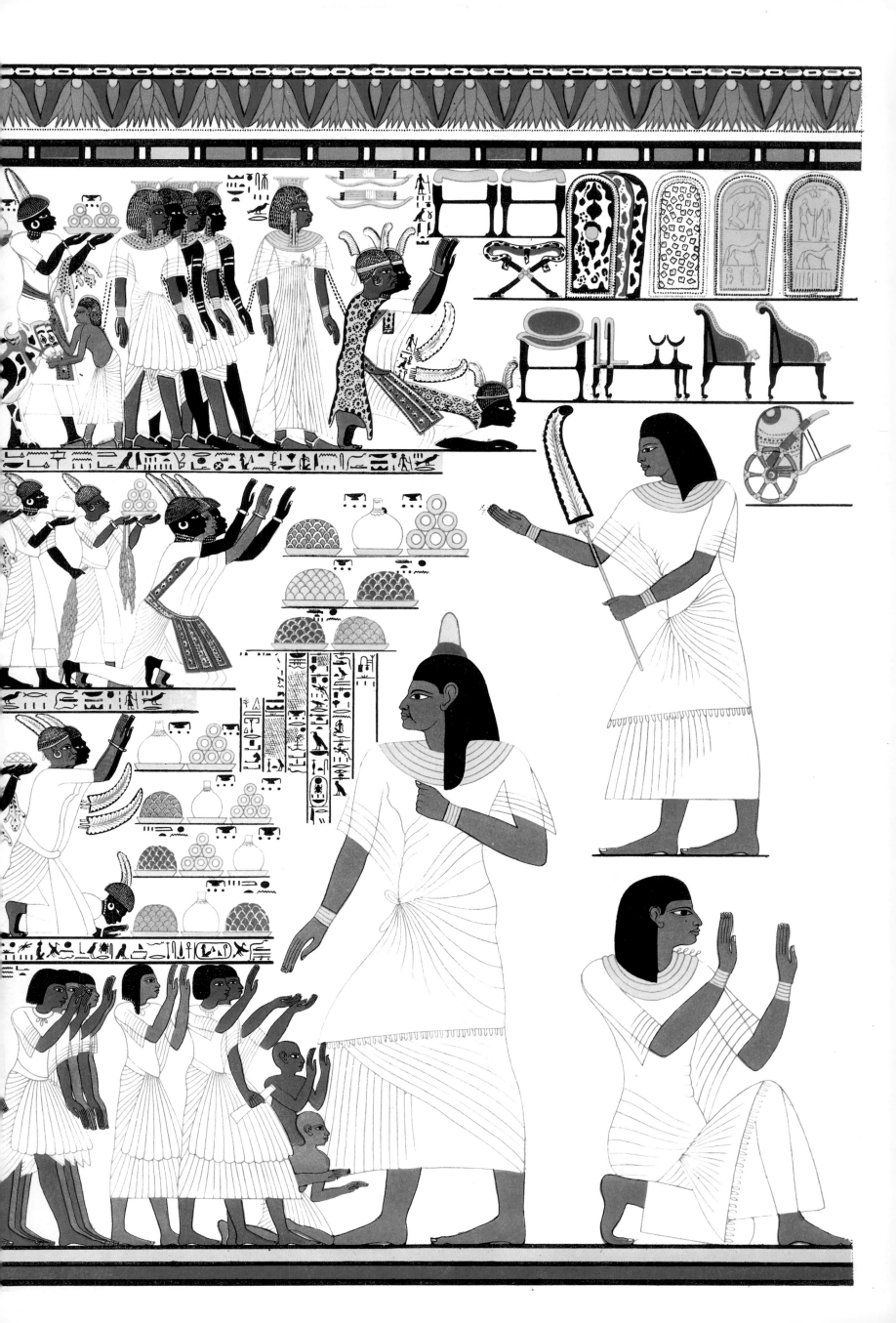

WILLIAM HENRY BARTLETT

Apprenticed to an architect at age fourteen, William Henry Bartlett (1809-1854) worked as an architectural illustrator for a number of years before beginning his travels, which took him around Europe, America, Turkey and the Near East. In June of 1845, he arrived in Alexandria, just as Richard Lepsius and his expedition were finishing their three years of work in Egypt and Nubia. Bartlett had prepared himself well and was aware of Lepsius's work, but his principal references to the monuments of ancient Egypt were the works of John Gardner Wilkinson, especially *A Handbook for Egypt,* published in 1847.

Having visited Alexandria and sites around Cairo, Bartlett set off up the Nile. Arriving at Thebes at noon on a brilliant summer day, he was at first disappointed by the huge expanse of space separating the various ruins, and thus diminishing their impact in his view. "The only grand feature was the lofty barren mountain of yellow sandstone overhanging the western quarter of the city, with the dark orifices of its countless tombs, and which seemed to reverberate the ardent rays of the vertical sun." But, in the end, he was impressed by the antiquities, and the largest portion of his travel journal is taken up with descriptions of the sites in western Thebes.

After his visit to the Valley of the Kings, Bartlett followed the path that leads out of the desert wadi and onto the cliffs that overlook the valley of the Nile. In *The Nile Boat*, an account of his travels which was published in 1849, he described this view of the site where the ancient city of Thebes once flourished: "It is, indeed, marked by nature for a great capital;—a grand valley many miles in width, divided by the Nile—defended on the west by the craggy range of mountains we stood upon, and on the east by the far distant hills on the Arabian side;—a mighty area, strewn for miles with the scattered remains of former magnificence..."

In the introduction to his book, Bartlett comments on the plethora of similar publications "To add another book on Egypt... may almost appear like a piece of presumption. But it should be remarked, that besides the army of erudite 'savans' who have enlisted themselves in the study of its antiquities, there has always been a flying corps of light-armed skirmishers, who...busy themselves chiefly

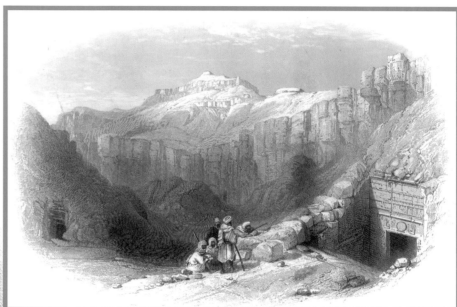

92 bottom
This view of Medinet Habu shows the Ramesseum in the center distance, and the Colossi of Memnon, reflected in the flood waters of the Nile at the far right.

93 top
This view of the Valley of the Kings was drawn from the same vantage point as that recorded by the Prussian expedition. At the right is the entrance of KV 9 (Ramesses VI). As with many of his illustrations, Bartlett includes contemporary Egyptians to give scale and set the scene.

93 bottom
In this rather wide-angle view of the Nile valley from the western cliffs, Bartlett has included all of the principal Theban sites: Karnak and Luxor temples on the distant east bank, and the Ramesseum, Colossi of Memnon, and Medinet Habu on the western plain.

THE IMAGES REPRODUCED IN THIS SECTION ARE TAKEN FROM *THE NILE BOAT*, BY WILLIAM HENRY BARTLETT (LONDON 1850).

with the picturesque aspect; who aim at giving lively impressions of actual sights, and at thus creating an interest which may lead the reader to a further investigation of the subject...Of this slight texture is the composition of the present volume."

Bartlett's book contains about 50 marvelous etchings made from drawings he had done on the spot, many with the Camera Lucida. These evocative illustrations are usually described in great detail in the accompanying text, and it would have been a shame had he not added this volume to the other nineteenth century accounts of travel in Egypt.

BIBLIOGRAPHY

ATHANASI, Giovanni d'(1798-1854), *Researches and Discoveries in Upper Egypt made under the direction of Henry Salt Esq.*, London, 1836.
BANKES, William John (1786-1855), *Geometrical elevation of an Obelisk… from the Island of Philae, together with the pedestal… first discovered there by W.J.B.*, London, 1821.
BARTLETT, William Henry (1809-1854), *The Nile Boat*, London 1850.
BELZONI, Giovanni Battista (1778-1823):
– *Narrative of the Operations and Recent Discoveries within the Pyramids, Temples, Tombs, and Excavations, in Egypt and Nubia; and a Journey to the Coast of the Red Sea, in search of the ancient Berenice; and another to the Oasis of Jupiter Ammon*, London, 1820.
– *Forty-four Plates illustrative of the Researches and Operations of Belzoni in Egypt and Nubia*, London, 1820.
– *Hieroglyphics found in the Tomb of Psammis discovered by G. Belzoni*, London, 1822.
BIEBRIER, Morris, *Who was Who in Egyptology*, third revised edition. The Egypt Exploration Society, London (1995).
BOURGUIGNON D'ANVILLE, Jean-Baptiste (1697-1782), *Mémoire sur l'Égypte ancienne et moderne suivi d'une description du Golfe Arabique ou de la Mer Rouge*, Paris, 1766.
BRUCE, James (1730-1794):
– *Travels to Discover the Source of the Nile on the years 1768, 1769, 1770, 1771, 1772 and 1773.* Edinburgh, 1790.
– *Voyage en Nubie et Abyssinie (1768-1773) traduit par J. Castera*, Paris, 1790-1792.
CAILLIAUD, Frédéric (1787-1869):
– *Voyage à l'oasis de Thèbes et dans les déserts situés à l'orient et à l'occident de la Thébaïde fait pendant les années 1815, 1816, 1817 et 1818*, Paris, 1821.
– *Recherches sur les Arts et Métiers, les usages de la vie civile et domestique des Anciens Peuples de l'Égypte, de la Nubie et de l'Éthiopie, suivies de détails sur les moeurs des peuples modernes de ces contrées*, Paris, 1831.
CHAMPOLLION, Jean-François (1790-1832):
– *Introduction à l'Égypte sous les Pharaons*, Paris, 1811.
– *L'Égypte sous les Pharaons ou Recherches sur la géographie, la religion, la langue, les écritures et l'histoire de l'Égypte avant l'invasion de Cambyse*, Paris, 1814.
– *De l'écriture hiératique des anciens Égyptiens*, Paris, 1821.
– *Lettre à M. Dacier…*, Paris, 1822.
– *Panthéon égyptien. Collection des personnages mythologiques de l'ancienne Égypte*, Paris, 1823.
– *Précis du système hiéroglyphique des anciens Égyptiens ou Recherches sur les éléments premiers de cette écriture sacrée, sur leurs diverses combinaisons et sur les rapports de ce système avec les autres méthodes graphiques égyptiennes avec un volume de planches*, Paris, 1824.
– *Précis du système hiéroglyphique augmenté de la lettre à M. Dacier*, Paris, 1824.
– *Lettres à M. le duc de Blacas d'Aulps, relatives au Musée royal égyptien de Turin*, Paris, 1824-1826.
– *Précis du système hiéroglyphique des anciens Égyptiens ou Recherches sur les éléments premiers de cette écriture sacrée,…*, Paris, 1827-1828.
– *Notice descriptive des momuments égyptiens du Musée Charles X*, Paris, 1827.
– *Lettres écrites de l'Égypte et de Nubie en 1828 et 1829*, Paris, 1833.
– *Monuments de l'Égypte et de la Nubie d'après les dessins exécutés sur les lieux, sous la direction de Champollion le Jeune*, Paris, 1835-47, edizione postuma.
– *Grammaire égyptienne, ou Principes généraux de l'écriture sacrée égyptienne appliqués à la représentation de la langue parlée*, Paris, 1836.
– *Grammaire égyptienne, ou Principes généraux de l'écriture sacrée égyptienne appliqués à la représentation de la langue parlée. Publié sur le manuscrit autographe*, Paris, 1836-41, edizione postuma.
– *Dictionnaire égyptien en écriture hiéroglyphe, publié par Champollion-Figeac d'après les manuscrits autographes; dessiné et tiré par Jules Feuquières*, Paris, 1841-44, edizione postuma.
– *Notices descriptives conformes aux notices autographes rédigées sur les lieux par Champollion le Jeune*, 2 voll., Paris, 1844-89, postumous edition.
CHAMPOLLION-FIGEAC, Jacques-Joseph (1778-1867):
– *Lettre à M. Fourier sur l'inscription grecque du temple de Denderah en Égypte*, Paris, 1806.
– *Annales des Lagides, ou Chronologie des rois grecs d'Égypte successeurs d'Alexandre le Grand*, Paris, 1819.
– *Explication de la date égyptienne d'une inscription grecque tracée sur le colosse de Memnon à Thèbes d'Égypte*, Paris, 1819.
– *L'Obélisque de Louqsor, transporté à Paris*, Paris, 1833.
– *Fourier et Napoléon, l'Égypte et les cents jours. Mémoires et documents inédits*, Paris, 1844.
– *Des Dynasties égyptiennes, à l'occasion des ouvrages de MM. Barucchi et Bunsen, da Nouvelle Revue enc.*, Paris, 1847.
– *L'Égypte ancienne*, 1858.
CHAMPOLLION-FIGEAC, Aimé, *Les deux Champollion, leur vie et leurs oeuvres*, Grenoble, 1887.
DENON, Dominique Vivant (1747-1825), *Voyage dans la Basse et la Haute-Égypte*, Paris, 1802.
DIODORO SICULO, *Bibliotheca Historica*, Libro I.

DONADONI, Sergio, Silvio CURTO, Anna Maria DONADONI ROVERI, *L'Egitto dal mito all'egittologia*, Milano, 1990.
DONATI, Vitaliano (1717-1762), *Giornale del viaggio fatto in Levante d'ordine di S.M. dal medico Vitaliano Donati di Padova, Professore di Botanica nella Regia Università di Torino*, manoscritto n.291, Biblioteca Reale di Torino.
EBERS, Georg, *Richard LEPSIUS, A Biography*, translated from the German by Zoe Dana Underhill. New York, 1887.
EDWARDS, Amelia Ann Blanford (1831-1892):
– *A Thousand Miles up the Nile*, London, 1877.
– *Pharaohs, Fellahs and Explorers*, New York, 1891.
ERODOTO, *Le Storie*, Libro II.
FORBIN de, Louis Nicolas Philippe Auguste (1777-1841), *Voyage dans le Levant*, Paris, 1819.
HARLÉ, Martin R, Nile *Notes of a Hawadji: a bibliography of travelers' tales from Egypt, from the earliest time to 1918.* Metuchen, N.J., London, 1992.
HOREAU, Hector (1801-1872), *Panorama d'Égypte et de Nubie*, Paris, 1841.
JOLLOIS, Prosper, *Journal d'un ingénieur attaché à l'expédition d'Égypte (1798-1802)*, Paris, 1804.
JONES, Owen (1809-1874), *Views on the Nile: From Cairo to the Second Cataract*, London, 1843.
LEPSIUS, Karl Richard (1810-1884):
– *Über die Anordnung und Verwandtschaft der semitischen, indischen, altägyptischen und äthiopischen Alphabete*, Berlin, 1835.
– *Lettre à M. le Professeur H. Rosellini sur l'alphabet hiéroglyphique*, 1837.
– *Auswahl der wichtigsten Urkunden des ägyptischen Altertums, teils zum ersten Male, teils nach den Denkmälern berichtigt…*, Berlin, 1842.
– *Briefe aus Aegypten, Aethiopien und der Halbinsel des Sinaï, geschrieben, 1842-1845*, Berlin, 1852.
– *Das Todtenbuch der Aegypter…*, Berlin, 1842.
– *Reise von Theben nach Halbinsel des Sinaï vom 4 März bis 14 April, 1845*, Berlin, 1845.
– *Lettre de M. le Dr R. Lepsius à M. Letronne…*, Berlin, 1847.
– *Denkmäler aus Aegypten und Aethiopien*, Berlin, 1848-59.
– *Die Chronologie der Aegypter*, Berlin, 1849.
– *Königliche Museen. Abteilung der Aegyptischen Altertümer die Wandgemälde*, Berlin, 1855.
– *Königsbuch der alten Aegypter*, Berlin, 1858.
– *Älteste Texte des Todtenbuchs nach Sarcophagen des altägyptischen Reichs im Berliner Museum*, Berlin, 1867.
– *Verzeichnis der ägyptischen Altertümer und Gipsabgusse von R. Lepsius*, Berlin, 1871.
– *Nubische Grammatik mit einer Einleitung über die Völker und Sprachen Afrikas*, Berlin, 1880.
– *Das bilingue Dekret von Kanopus in der Originalgrösse mit Übersetzung beider Texte*, Berlin, 1886.
– *Discoveries in Egypt, Ethiopia, and the Peninsula of Sinai, in the years 1842-1845, During the Mission Sent Out by His Majesty Frederick William IV. of Prussia. Edited with notes by Kenneth R.H. Mackenzie. Second Edition with Additions and Corrections.* London, 1853.
L'HÔTE, Nestor (1804-1842):
– *Notice Historique sur les Obélisques Égyptiens et en particulier sur l'Obélisque de Louqsor*, Paris, 1836.
– *Lettres écrites d'Égypte en 1838 et 1839*, Paris, 1840.
– *Lettres d'Égypte en 1840-41*, Paris, 1841.
– *Memoires d'Égypte*, (Catalogue for an Exhibition of the same name), Strasbourg, 1990.
– *Sur le Nil avec Champollion, lettres, journaux et dessins inedits de nestor L'Hôte: premier voyage en Egypte, 1828-1830. Recueillis par Diane Harle et Jean Lefebvre; preface de Christian Ziegler. Editions Paradigme*, 1993.
MURPHY, Edwin, *The Antiquities of Egypt, A translation with Notes of Book I of the Library of History of Diodorus Siculus*, New Brunswick, London, 1990.
NORDEN, Frédéric Louis (1708-1742):
– *Voyages d'Égypte et de Nubie (1738) Ouvrage enrichi des cartes et figures dessinées sur les lieux, traduit du danois en français par des Roches de Parthenais*, Copenhagen 1751, 1755.
– *Voyages d'Égypte et de Nubie*, Paris, 1795.
PATANÈ, Massimo, "Nouvelles recherches sur le voyageur J.-J. Rifaud (1786-1852)," in *Göttinger Miszellen* 135 (1993), pp. 73-75.
POCOCKE, Richard (1704-1765):
– *A Description of the East, and Some other Countries*, London, 1743.
– *Voyages dans l'Égypte, l'Arabie, la Palestine, la Syrie, la Grèce, la Thrace, etc., contenant une description exacte de l'Orient et de plusieurs autres contrées …, traduits de l'anglais sur la seconde édition [1771] par une société de gens de lettres*, Paris, 1772-73.
PRISSE D'AVENNES, Achille Constant Théodore Emile (1807-1879):
– *Coup d'oeil sur la situation en Égypte*, Paris, 1831.
– *Excursion dans la partie orientale de la Basse-Égypte, Miscellanea Aegyptiaca, Alexandrie*, Paris, 1842.
– "Lettre sur l'archéologie égyptienne à M. Champollion-

Figeac", 27 mai 1843, *Revue Archéologique*, 1844.
– *Les Monuments Égyptiens*, Paris, 1847.
– *Oriental Album*, London, 1848-51.
– *L'Histoire de l'Art Égyptien*, Paris, 1878.
PRISSE D'AVENNES, Emile, fils, *Notice biographique sur E. Prisse d'Avennes, voyageur français, archéologue, égyptologue et publiciste*, Paris, 1894 e 1896.
RIFAUD, Jean-Jacques (1786-c. 1845):
– *Rapports faits par les diverses Académies et Sociétés savantes de France sur les ouvrages et collections rapportés de l'Égypte et de la Nubie*, Paris, 1829.
– *Tableau de l'Égypte, de la Nubie et des lieux circonvoisins: ou itinéraire à l'usage des Voyageurs*, Paris, 1830.
– *Voyages en Égypte, en Nubie et lieux circonvoisins, depuis 1805 jusqu'en 1827*, Paris, 1830.
ROBERTS, David (1796-1864):
– *The Holy Land, Syria, Egypt and Nubia*, London, 1842-49.
– *Egypt and Nubia*, London, 1846-50.
ROSELLINI, Ippolito (1800-1843):
– *I Monumenti dell'Egitto e della Nubia*, 9 voll. e 3 in folio, Pisa, 1832-44.
– *Tributo di riconoscenza e d'amore reso alla onorata memoria di G.F. Champollion il minore*, Pisa, 1832.
– *Giornale della Spedizione letteraria toscana in Egitto negli anni 1828-29*, 1925, edizione postuma.
SALT, Henry (1780-1827):
– *Twenty-four Views taken in St.Helena, the Cape, India, Ceylon, Abyssinia and Egypt*, London, 1809.
– *Account of a Voyage to Abissinia and Travels into the Interior of that Country… in the years 1809 and 1810*, London, 1814.
– *Essay on Dr. Young's and M. Champollion's Phonetic System of Hieroglyphics, with some additional discoveries*, London, 1825.
SICARD, Claude (1677-1726):
– *Lettre à Mgr. le Compte de Toulouse, contenant une relation de ses trois voyages dans la Haute et Basse-Égypte, écrite en 1716*, Paris.
– "Relation d'un voyage aux Cataractes et dans le Delta", in *Nouveaux Mémoires des Missions de la Compagnie de Jésus*, Paris, 1717.
SILIOTTI, Alberto, *La scoperta dell'Antico Egitto*, Vercelli, 1998.
STRABONE, *Geografia*, Libro XVII.
– *The Geography*, vol. III, literally translated, with notes, by H.C. Hamilton and W. Falconer, London (1906).
THOMPSON, Jason, *Sir Gardner Wilkinson and His Circle*, Austin, 1992.
TOLOMEO, Claudio, *La geografia di Claudio Ptolomeo alessandrino…*, Venezia, 1548.
WILKINSON, John Gardner (1797-1875):
– *Materia Hieroglyphica. containing the Egyptian Pantheon and the Succession of the Pharaohs, from the earliest Times to the Conquest by Alexander, and other Hieroglyphical Subjects*, 2 voll., London, 1828-30.
– *Extracts from several Hieroglyphical Subjects found at Thebes and other parts of Egypt. With remarks on the same*, London, 1830.
– *Topographical Survey of Thebes, Tape, Thaba of Diospolis, Magna*, London, 1830.
– *Topography of Thebes, and general view of Egypt…*, London, 1835.
– *The Manners and Customs of the ancient Egyptians…*, 3 voll., London, 1837.
– *Modern Egypt and Thebes. Being a description of Egypt, including the information required for Travellers in that Country*, 2 voll., London, 1843.
– *A Handbook for Egypt. Including Descriptions of the Course of the Nile to the Second Cataract, Alexandria, Cairo, The Pyramids, and Thebes, the Overland Transit to India, the Peninsula of Mount Sinai, the Oasis…*, London, 1847.
– *The Architecture of Ancient Egypt: in which the Columns are arranged in Orders, and the Temples classified, with remarks on the early progress of Architecture…*, 2 voll., London, 1850.
– *The Egyptian in the Time of the Pharaohs. Being a Companion to the Crystal Palace Egyptian Collections. To which is added an Introduction to the Study of the Egyptian Hieroglyphs by Samuel Birch*, London, 1857.
– *The Fragments of the Hieratic Papyrus at Turin, containing the names of Egyptian Kings, with the Hieratic Inscription at the back*, 2 voll., London, 1851.
– *A Popular Account of the Ancient Egyptians, revised and abridged from his larger work*, 2 voll., London, 1854.
– *Desert Plants of Egypt. Illustrations with descriptions, by Wm Carruthers F.R.S.*, London, 1887, edizione postuma.
WORTHAM, John David, *British Egyptology 1549-1906*, Newton Abbot, 1971.
YOUNG, Thomas (1773-1829):
– *Remarks on Egyptian Papyrus and on the Inscription of Rosetta*, London, 1815.
– *Account of some Thebaic Manuscripts written on leather. Legh's Narrative*, London, 1816.
– *An Account of Some Recent Discoveries in Hieroglyphical Literature and Egyptian Antiquities, including the author's original alphabet as estended by M. Champollion*, London, 1823.

INDEX

PHOTO CREDITS

All the images are by Archivio White Star except for the following:
6 top: Peter Whitfield/ Wychwood Editions
6 bottom: Alberto Siliotti/ Archivio Geodia
7: BNF
8: Civica Raccolta Stampe A. Bertarelli, Castello Sforzesco, Milan
9: BNF
20 center: BNF
34 top: Alberto Siliotti/ Archivio Geodia
34-35: Alberto Siliotti/ Archivio Geodia

44 top: National Trust Photographic Library, Mike Williams
48 bottom left: Alberto Siliotti/ Archivio Geodia
48 bottom right: Alberto Siliotti/ Archivio Geodia
48-49: Archivio Scala, Museo Archeologico, Firenze
61 top: Musee D'Annecy
76 top right: Scottish National Portrait Gallery

The coloring of the plates has been done by Old Church Galleries, London.

Portrait of Seti I, from his tomb in the Valley
of the Kings. From Karl Richard Lepsius's
Denkmäler aus Aegypten und Aethiopien.